Touching this woman was nothing short of torture

Lucas cleansed the cut on Bree's leg, an innocent touch that inspired some not-so-innocent thoughts. Her thigh was supple and soft. He wanted to run his fingers up her leg and feel her muscles tense beneath his touch. He wanted to lean over and press his mouth to her thigh and watch her react.

He couldn't ever remember being so attracted to a woman.

But he'd never met a woman like Bree before, either. No woman had ever dropped into his garden in the middle of the night.

Forcing himself to focus on his task of mending her injuries—incurred in that drop into his shrubbery— Lucas stood between her spread knees and tried not to be affected by the sight of her. But the way Bree braced herself on her hands gave him an incredible view...and the pulse beating quickly at the base of her throat made him hope she'd noticed his nearness, too.

Suddenly she shifted, her hand coming to rest on his where it dabbed at the corner of the cut. "You know, Lucas, you're *very* good with your hands."

D0206790

Blaze™

Dear Reader,

One of the things I love about writing romance is creating worlds. I love masterminding the intricacies of a situation and forcing my characters to rise to challenges. I want them to overcome their struggles while finding the way to love and happily ever after.

To date, I've created my worlds alone, but with the RED LETTER NIGHTS miniseries, I shared the job with Harlequin Blaze authors Alison Kent and Karen Anders. We brainstormed. We dreamed. We had fun!

There's another descendant of Captain Dampier living in Court du Chaud and, like him, she's tackling a past mistake. But Bree rises to the challenge, because until the past is in the past, she won't have a future. And a future with Lucas Russell is worth fighting for. Enjoy!

Drop me a line in care of Harlequin Books, 225 Duncan Mill Road, Don Mills, Ontario M3B 3K9, Canada, or visit my Web site at www.jeanielondon.com.

Very truly yours,

Jeanie London

Books by Jeanie London

HARLEQUIN BLAZE
153—HOT SHEETS*
157—RUN FOR COVERS*
161—PILLOW CHASE*
181—UNDER HIS SKIN
213—RED LETTER NIGHTS
 "Signed, Sealed, Seduced"

*Falling Inn Bed...

HARLEQUIN SIGNATURE SELECT SPOTLIGHT
IN THE COLD

GOING ALL OUT

Jeanie London

TORONTO • NEW YORK • LONDON
AMSTERDAM • PARIS • SYDNEY • HAMBURG
STOCKHOLM • ATHENS • TOKYO • MILAN • MADRID
PRAGUE • WARSAW • BUDAPEST • AUCKLAND

To my cousin, Marietta Cesarini.
You have the biggest heart of anyone I know,
and I've always found you such an inspiration ;-)

ISBN 0-373-79235-2

GOING ALL OUT

Copyright © 2006 by Jeanie LeGendre.

This edition published by arrangement with Harlequin Books S.A.

® and ™ are trademarks of the publisher. Trademarks indicated with ® are registered in the United States Patent and Trademark Office, the Canadian Trade Marks Office and in other countries.

www.eHarlequin.com

Printed in U.S.A.

1

LIFE MIGHT NOT HAVE dealt Bree Addison a royal flush in wealth or circumstance, but it had dealt her enough high cards to play toward a winning hand. Intelligence. Decent looks. Ambition. Lately she'd been playing every one.

And while walking home tonight after her shift at Toujacques—New Orleans's premier casino—Bree could feel she was on the verge of pulling an ace from the deck.

Life had also dealt her stellar instincts. She had an internal alarm that could sense trouble from across Lake Pontchartrain.

The trick was paying attention.

So when she realized a car was following her, Bree took the alarm shrieking inside her head very seriously.

As if emphasizing her sudden awareness of danger, the moon slipped behind a cloud, throwing the street into shadow along the lengthy stretch between street lamps. She caught a heel on the uneven sidewalk and stumbled.

Grabbing the hem of her cocktail dress, she managed to catch herself and regain her balance before going down, but the effort left her pulse spiking hard.

The car drove along barely in her periphery, and she wondered how she could have missed it. How long had she been waltzing down these streets, so filled with good fortune at being named one of the two women under con-

sideration for the promotion to Toujacques' head VIP hostess job that she hadn't noticed what was happening around her?

Bree didn't know, and she didn't like not knowing. It meant she'd been ignoring her instincts, *never* a smart thing in the best of circumstances.

Three in the morning in New Orleans's French Quarter didn't qualify as the best of circumstances.

Glancing around at the familiar surroundings that seemed strangely unfamiliar in the dark, she gauged the distance to the entrance of the court where she lived, relieved to see the brick wall that separated Court du Chaud from the rest of the French Quarter. If she could just make it around the corner and down the block to the alley…

Did she want that driver to see where she lived?

Taking a calculated risk, she stopped suddenly and leaned over as if to adjust the slingback strap on her sandal. Beneath the fall of her long hair, she peered at the car—a generic sedan, probably a rental. It kept moving toward her, achingly slow, but her instincts told her the driver worked hard not to tip his hand by noticeably decelerating.

Tires ground over a street clammy with late-night dew, a spongy sound that grew steadily louder. Chrome glinted as the sedan inched beneath a streetlight, and Bree recognized her opportunity. She straightened while lifting her gaze across the windshield….

And staggered as if she'd been punched.

For one startling second her heart seemed to stall in midbeat. Bree stood suddenly paralyzed, her face shielded by the fall of her hair, purse dangling from her shoulder. The February chill that had invigorated her earlier now prickled through her coat in icy needles.

Jude.

He'd always been a striking man, and the ruthless beauty of his face still held the power to make her stare stupidly, as if she couldn't quite believe he was real. No man who looked like this could possibly be real.

His long black hair was pulled back, a look that emphasized the flawlessly carved lines of his face, his unusual eyes. Up close those gray eyes would glint crystalline from beneath thickly fringed lashes. His eyes could play award-winning performances to any crowd.

Bree knew that firsthand because she'd been an audience he'd played to. Once upon a time, he'd played her *big*.

With every instinct shrieking to run and hide, she sucked in a breath that went down so hard she choked. By a sheer effort of will, she forced herself to step into the wash of light from a street lamp, becoming a bull's-eye in her gold-spangled cocktail dress, a vulnerable target in heels that looked so sweet but made running impossible.

What was *he* doing here?

She wasn't waiting around to find out.

Forcing herself into motion again, she strolled along as if she hadn't a care in the world. She fought the urge to turn to see what he was up to. Taking her eyes off this man was never smart. But she couldn't let him know he'd been made.

She wouldn't tip her hand. Not to *him*.

Not ever again.

Every second underneath a streetlight scorched like the Louisiana summer sun, and Bree hadn't realized she'd stopped breathing until moving into the shadows again, where she sucked in a hard breath that needled along her skin.

Think. *Think.*

He obviously knew where she worked or he wouldn't be following her. He probably knew where she lived, too, but she didn't have to lead him straight to her front door.

Lose him.

That was the only thing to do. But she couldn't outrun his car wearing these overpriced sandals....

With her pulse hammering loudly in her ears, Bree eased her way toward a live oak that spread its branches over the street. She hiked her hem high to conceal the flashy gold dress beneath her coat and edged along the dew-slick brick wall.

Jude was almost past her before his taillights sparked red. He braked, and for a split second she could see him leaning over the steering wheel, scanning the street, looking for her.

His car inched forward, and she dared to breathe, hoping, *praying* he'd just keep on going. But Bree knew firsthand Jude Robicheaux was nothing if not determined.

The brake lights flashed again. He was turning around.

She stood frozen, knowing his headlights would soon expose her. If he saw her crouched in the shadows, he'd guess she'd made him. This little game of cat and mouse would end, and what he'd do then was anyone's guess. Once, Bree had thought she'd known what this man was capable of.

She'd been wrong.

Why he was back in town was a mystery. Revenge maybe? The last she'd heard, there was an outstanding warrant for his arrest, and as she'd been a material witness when the cops had been building a case against him...

But after all this time? Jude had been the one caught scamming. He had to have known she would cooperate

with the police. Wasn't as though she had much of a choice since they'd been trying to implicate her. Then again, Jude had expected her to leave town with him and outrun the law, to leave her family and stick by him no matter what he'd been involved in.

She shivered. Didn't it figure he would show up when she finally had the world by the tail, on the very night she'd learned all her hard work was paying off and she might actually realize her ambitions. He'd always had impeccable timing. He'd made his move on her when she'd been too young and stupid to see through him.

But Jude Robicheaux had already wasted as much of her time as Bree would let him waste. He wouldn't get another second.

One fast glance around the street convinced her there was nowhere to run. Even without the lights flashing all over her cocktail dress, her formal-length hem and heels made her easy prey. He could be out of his car and on her before she screamed long enough to get anyone's attention.

So Bree did the only thing she could do.

She lunged for the lowest branch. Catching the limb, she winced as the spiny bark bit into her palms but forced herself to hang on and swing her legs high to build momentum.

She tried to catch the branch with her foot, but her narrow dress left no room to maneuver. Luckily the seam gave at the last possible instant, and she managed to hook a knee over the limb and scramble on.

"Argh," she groaned as prickly twigs and rough bark scratched nasty trails along her skin.

She could repair the seam of her fancy dress, but this was the end of a brand-new pair of seventeen-dollar panty hose.

Damn that Jude Robicheaux anyway.

With irritation fueling her efforts, she reached for an overhead branch and pulled herself upright.

She clung to the branches for balance, the heels of her shoes providing surprising leverage. The slope of the insteps caught the limb snugly, and she was able to gain enough footing to reach the top of the wall. Maybe they'd been worth the obscene amount she'd paid for them after all.

The sedan's tires ground over the asphalt, engine belts whining in protest as Jude maneuvered a tight turn. The headlights swung around, aiming for her. Gritting her teeth, Bree hoisted herself onto the wall, glancing around desperately for something to hang on to as she lowered herself into the courtyard below.

Light shone through the French doors of the town house, casting the landscape into blackness despite the solar lights along the hedges. She didn't recognize the town house she was invading, had no idea which of her neighbors might be awake so late.

Whoever he or she was, this neighbor obviously kept the landscaping tidy and the branches neatly trimmed. *Not* good for her. When the headlights sliced directly below her, there was no place for Bree to hide, nothing for her to do but tackle that twelve-foot drop.

With the wild thought that she should have known better than to walk home tonight, she let go of the branch and fell with a nauseating plunge until…

Something cushioned her fall at the very last second before she landed in the shrubbery with a noisy crash.

"Damn!"

Though she didn't come down as hard as expected, every bone in her body rattled. She felt an icy wave pour

through her and fought to free her arms from the tangle of twisted coat. Another seam split, and branches took out what was left of her hose.

A second passed before she caught her breath, another as she shook off her daze, but Bree didn't dare move until assessing the damage. All things considered, she'd have expected that drop to be a lot worse. She had no idea what had broken her fall—had her coat caught on a branch and slowed her descent?

She didn't get a chance to find out.

By the time she'd determined she'd live, despite some stinging scratches and a bruised hip that would wind up the color of a bayou sunrise, a shadow sliced across the light illuminating the courtyard.

Great. Someone was coming.

She had no clue which of her neighbors would find her but seriously hoped that he or she hadn't called the police yet. If the police came, there'd be sirens and commotions and, worse still, *explanations.*

Any explanation involving Jude Robicheaux was likely to land Bree in the backseat of a police cruiser, and if she landed in lockup, she'd have no choice but to call her twin sister to spring her, which would mean more explanations.

Even worse, if work got wind of her unfortunate past, Bree wouldn't stand a chance in hell of beating out Lana for that promotion....

Think. *Think!*

The light pouring through the French doors should work to her benefit rather than the neighbor's, so if there was any way to slither unseen from the bushes and make a break for the gate... Rational thought stopped the instant her neighbor appeared in full view of the French doors and Bree realized whose courtyard this was.

Josie Russell's.

Under normal circumstances, she would have just asked Josie to harbor her until Jude had moved on. Unfortunately tonight was decidedly *ab*normal.

Last weekend Bree had been one of the Court du Chaud crew to attend Josie's wedding, and now the new Mrs. Max LeClerc honeymooned with her new hubby somewhere in the South Pacific.

The current occupant of Josie's town house could be none other than the new bride's brother, who'd traveled in from California for the wedding.

He wouldn't have a clue who Bree was.

Josie had mentioned him, of course, but Bree couldn't even remember his name. She'd noticed him at the wedding, though. Not only had he stood as the groom's best man, but she didn't think any woman alive could help noticing such an attractive man.

But while Josie's brother might be really easy on the eyes, he was also one of those rich and powerful men like those she worked for as a VIP hostess at Toujacques, which meant he probably wouldn't have a lot of sympathy for her trying to give her bad-news ex the slip.

If he even believed her.

He'd probably take one look at her torn dress and shredded hose and figure she'd run afoul of a particularly nasty john.

Boy, did she know this guy's type.

Well, in all fairness, Bree didn't know if Josie's brother even liked to gamble, but Mr. Rich and Powerful had worn his custom tux that cost more than the down payment on her town house like a second skin. Even without the expensive suit, his attitude had flashed like neon.

I'm way beyond bored with my high-powered lifestyle,

expensive toys and all those rich-bitch women throwing themselves at my feet.

Now he'd obviously heard the noise from her fall, and with the same arrogant self-assurance that had impressed her across a banquet hall, he strode to those French doors to find out what was happening in his sister's backyard....

Bree blinked. Again.

Mr. Rich and Powerful wasn't wearing an expensive tux tonight. He must have been taking a shower, because he wore nothing but a towel to cover some seriously toned, tanned and dripping wet skin.

Adrenaline had already been working a number on her. Now her heart started throbbing again. Her pulse rushed too fast, and Bree could only stare as he reached the doors and raised an arm to the lintel—to flip a lock, presumably—gifting her with the sight of shifting neck muscles, gathering biceps and rippling tummy. The towel slipped enough to reveal a lean hip and smooth skin angling down toward the telltale bulge of the goodies he kept hidden beneath the plush cotton.

Honestly, the man was entitled to parade around in the wee hours dressed in anything he chose. Bree couldn't blame him because she found herself in his bushes.

She could, however, blame him for flipping off the light. Not only had he ended the show that was diverting her from her aches and pains, but he'd left her with a problem. She'd been staring into the light and was now nearly blind.

Had he already called the police?

When the door creaked open, Bree decided to play it safe.

"Mr. Josie's Brother from California," she called out. "I surrender. I'm not here to rob the place. I just sort of... dropped by for an unexpected visit."

Her voice echoed eerily through the darkness. Blinking furiously to adjust her sight, she crouched in the shrubs like a sitting duck, unable to hear a thing above the sound of the wind rustling through the branches of an overhead tree and her own aching pulse.

And just when she could finally differentiate the outline of the hedge behind the strings of solar lights, Bree found herself blinded yet again by a wickedly bright flashlight.

Suddenly the man himself appeared, and she hadn't even heard him coming.

"You're one of the twins who live in Number One."

"Guilty."

He lowered the beam from her face, and she could almost make him out—lots of bare skin and chiseled features. Even half-blinded, she could see the man was even more striking up close than he'd been from far away.

"So what did I do to deserve a visit from such an illustrious person at this time of night?" he asked.

"Illustrious? What did I do?"

"Found the captain's treasure."

And here Bree thought she'd made an honest impression. "Actually, my sister found the treasure."

"Still part of an illustrious family."

Bree inclined her head. No lie there. "Bree Addison, descendent of Gabriel Dampier, captain of the privateer ship Crescent."

He shifted the light over the gold spangles littering the ground and grabbed her hand with a strong grip. "Lucas Russell. Number Sixteen. You weren't kidding when you said 'dropped by.'"

"Unfortunately."

He chuckled, and the deep, throaty sound rippled silkily through her.

Surprise, surprise. Adrenaline must be doing all sorts of screwy things, because under normal circumstances, Bree wouldn't have given this guy a reaction no matter how attractive he was. Not a man who was a carbon copy of those she catered to at work.

With Lucas Russell's solid grip providing leverage, she cautiously extricated herself from the shrubs. She swallowed back a groan when every muscle in her body throbbed in protest and spangles showered the ground at her feet.

She tried not to think about how she must look with foliage in her hair, in her clothes, in her shoes.

All things considered…Bree had fared remarkably well. No broken bones. One very handsome savior, whether she was interested or not.

Things were looking up.

Lucas helped extricate her from the tangle of her coat and steadied her against him, bringing her up close and personal to a whole bunch of naked man. She found herself distracted from her aches and pains long enough to notice shoulders so broad she couldn't see around them.

He towered above her, and she wasn't exactly short. But even more striking was the strength she felt in the hand he kept locked around hers, the warmth of his skin. After all the shocks she'd gotten tonight—both good and bad—Bree shouldn't have had any energy left to react to this man.

But she was reacting, *big*.

Especially when he raked his gaze over her. The darkness hid the color of his eyes, but he was clearly inspecting her for damage. She must have looked as bad as she felt, because his eyebrows knitted in a frown.

Lucas, however, looked as good as he felt. At this close

vantage, his face was all cut lines and chiseled angles. He was handsome in a very aggressive, male way.

She should have been immune. Damn adrenaline.

"You're bleeding." The flashlight beam traveled down her leg.

One glance at the carnage of tattered hose stained with blood and she did groan. "So I am. Guess I'll say thanks and be on my way. It was a pleasure."

She moved to extricate herself from him, but Lucas didn't let go. "Come inside. Let's take a look at your leg."

"I appreciate the offer, but there's no need. Just a few scratches. I'll live."

"I'm trained in emergency first aid."

"Really? Josie said you were the king of a software empire. Do your subjects get hurt working with the keyboard and mouse?"

"I write law-enforcement software," he said drily. "I spend a lot of time consulting with various national agencies and participating in training so I can target their needs."

Great. Jude Robicheaux was back in town and she'd run for cover to a man with law-enforcement connections.

Why had she thought she'd been dealt a decent hand tonight again?

Raking her gaze down all that yummy skin, she tried to assess the threat. Any man who rescued a lady from treacherous shrubbery wearing only a skimpy towel couldn't be all bad, could he?

"Can you walk or shall I carry you?" he asked.

Yummy or not, Lucas was determined to get his way. It was in his almost amused tone, in the grip that assured her he had no intention of letting go.

No surprises here. "Really, this isn't necessary."

"It is. I'm not dressed to walk you home."

"I'd argue. The neighbor ladies would love watching you parade through the court in your towel."

He blinked in surprise, and under any other circumstances, Bree might have laughed.

Not tonight.

Like it or not, without knowing why Jude had followed her, she wasn't all that eager to head home yet herself. About the last thing she wanted was to meet him on her doorstep. Not in her present condition. And definitely not in the dark.

Bree didn't have too many options right now, and stalling seemed like a good one. If Lucas wanted to play the knight in skimpy towel then she'd be a fool not to oblige.

"Well, then, thank you." Tipping her gaze to stare into his face, she found herself almost startled again by his sheer maleness. He'd been handsome from across a banquet hall, but up close… "I appreciate the help."

He only inclined his head in that regal way of the wealthy, as if it was both his privilege and duty to help those in need. Ever the gentleman, he didn't mention the golden trail of spangles she left in her wake to mark a trail for the squirrels.

He didn't release her hand while leading her across the yard. She almost smiled at how he managed to look large and in charge while walking through damp grass half-naked and barefoot.

It was in the DNA. Had to be.

He held the door as she slipped inside, then motioned her to a breakfast nook separating the dining room from the kitchen.

"Have a seat while I hunt down Josie's first-aid kit."

"Yes, Lucas." Bree did as he asked, appreciating a chance to admire the back half of him as he strode from the room.

Very nice indeed.

Everything about this man was attractive, she decided, exhaling a sigh that had nothing to do with her bumps and bruises. She wasn't hurt, not really, just achy and sore from the fall and jittery from too much adrenaline.

Slipping off her coat, Bree hiked up her dress to rig broken threads of sequins so she wouldn't trash the town house. She'd been inside once before, and even with the huge windows shuttered against the night, Josie's place managed to be as warm and welcoming as Josie herself.

The spacious rooms were filled with stylish wicker and sunny colors and woodwork painted bright white. Bree thought the look contrasted nicely with the weathered exteriors and ornate ironwork that made up all the centuries-old town houses in historic Court du Chaud.

As she and her sister had only moved into the court last year, Bree didn't know Josie all that well. They both worked a lot. Bree divided her time between Toujacques and her moonlighting for a local fashion designer, so get-togethers generally happened at homeowners' association and Krewe du Chaud meetings or brush-bys for coffee in Café Eros, the bistro where her sister worked.

But Bree liked Josie and wished her well in married life. Many of the court's residents seemed to be getting on with their futures lately. Even Tally had gotten engaged to Christien and bought the nightclub she'd been longing for. Claire and Randy had hooked up. Perry and Jack, too. And after learning about her shot at the head hostess job tonight, Bree had thought she'd been moving on with her life, too.

Until her past had followed her home.

"Found it," Lucas said when he returned from upstairs.

He'd thrown on sweatpants, and she couldn't help but wonder if she'd have been so affected by this man if she hadn't met him when he'd been half-naked.

Probably. The man was gorgeous, all touchable and male. Not at all like Jude, who was almost too pretty to be real. Up close Lucas had the same sable-colored hair as his sister and eyes as bright green. The combination tempered his chiseled features. Otherwise that strong face and drop-dead gorgeous body combined made him almost too male. If such a thing was possible.

Setting the first-aid kit on the table, Lucas sank to his knees in front of her. He hesitated with his hands poised over her ankle and asked, "Do you mind?"

"Have at it." Lifting aside her destroyed dress, she gave him a bird's-eye view of the carnage.

Both knees were a mess. Scratches streaked her skin, and blood had congealed on the torn edges of her hose. One particularly nasty branch had carved a crevasse up her thigh.

Lucas frowned and stood again, giving her a tour of that magnificent chest as he grabbed the kit again and said, "Come with me."

"Where are we going?"

"To the sink."

Okay, there was no arguing she needed soap and water. She'd come out on the bad end of the dirt and mulch in Josie's flower bed, so she followed him into the kitchen without comment.

Lucas flipped on a light, deposited the kit on the counter and ran the water. "Take off your stockings."

"We only met ten minutes ago."

He laughed. "We need to clean those cuts well or you'll wind up wishing you did. Trust me."

"Another lesson learned in law-enforcement training?"

"From my mother."

"Why doesn't that surprise me? I'm sure she tended lots of boo-boos while you were growing up."

His expression morphed into a full-fledged smile that softened his features and brightened his eyes and coaxed a reaction low in her belly. A crazy sort of swooping feeling that distracted her from her aches and pains.

"I'd be lying if I said no. Now lose the stockings."

"I'll bet you say that to all the girls." She made a little *humph* sound and couldn't resist giving him a show while slithering her hose out from underneath her dress.

She could feel his gaze on her when she bent over to unfasten her sandals and wondered if he noticed the way her neckline drooped, if he watched her cleavage plump forward. Did he think she was taunting him? Or flirting?

She wasn't entirely sure which it was herself.

There was something about this man that made Bree want a reaction. Probably nothing more than a need to flex her control muscles after the shock of seeing Jude again.

And she got one.

Lucas grabbed her, strong hands circling her waist. He lifted her up to a seat on the counter and without preamble he brushed aside her torn dress and got to business.

She braced back on her arms, feeling a bit breathless as he cleansed her skin with soapy gauze.

"That feel okay?" he asked.

"I'll live."

"So why'd you drop by tonight?"

Questions were inevitable, but she had to give Lucas credit for not starting the interrogation the minute he found her.

"I noticed someone following me while I was walking

home from work. It was late, and I'm not exactly dressed to defend myself. I decided to beat a hasty retreat."

He peered at her from beneath the silky fringe of thick lashes. "So you scaled a wall in a formal gown and high heels? I'm impressed. What kind of work do you do?"

This was another question she'd expected, and Bree wondered what type of work he thought she did.

Evening formal wear. Three in the morning. Dark street. *Hmm.*

"I work at Toujacques. I'm a VIP hostess."

"Do you always walk home from work?"

"Not when it's so late. I normally drive."

"But not tonight."

"Not tonight." She knew he was waiting for some further explanation, but she wasn't volunteering any. He didn't need to know that her brother had flown home for the weekend from college and had borrowed her Jeep.

But to her surprise, Lucas didn't push. He just tossed the filthy gauze in the trash and lathered a new batch with soap under running water. He started working on her other knee and went back to his original line of questioning.

"Did this someone threaten you?" he asked.

"Didn't give him a chance. Didn't want to lead him to my front door, either, so here I am."

Bree expected a lecture on the perils of walking through the French Quarter alone at night. Men like Lucas were invariably throwbacks from the feudal days when the rich and powerful protected the weak and defenseless.

But instead of a warning, Bree got strong hands on her thighs. It was a casual touch—if any stranger's touch in such an intimate place could really be casual. *Perfunctory* might be a better description. The thing was…his touch didn't feel perfunctory.

Even though he only tended her cut, she felt him everywhere. Heat melted through her, and she was so very aware of her parted thighs. Probably because she didn't wear panties beneath her panty hose, which put this man's strong hands in very close proximity to some oh-so-bare private places.

"So are you enjoying your stay in New Orleans?" she asked to distract herself from the feel of his hands and to end the discussion about why she'd dropped in for a visit.

"I always enjoy coming home."

"Josie told me she bought this place from your parents after they retired to Florida. You were reared here?"

"Court du Chaud homegrown."

Ironic that he'd take off for California when she and Tally had always thought the court would be the best place in the world to live. "Is that why you're hanging around while Josie and Max are on their honeymoon? Visiting friends?"

"One of the reasons. My parents stayed after the wedding, too. I wanted to see them off. And my sister has me doing some work around here."

"What sort of work?"

"Cleaning out the attic. My mom's a pack rat. She stashed memorabilia the whole time we were growing up, then left it all when she moved. Josie's afraid the fire marshal will condemn the place. Now that she and Max are married, they're making some decisions about living arrangements, and she wants to make sure I take everything I want in case they decide to sell the place."

"Couldn't live without your baseball trophies, hmm?"

"Or the sculpture of Cupid I made Mom in third grade."

"It's still around?"

"Give or take a few limbs."

"I can see why you'd want to save it."

"Absolutely. Some superglue and I've got the perfect Mother's Day gift."

Bree smiled. Oddly she had no trouble imagining Lucas as a young boy making sculptures for his mother. Maybe the way he tended her injuries with such a gentle touch made such a caring gesture seem to fit this strong man.

"So tell me, are you the twin I've heard singing?" After tossing the gauze into the trash, Lucas fished through the first-aid kit.

"'Fraid I'm going to disappoint you again. My sister's the singer in the family."

"Just you and her?"

"Got a musically inclined brother, too. I'm the untalented one of our illustrious bunch. No treasure hunts. No musical talent. The younger twin, wouldn't you know? Something to do with the gene pool, I'm guessing. Watered things down a bit."

Glancing up from his task, he dragged his bright gaze over her in a lazy caress. "Untalented?"

"One in every bunch."

"Scaling a tree in this dress and those shoes? Ever thought about stunt work?"

She laughed. Lucas was proving to be a chuckle a minute, easy to be around for a man she'd just met under some very tenuous circumstances. Bree must really be off her stride after all the night's shocks. She usually had much more self-control.

But when Lucas patted the antiseptic wipe against her thigh, then blew gently to soothe away the sting, she felt the tingle of his warm breath from the top of her head to her toes.

"Still okay?" he asked.

"Mmm-hmm." The antiseptic burned, but her awareness of his mouth overrode any other sensation.

She could feel the determination in his touch, but she sensed compassion in the warm burst of breath against her skin. He was a surprise, this one. Bree made her career catering to overindulged rich men who lived life for new challenges. She recognized Lucas as one. No mistake.

But there was something else here, too.

She wasn't sure what it was. Not the way he'd chosen to play the knight in skimpy towel.

What self-respecting man wouldn't rescue a damsel in distress?

It wasn't the way he'd dragged her inside to care for her boo-boos either.

No, Bree wasn't at all surprised that he'd charged in to save her.

Maybe she was surprised by how glad she was that he had.

2

TOUCHING THIS WOMAN with no hope of making love to her was nothing short of torture, Lucas decided. He cleansed the slash that marred Bree's skin, an innocent touch that inspired some not-so-innocent thoughts. He wanted to run his fingers up her leg and feel her muscles tense beneath his touch. He wanted to lean over and press his mouth to her thigh and watch her react.

He couldn't ever remember being so attracted to a woman.

But he'd never met a woman like Bree before either.

She wasn't what Lucas had expected to find in the bushes when he'd heard noises from outside earlier. Some kid who'd sneaked out his bedroom window for a late-night party on Bourbon Street, maybe. Or a trapped raccoon escaped from the wildlife rescue shelter down the street.

Not this intensely desirable neighbor who was playing hell all over his restraint.

Forcing himself to focus on his task, Lucas stood between her spread knees and tried not to be affected by the sight of her. A lost cause. Not only hadn't he dated since a Swedish scientist had skyrocketed his libido past the stratosphere, but the way Bree braced back on her hands gave him an incredible view of her gown bunching

up around her hips. All that sparkly fabric molded her narrow waist and full breasts, and the pulse beating quickly at the base of her throat made him hope she'd noticed his nearness, too.

Her exotic eyes were as dark as the sable hair that fell in lustrous waves over her shoulders, a rich color that contrasted strikingly with her creamy-gold skin. She had a mouth that looked as if she'd just been kissed, full lips that managed to be as expressive as her flashing eyes.

From the instant he'd seen her at Josie's wedding, Lucas had thought Bree one of the most stunning women he'd ever laid eyes on. Impossibly beautiful because there were two of her. Her twin was a mirror image, and while he knew there must be differences, he hadn't gotten close enough to discern them.

Nor had he managed an introduction. With family and friends coming in from far and wide for the celebration, uncles, aunts, cousins and acquaintances who he'd barely recognized had cornered him through the entire reception.

According to Josie, the twin who'd found the treasure had gotten engaged after her adventure. Since his sister hadn't mentioned anything about this twin's situation, Lucas didn't know much about Bree.

He'd admired her from a distance, though, or *them,* because without formal introductions they were a duo in his mind—the twins from Number One—but from the moment Bree had gazed into his face and her hand had slipped inside his, she'd become the woman who made him respond.

He'd been feeling the effects ever since.

Granted, it had been a while since the Swedish scientist, and he hadn't met anyone interesting enough to pursue since then. But Lucas knew chemistry, and it was

tearing through him right now. He struggled to carry his half of the conversation as thoughts of what he'd like to be doing to Bree distracted him.

Run his hands along her thighs…. Investigate what was going on beneath the hem of her dress…. Find out if she was as attracted as he was.

He couldn't decide if Bree was flirting with him. She was a beautiful woman who would no doubt be used to men gawking, so he suspected she was charming as a matter of course. Her job as a hostess would demand that.

But Lucas wanted to know more about what had brought her into his backyard tonight. Given the damage she'd endured to her person, she must have been very serious about getting away from whoever had been following her.

He didn't think this woman would frighten easily.

"So what does a VIP hostess do?" He gently probed her skin, searching for debris. Finding her scratches pink and clean, he tossed the antiseptic wipe and went for the antibiotic ointment.

"I'm guessing you don't gamble much," she said.

"Some buddies and I head into Vegas every so often to make a weekend of it. I went to a wedding there once."

Her mouth pursed in a thoughtful moue, red, ripe and ready to be kissed. "In a nutshell, it's my job to keep my guests happy so they don't have to think about anything but spending their money at our tables. I arrange their meals and their schedules. I entertain their families while they're gaming."

"Sounds demanding."

"Sometimes. What a man wants is what he gets."

There were so many places Lucas could take that statement. Of course, his supercharged libido conjured up

images of her stretched out before him much in the way she was right now, thighs parted, breasts thrust forward.

Wearing nothing but a smile.

He knew what he wanted. "Lucky guys."

She only shrugged.

Running a fingertip down her thigh, he traced the outer edge of a scratch. "We definitely need to cover this one. What do you think about your knees? I've got some bandages here that should do the trick."

Her eyes shuttered beneath thickly fringed lashes as she stared at the scratches, considering. "Please. I'd like to get home without all this greasy ointment on my dress. I've done enough damage tonight already."

"Take it off. I'll get you a towel. We've got neighbors who'd like watching you parade through the court."

Tilting her head to the side, she sent a wave of glossy hair tumbling over a shoulder as she laughed. "Wouldn't want to steal your thunder."

"Plenty of thunder to share."

"Gracious of you. But I'm just glad you weren't asleep when I dropped in. My luck and you'd have awakened and called the police before I raised the white flag."

"I'm glad, too." He met her gaze, drawn to the way those eyes flashed with humor, daring, excitement. Such expressive eyes.

"So tell me, Lucas. Do you always shower so late at night? Or is this early morning for you?"

"Late. I was working and lost track of time."

"Designing law-enforcement software?"

He nodded. "A job perk. I work anytime, anywhere."

"Lucky you."

Lucas agreed. Especially when he got to touch her again, smoothing the antibiotic ointment up her thigh.

Her skin was supple and velvety-soft beneath his fingers. Each stroke became an effort of will. He wanted to trail his hands even higher. His blood started a throbbing descent toward his crotch, and Lucas wondered what he'd been thinking when he'd put on these sweatpants. A tight seam right now would have worked.

"What are the other job perks to writing law-enforcement software?" she asked.

Hearing that slight breathlessness to her voice steeled his resolve not to let her see how she affected him, not when she worked so hard to keep him guessing about how he was affecting her. "Owning the company, for starters. I come and go as I please. I touch base with my office staff and my programmers a lot, but that's what the phone, fax and Internet are for."

"So you're a high-tech kind of guy. I'm a little surprised. Josie strikes me as very traditional."

After watching his sister pursue her new husband through the decades, Lucas wasn't sure he'd go straight to traditional. "Josie's more of a people person."

"Meaning you're not?"

He shrugged. "I spend a lot of time in the field, getting to know what's happening inside various law-enforcement agencies. That's how I learn what they need from their software and how to provide it."

"You get bored easily, don't you? You like a challenge."

There was something in her voice, and he couldn't pinpoint whether liking challenges was good or bad in her estimation. Either way, he couldn't deny the charge. "I do."

"And the freedom of traveling."

He smoothed a strip of adhesive tape over her thigh, securing gauze over the cut. "Like I said, give me a laptop with a satellite uplink and I can work anywhere."

And frequently did. One particular bluff overlooking the Pacific Ocean came quickly to mind. Then there was a national park where he felt like the only person on the planet. He could think better when his head was quiet, late night or early morning or during the day with nothing but the surf breaking on the cliffs or the wind rustling through the trees.

He'd worked hard to shape his life to his wants, which was why he couldn't understand when it had all become so routine. Work had been his only salvation from a growing sense of discontent, and when he came across a new interest, there was no avoiding how lifeless everything else had become by comparison.

Bree Addison felt like a challenge.

"Here we go." He wrapped up his triage with a large bandage over each knee. "Feel good?"

She nodded, sitting up to survey the result. "You're very good with your hands. Thank you."

"All in a night's work."

She laughed at that, a whiskey-rich sound that filtered through him with a lot more impact than a laugh should have.

Lucas didn't want to let her go yet. The idea of brewing coffee and greeting the dawn while continuing their conversation appealed, but he had no real reason to keep her here.

He settled for retrieving her shoes, thinking it was sort of a sad commentary on what his life had become that he had to devise ways to keep a beautiful woman with him.

"Allow me." He reached for a shapely ankle.

"Tell me, Lucas. What did I do to deserve all this five-star treatment? By all rights, you could have sent me downtown for trespassing."

"And let the police have all the fun of interrogating you? I don't think so."

She treated him to that laugh again, a sound as dusky and sultry as the dark outside, a sound that shouldn't feel physical but did.

Dragging his hand down her ankle, Lucas explored the feel of her smooth skin beneath his fingers and hoped he wasn't being too obvious. Bree had feet as delicate as the rest of her and as well groomed. Her toes boasted perfectly maintained nails in a subtle red shade that matched her manicure.

He slid the sandal into place, then attempted to fasten the strap around her ankle.

"Here, let me," she said. "You might be very good with your hands, but this is a job for smaller fingers."

She brushed him away with a warm touch. Her hair swung forward in a silky wave as she leaned over, and Lucas stood rooted to the spot, inhaling a breath that was subtly spicy fragrance and all enticing woman.

With a few deft maneuvers, Bree fastened the strap, then extended her other foot. "Teamwork."

He only slid on her remaining sandal and let her work her magic while he tried again to gauge whether he was having an effect on her. She seemed breathless, too fast with her answers, so when she finished fastening her sandal, Lucas slipped his hands around her waist and helped her off the counter.

The air charged with awareness. The top of her head didn't quite reach his nose, so his every breath filled with the scent of her. He fought down the urge to pull her close—one easy move and she would mold sleekly against him, all feminine curves he knew would align perfectly. Her breasts would press against his chest. Her hips would

tip and cradle what threatened to become a raging erection.

She raised her dark eyes and peered beneath her lashes. "Thank you."

"My pleasure, Bree." He wanted to kiss her more than he could remember ever wanting to kiss before, but the expression in her gaze stopped him. There was something there…something almost amused, as if she was well aware of the impact of her beauty and expected him to be unable to resist her.

That look dared him to resist.

"I'm glad you dropped in tonight." By sheer effort of will, he moved away, found even those few inches helped to clear his head. "I've enjoyed meeting you."

"I've enjoyed meeting you, too. Thanks for rescuing me."

That made him smile. He'd never met a woman less in need of rescuing than Bree Addison. He might have helped her out with some first aid, but as she watched him with those exotic eyes and kissing lips, Lucas knew that this woman was shielding a lot behind the mysterious expression.

"I'll walk you home," he said.

He half expected her to blow off his offer and vanish as suddenly as she'd appeared. But she only said, "Thank you," and grabbed her coat.

Perhaps she was concerned about heading back out into the dark alone. As she'd proven tonight, Court du Chaud wasn't a world unto itself. Their court was part of the busy French Quarter that teemed with the lighter and darker sides of life.

Although the idea of her being in danger on a walk home from work disturbed him, he wasn't unhappy with the result—the chance to meet her.

After pulling on a sweatshirt and shoes at the door, Lucas escorted her into a night where the moon hung low over Court du Chaud, tightly knit town houses that Captain Gabriel Dampier had built nearly two centuries before. The captain had been a comrade of Jean Lafitte and other privateers during a time when New Orleans had needed swashbuckling men who were bold enough to break rules and take chances. Men whose courage and disregard for the law had made them heroes.

Court du Chaud was typical French Quarter, with metal filigree balconies and wrought-iron gates surrounding small front yards. Ornamental lamps spilled golden light into the night along a cobbled walkway.

Neighbors often met in the gardened piazza, chatting around the fountain or relaxing on benches. Older kids tore through on their bikes and skateboards, while younger kids chalked up the cobbles with hopscotch and four squares.

At Christmas the residents erected and decorated a towering tree. At the start of each new year they gathered to shoot off a dazzling display of fireworks. At Easter they hid colored eggs for the kids to hunt. On Fourth of July they picnicked and opened the fire hydrants to cool off.

Court du Chaud was home to Lucas, and it was only now, after leaving for so many years, that he could see it with more objective eyes. A slice of another world in a city that had grown large and often dangerous around it, the court represented another era, a way of life that could feel simple and safe.

Looping his arm through Bree's, he led her down the walkway toward her house. "Josie mentioned that you and your sister had some work done on your place after you inherited it from your uncle."

"We separated the town house into two units. Seemed like the smartest thing to do. We had some friends who did the work. Turned out nice."

"The place is big enough." Lucas knew that as Captain Dampier had built Number One for himself, the town house was larger and grander than the others. "I earned money mowing your uncle's yard while I was growing up. He was a character. Used to tell stories about his life as a tug captain. We called him Old Man Guidry. He always said the place was haunted."

"To hear my sister tell it, the place still is. The ghost of our ancestor."

"Really?"

"Don't get too excited. My sister just got engaged. I think too many orgasms are frying her brain cells."

"I can think of worse things. But people have been saying this place is haunted for as long as I can remember."

"Have you ever seen a ghost, Lucas?"

"No, and trust me when I say that my old friend Max and I spent our fair share of time looking for one. It's a court tradition with the kids who grow up here."

"Chasing ghosts?"

"And perpetrating the myth."

She smiled. "So that explains all the mystery around here."

"Some of it. Max and I were definitely on a roll for a few years. Came up with some brilliant stuff. But all the talk of curses started long before we came around."

"I'm surprised. I took you for Mr. High Tech. I didn't think you'd believe in ghosts."

"Didn't say I did." Reaching for her front gate, he noticed the wary glance she cast around her yard, as if she expected someone to jump out from behind a tree. "Let's

say I'm keeping an open mind. I grew up here, remember?"

Bree didn't reply as she reached inside her coat pocket and withdrew a set of keys. Lucas glanced at the house, at the dark windows. A coach lamp on the portico show-cased them as they climbed the stairs.

Plucking the keys from her hand, he only smiled when she gazed up at him and asked, "Still rescuing me?"

He shrugged, not sure what he was doing. Bree was putting on a show for his benefit, but he got the feeling that there was more to her story than she had told him.

Nothing seemed out of place in the court. He heard only the wind rustling the trees and the muted sounds of their footsteps as they crossed the portico.

Glancing at the emblem of a security company on the sidelight, he slipped the key into the lock, pushed open the door. What had once been the front door to Number One now served as an entry to the twins' separate units.

"Same key." She gestured to the door on the right.

Lucas wondered if he'd get an invitation inside, was struck again by how much he'd like one. But when the security system signaled the opening door with a whining countdown, Bree flashed him a smile he recognized as a goodbye.

"If I don't see you again before you leave, thanks for the rescue." Rising up on tiptoes, she kissed his cheek.

He'd been right about one thing—she had a kissing mouth. Her lips were full and soft and warm, and one simple, friendly kiss galvanized him. He barely resisted the impulse to pull her into his arms. With effort, he handed her the keys.

"The pleasure was mine, Bree. Take care."

She nodded and he took his cue. Her gaze flashed to

his for a brief instant as the door shut, leaving him with the image of those exotic eyes and beautiful smile. Lucas waited until he heard the lock click and the inside door close before heading back down the steps.

As Lucas opened the gate, a cat streaked across the sidewalk, clearly startled by the sound of the creaking hinges. He watched it disappear into the hedge around the piazza, then glanced around the courtyard he'd grown up in.

No sign of prowlers. Only reminiscences from his youth were everywhere.

His family coming and going through the years. Max and Nana LeClerc always with them. Josie always noisy and noticeable. She'd burst in on their family when he was seven and she hadn't stopped talking since.

Age hadn't subdued his sister's spirit, but it had taught him a lot about appreciating her. Josie was a caring person with a gift for bringing out the best in people. As a result, everyone in her life loved her.

Now she'd likely move into Max's place at Number Seventeen. There was no real reason to keep two places—not unless they planned to eliminate the alley between the town houses. With Josie's social work and college expenses, she might not be flush, but Max certainly wasn't hurting for money.

But Lucas couldn't see them going that route. Adding a few walls and a doorway, as Bree and her sister had done, hadn't defaced the property. Even if historic preservation laws would allow more extensive reconstruction, he couldn't see his sister tampering with anything that would change her beloved home.

For the first time, the reality of the changing situation hit him. While he'd remain connected to Court du Chaud

through Josie and Max, his home wouldn't be the same. No matter how far away he moved or how long he stayed away, his home was still a familiar and special place. Funny how he hadn't remembered that until tonight.

Maybe he'd offer to buy Josie's place and keep it for when he came to town, which he planned to do often now that he and Max had renewed their friendship and Josie had officially made him part of the family. Chances were they'd eventually have kids, and the job would fall to Uncle Lucas to teach his nieces and nephews the ins and outs of life at Court du Chaud so they could keep their parents on their toes.

Just the thought made him smile. He and Max had not only kept his parents and Nana LeClerc hopping, but all their neighbors, too. He remembered tear-assing through the piazza on their bikes after school, popping wheelies around the fountain and almost running down Old Man Guidry, who'd threatened to send his ghost after them.

If Bree's sister believed a ghost haunted Number One, then she might step in to replace her late uncle. Lucas hoped so. His future nieces and nephews would need a crazy neighbor to torment.

Lucas had no clue what had him so reflective tonight, but by the time he got back inside and kicked off his shoes, he knew sleep was off the agenda. He was heading back to Pescadero at noon and had planned to get up early to pack and ship all the memorabilia he'd collected from the attic.

But when he glanced around the living room filled with mementos his mother had saved to commemorate his youth, he found his enthusiasm to get back to his familiar work environs—which had been mounting steadily since sending Josie and Max off on their honeymoon—had vanished.

Grabbing the phone, he sank onto the couch and dialed a number. His sister's sleepy voice answered just before the cell phone rolled him over to voice mail. "Lucas. Everything okay?"

"Fine. Just wanted to chat."

"Chat?" Josie demanded through her drowsiness. "What time is it?"

"It's after four here. It can't be that late in your part of the world."

"Lucas—"

"Get over it, sunshine. You buried me in that attic sorting through our lives. You owe me. And unless I miss my guess, you and Max aren't doing much sleeping on this honeymoon anyway."

"Which is why these precious hours are crucial."

"Don't want to hear about it. What I want to hear about is Bree Addison."

There was a beat of silence on the other end. "Bree? Did you get a chance to meet her?"

"Tonight."

"Oh, I'm glad. She's a sweetie, isn't she?"

Sweetie? He'd been left more with the impression of a seductress or siren. "Tell me about her."

Josie took off on a commentary that answered more questions than he'd have ever thought to ask.

"I know Tally better, but Bree belongs to the krewe and I run into her all the time at the café," Josie explained. "She pops in for coffee a lot."

Lucas cradled the phone against his shoulder and moved aside a stack of old school photos on the coffee table so he could prop up his feet.

"Okay, so she likes coffee," he said.

"She and Tally are sharp. I like them a lot," Josie con-

tinued. "I was really glad when Tally got a break finding the captain's treasure. She's putting the reward money to good use. I get the impression that neither of them has had an easy road. Not from anything they've said, mind you, but they have a younger brother. From what I gather, they've been taking care of him for a long time."

"What happened to their parents?"

"Haven't heard one word about their father, but it sounds like their mother's been out of the equation for a while."

Lucas put these facts together with the provocative woman he'd met tonight. "Know if she's been at Toujacques long?"

"A few years, from what she's told me. She works a second job, too, so her schedule is screwy. She doesn't always make homeowners' association and krewe meetings."

"So you roped Bree and her sister into painting floats?"

"Lucas! You know very well that we do more than paint floats. And if you don't know then I'm not doing a very good job keeping you up on what's happening around here. Maybe you should try coming home to visit more often."

Lucas smiled. While living inside the court wasn't co-requisite with belonging to the organization whose sole purpose was carrying on the legend of Captain Dampier at Mardi Gras, he knew that with Josie at the helm, court residents wouldn't stand much chance of avoiding membership.

To her credit, though, Josie had done a lot to further the krewe's involvement in the community. Under her administration, they paraded year-round for charitable causes such as the Big Buddies society and women's shelters.

"I'll think about coming home more often if you tell me if Bree's dating anyone."

Silence on the other end…then Josie said, "Interested?"

"Just met the lady tonight, sunshine."

"And yet you woke me up to chat about her. Hmm, what should I make of that? Wait— What?" She directed her question away from the phone, presumably to her new husband.

Sure enough, Max's muffled voice carried through the receiver, and Josie gave a laugh. "Max said you better run while you still can. He came home to visit and wound up standing in line for a new driver's license."

"Tell him not to worry. I wouldn't move back because I'd have to see his ugly face every day. But you know what? I'm feeling generous, so I'll give you another wedding gift."

"Ooooh, really?"

"Really. Tell me when and where, and I'll pinch-hit for you with the krewe. I've decided to stay in town a while longer."

"Lucas!" Josie squealed through the phone, causing him to yank the receiver away from his ear. "Thank you! I've been worried about how shorthanded they'd be with me gone. I'm so glad you changed your mind—" She stopped. "What made you change your mind? Meeting Bree?"

He could still hear that sultry voice in his memory. *What a man wants…*

This man wanted to know Bree Addison better.

"Actually I just didn't feel like packing the memorabilia. It's going back up in the attic."

3

BREE MOVED QUIETLY around her house, more out of habit than necessity. With walls separating her from Tally and Christien, she didn't have to worry about her odd hours at Toujacques disturbing anyone anymore.

She told herself she was glad. All things considered, life hadn't changed too, *too* much with her sister's engagement. The renovation had been a piece of cake as far as renovations went. The town house had been a split plan to begin with, so a few cleverly placed walls, a new kitchen and doorway had done the trick. She'd been pleased with the effect…until now. Tonight her place felt too dark, too quiet.

Or maybe that was her mood talking.

Pausing in her workroom, Bree stripped off her damaged dress and tossed it on top of her sewing machine. Here's hoping she could pull this dress back together or else all the money she'd spent on it just went down the drain.

Thank you, Jude Robicheaux.

Fortunately she was a capable seamstress. Working with high rollers meant dressing the part, and since she'd always been too broke to do anything but buy off the rack, she'd honed her altering abilities to a fine edge. She liked sewing and designing her own clothes, too, when she got

the chance. In fact, she liked it so much that she'd turned her unexpected skill into a side job that earned her good money.

Still, the split seams had snagged the fabric and broken more than a few strings of sequins. This dress might be too far gone for even her ability.

Forcing her throbbing legs to carry her up the stairs, Bree headed into her bedroom. She just wanted to crawl into bed, pull the covers over her head and forget all about this roller coaster of a night.

A possible job promotion.

The bad-news ex.

Lucas Russell.

Eventful for sure and not at all what she'd expected when heading out earlier to arrange Mr. Loaded Cowboy from Dallas's trip away from the faro tables to a visit behind the velvet ropes of the French Quarter's most exclusive gentlemen's club.

Her heart still throbbed a little harder than it should. She should shower and let hot water soothe her racing thoughts and soak away her aches, but showering would mean dealing with her bandages. She simply didn't have the energy.

Lucas had done all the hard work already, so Bree just pulled on comfy jersey pajamas and crawled into bed. Nestling deep beneath the warm covers, she paced her breathing and tried to clear the thoughts snapping through her brain like a ball around a roulette wheel.

But the sound of Lucas's laughter still echoed on the fringes, along with her breathless thanks when her boss had given her the news about the promotion opportunity.

She could also hear the grinding of rubber over wet pavement, tires turning behind her, pulse throbbing dully in

her ears as the sedan had followed her through the dark streets.

Damn, why now? She stood a really good shot at the head hostess job. And she needed the money. While the treasure reward money had raised Tally's fortunes considerably, her sister shouldn't be expected to put aside her goals to foot the bills for their family.

She and Tally had been the sole support of their younger brother, Mark, since their mother had gone AWOL. Mark had been only fourteen at the time, and raising him hadn't been cheap. Both she and Tally had given up college scholarships to work, and Bree would continue covering her share of Mark's expenses now that he'd finally—thankfully—decided to focus on college.

Tally deserved to spend her share of the money on reaching for her goals and starting a new life with her handsome fiancé. And even more importantly, Bree deserved the head hostess job. She was detail-oriented and worked well with the other VIP hostesses. She knew the ins and outs of the Big Easy better than anyone on the staff. She'd been at Toujacques longer, too.

Except for Lana. And the thought of working for that self-absorbed, ass-kissing former Vegas showgirl made Bree toss restlessly under the covers.

Plumping her pillow, she tried to find a more comfortable position. On her side, and her knees squeezed together and ached. On her back, and her legs extended and her knees ached. Lying on her stomach wasn't even a consideration.

Finally settling in an awkward place somewhere between her back and side, she tried to convince herself that Toujacques' big boys would be fair enough to promote the woman most qualified for the job.

She was most qualified. No question.

Everyone knew it. Everyone also knew Lana would feel she deserved the job because she'd been there longer. She'd torture the entire staff if passed over. Everyone knew that, too, which meant Bree's future boiled down to whether or not the managers wanted to deal with Lana's tantrums.

Unfortunately Bree understood. Time didn't exist in the around-the-clock world of big money and high rollers. The casino stayed open 24/7, an active and exciting life but a demanding one. So the absolute last thing Bree needed to do was give the big boys any grief or aggravation.

Jude Robicheaux was always grief and aggravation.

If Lana caught wind of Bree's former connection to the smooth-talking Cajun con man, she'd have a field day making sure everyone from the French Quarter to Bayou Teche knew about Bree's not-so-stellar past. After turning her life around and establishing herself in a solid career, Bree could kiss any hope of job advancement goodbye.

Management would be announcing the promotion after their quarterly meeting next week. Why couldn't Jude have waited one more stupid week before coming back to town?

And what was she going to do now that he had?

Bree had no answers, and with a sigh she turned restlessly again, debating whether or not to get out of bed and tackle alterations on her dress. Or scrub the bathroom, which seriously needed it.

She was only torturing herself by lying here. Sleep wasn't in the cards tonight. She needed to distract herself. Or talk. Not so long ago, she'd have come home, plopped down on Tally's bed and spilled her guts.

Now there was a man in bed with her sister.

Bree was thrilled with Christien. Really. Tally was head over heels, and Bree couldn't have picked a more perfect man. She wanted Tally to be happy, even if her sister had gotten so caught up in the spirit of the treasure hunt that she was taking the whole ghost legend thing seriously. Even if all the time she spent in bed with her new fiancé or at the Blue Note meant Bree didn't get to see her nearly enough anymore.

Right now Bree needed to hear her sister laugh as if everything was a joke, because it all felt big. *Too* big. Bree had worked her butt off to put Jude Robicheaux behind her. She was independent now and making something of her life.

Her sister would agree. She'd praise Bree for how hard she'd worked to be considered for this promotion, for how she'd started at Toujacques as a cocktail waitress and worked her way up through the ranks.

She'd remind Bree about how long they'd dreamed of moving into a real home that wasn't some tiny apartment in a dumpy complex or a prefab rental in a bad section of town.

To Bree and Tally a real home had meant Court du Chaud. Their connection to the swashbuckling Captain Dampier had been the only thing to make them feel special in an existence that often felt weighted with problems and responsibilities. And when they'd finally gotten their shot at owning their own home, it had all felt magical, special.

Tally would tell Bree not to let anything take that feeling away, not to let anyone smack her down again.

She knew Tally was right, but as Bree sat up in bed and stared at the wall that had been skillfully designed to match the old, she wished she could actually hear Tally say it.

WITH HIS EYES TIGHTLY shut, Captain Gabriel Dampier moved through the wall of the bedroom that had once been his in life. After spending nearly two hundred years haunting his former quarters in Court du Chaud, he had witnessed many who'd inhabited these rooms and had no wish to intrude on anyone's privacy.

Especially this chit's. She was directly descended from him, and the very idea of chancing across her in a state of dishabille or, heaven forbid, engaged in some intimate activity smacked far too close to perversion for comfort. As much as he wanted Breanne to fall wildly and hopelessly in love, he had already established guidelines for proper behavior with her twin. He would adhere to those rules now.

Neither death nor the passing of generations apparently tempered the familial bond running through his bloodline. He was Breanne's many-times-removed *grandpère*. While he might not have behaved appropriately paternally in life—or even been aware he'd sired offspring—he was correcting the oversight in death.

After listening closely for any sounds of movement, Gabriel peered narrowly through half-closed lids to find his beautiful descendent lying restlessly across the bed.

He sighed, relieved, and opened his eyes.

"You are a fool." A familiar voice startled him.

"Eternal damnation," he snapped much louder than he had intended, a rebellion against the invisible barrier between the living world and his own. "Must you plague me at every turn?"

"Yes."

An unnecessary reply to a question he well knew the answer to. This crone had been tormenting him ever since the fateful night he'd been gunned down on his ship. He'd

awakened to find himself dead and *her* his only companion in the afterlife.

Talk about cursed!

Glancing back over his shoulder, he saw her ghostly form emerge through the wall, a shawl pulled tightly around her stooped shoulders, a pleased expression on her withered face.

The sum of his life obviously equaled a dismal failure to have earned this woman as an eternal reward.

"Go away. I have no wish to deal with you tonight."

She laughed, a grim sound that would have raised the hairs on his neck had life still pulsed through his veins. "You should have thought of that before you involved yourself with my granddaughter and spawned a bloodline that we share. I'm surprised you have not yet figured out that death is not about what you wish."

That much he knew. "You shall not ruin my mood, *belle grand-mère*. Not when the end is finally within my grasp. Breanne has met a man who sparks her interest. She is all that is standing between me and my eternal peace. I can break your damn curse once and for all."

"Still so proud, pirate."

"I am no pirate." The words fell from his lips mindlessly, a habit from long ago.

But even as his denial faded to silence, he could see a smile split her shriveled cheeks until she reminded him of an apple left too long in the sun.

"Then go about your business. I will not disturb you. I would only savor the joy of watching you fail."

"Fail? This chit's twin lies in the arms of her new fiancé. Tallis has placed her love for him above her ambition. The curse you placed on our descendents—"

"You I cursed, pirate. Our descendents I blessed to

never know the heartache you heaped upon my beautiful granddaughter."

Curses. Blessings. A matter of opinion. Gabriel's only consolation was that by cursing him, this vengeful old *grand-mère* had cursed herself to share in his fate. Not much of a consolation when he'd had to actually listen to her for two hundred years, of course.

"As I was saying," he continued. "The curse is almost broken. You should be grateful, so you can finally rest, too."

"I'd rather watch you fail than rest, pirate."

"Fail? You seem to have forgotten the new skill I acquired to help me bring Tallis and Christien together."

"Oh, no, no, no," she said in an irritating singsong voice. "I've forgotten no such thing. You have every right to be flush with your new skill."

A compliment? Had he been alive, the hairs on his neck would have been bristle-straight. This woman loathed him. He loathed her, too, truth be told, but she actually had more of a reason. He had been the biggest fool where the beautiful Madeleine had been concerned.

But hadn't he heard somewhere that forgiveness played a part of death?

Sheer stubbornness forced Gabriel to turn away and pretend to ignore her. He would not ask what she meant because he knew she wouldn't tell him. No forgiveness with this one. She would only reveal herself when she knew it would stab like a knife, and he'd entertained her far too often with his failures to doubt that. He wouldn't let her see that her words had hit their mark. And honestly, he wasn't all that confident of his ability to help Breanne overcome her ambition.

Even in sleep his granddaughter's aura gleamed the dull

gray of one who would never know any true emotion. She'd wandered through life in pursuit of ambition, restless in spirit and unfulfilled by her goals, never experiencing the plunging despair that made the heights of happiness all the more sweet.

And Breanne was only one in a long line of descendents he'd watched suffer the same cursed fate because of his selfish actions. When all was finally said and done—and it would be—he wondered if there would be much forgiveness among any of them.

To his credit, though, Breanne also had him to thank for remaining in one piece after her stupid stunt in the yard of Number Sixteen tonight.

Not that she knew it, of course. Spirits had no substance in the living world. A fine thing, too, since had he been of corporeal form, he would have broken his bloody neck saving her when she'd fallen off the wall. But he had managed to cushion her fall—a fine feat.

Generally, spirits could not appear to the living. Apparently only those old enough or powerful enough could learn to summon matter and affect the living world. It had become rather a race between him and the old crone to see who could sharpen their abilities best.

So Gabriel had practiced summoning his strength to bridge death to the living world. It was draining business, to be sure, but he continued to prevail and proudly added new and useful skills to his repertoire.

His proudest achievement thus far had been fully materializing to Tallis and her fiancé.

That had been the only reason he'd finally convinced Tallis to recognize how precious love was. But Breanne was even more headstrong than her sister, and until tonight there hadn't even been a potential male around.

But Gabriel had seen the way her aura had sparked off Lucas. Lucas's aura had sparked right back.

These two had the potential to share a truly great love. Auras never lied, and he'd grown quite sensitive to reading the nuances of energy that radiated off the living.

"What shall I do with you, Breanne?" he asked aloud, almost forgetting the old woman who watched him. "Aha. I know."

He would start by whispering suggestions while she slept.

Yes, the helpful man in Number Sixteen is very handsome.

Yes, he had been a gentleman to bandage your wounds and see you home.

Yes, the sparks had flown between you.

Yes, you want to see him again.

Gabriel sat on the bed beside Breanne, leaned close to her ear and summoned his strength to materialize so she could hear him speak….

Nothing happened.

He felt no echo of the life that had once pulsed through his veins, no stirring of the heart that had once beat in his chest. He felt no rush of the air through his lungs.

Puzzled, he inhaled deeply—another habit of old that had no place in the afterlife—and tried again.

Nothing.

He heard the crone's laughter.

Amazing how he could feel fear chase up his spine. "What have you done to me?"

"I have done nothing."

"I appeared to Tallis. And Christien. They could see and hear me. Why can I not now? Is this some new trickery of yours?"

"You credit me with too much power, pirate. And yourself." She held up her hand dismissively when he opened his mouth to argue. "You did nothing special to appear to our Tallis. You delude yourself in death the way you did in life. In all these years of haunting you, I still cannot fathom what my darling granddaughter ever saw in you."

Shaking her head, she sent lank white hair whirling around her face. "The curse gave you the ability to appear to two people. Only two people. It was your chance, pirate."

Two people?

The twins.

It made such coldly logical sense that Gabriel couldn't believe he hadn't guessed sooner. Instead he'd appeared to Tallis and her lover and had prided himself on gaining enough power to take a ghostly form again.

Damn his pride!

Nearly two hundred years spent haunting this court. Nearly two hundred years denied his eternal peace. Denied any peace when he stared at the horrible old crone who had been his only companion. Nearly two hundred years to atone for his sins.

Nearly two hundred years and he'd learned nothing.

"You tricked me," he cried. "You set me up to fail."

"I only cursed you. Your failure is your own." She gave a bitter laugh. "Do not despair, though. Perhaps if you practice materializing as hard as you practice your other parlor tricks, you may be able to manage the task in another century or two."

Which was how long it would take before another set of twins would be born into this family.

She blew him a kiss and stepped back through the wall,

and with her laughter still ringing in his ears, Gabriel stared down at the bed where Breanne moved restlessly. He was so close to breaking the curse, to ending this eternal limbo…and all he had to rely upon were parlor tricks.

ALTHOUGH MONTHS HAD PASSED since Bree had joined Krewe du Chaud, she still hadn't decided why she'd become a part of this organization. It certainly wasn't to hand over her hard-earned money paying steep annual dues.

But Josie hadn't given her much of a choice. The acting president had been pretty strong-handed about the whole thing. A bully, really.

When you move into a court that's a huge part of French Quarter history, Josie had told Bree in a tone that left no room for debate, *it's your duty and responsibility to keep the legend alive…*.

Blah, blah, blah.

Tally, of course, had jumped in with both feet. No surprise there. Tally had been enamored with the krewe since they'd been kids, standing on the streets as the captain's floats had passed by in the Mardi Gras parade.

Bree had never understood her sister's obsession with all this historic family tradition stuff. It was sort of cool to bring up the connection in party conversation, but Bree had never found it much use otherwise.

Being descended from the captain certainly hadn't done anything for their mother, who'd spent her life—was probably still spending her life, as far as any of them knew—trying to capitalize on the connection with her alcohol-induced get-rich-quick schemes.

Only Tally had ever managed to change her fortune.

And she'd been on quite a roll lately, and Bree wished some of her luck would rub off.

After last night, Bree could use it.

Scooping up her mail from the floor in her foyer, she locked up the house and headed out into the bright afternoon. She walked through the alley past Café Eros, inhaling deeply of all the wonderful smells emitting from within. Beignets. Coffee.

After a night spent tossing and turning while visions of Jude Robicheaux and Lucas Russell warred through her subconscious, she'd awakened feeling as if she'd been run down by a riverboat.

But she had a problem to solve, so she'd gone online to the sheriff department's Web site to confirm Jude's status.

He did still have an active warrant, which meant he wouldn't surface openly. She couldn't decide if that would bode good or bad for her.

Today wasn't the best of days for a krewe meeting, but Bree knew the distraction would do her good. Otherwise she'd be sitting at home, alternately debating what to do about Jude and remembering how tingly she'd gotten when Lucas had touched her.

So stepping into the busy street, she flagged a passing cab. She hopped in, gave the driver the address of the krewe's den on the river and skimmed through her mail as they wove through Canal Street traffic.

Bill, bill, *overdue* bill…hmm, what was this?

Lifting up the plain white envelope, she scanned her name and address in computer-generated text. There was no return address or any postmark, which meant the sender must have hand delivered the letter to her door.

A chill skittered up her spine, and she had the wild

impulse to tear the envelope to shreds and toss the pieces out the window to scatter through the streets like so much confetti during a Mardi Gras parade.

Oh, please don't let Jude know where she lived!

Lifting her gaze to glance at the cabbie, who didn't seem to notice the earthshaking anxiety happening in his backseat, Bree inhaled deeply to dispel the sensation.

With the thought of a ruined pair of seventeen-dollar hose steeling her resolve, Bree opened the envelope to find a single sheet of copy paper and more of the same computer text.

A vanishing act, gorgeous? Is that any way to welcome back the love of your life?

Blood rushed to her head only to drain away just as quickly, leaving her clammy, dizzy and nauseous.

Two sentences, but the message was crystal clear.

You can run but you can't hide.

Arrogant bastard probably thought she couldn't resist him—prize catch that he was.

And the humiliating part—once upon a time she couldn't.

Damn man looked like a dark angel with that inky black hair and those crystal eyes. He knew it and used his looks to disarm stupid young women who hadn't yet learned that the inside of the man was a lot more important than his yummy chocolate coating.

But in all fairness to her, while Jude's looks had first attracted her, his looks hadn't been what had sucked her deep into his life. That had been all about being taken care of. Jude had spotted her weak spot and had exploited it.

Bree had been a shamefully easy mark.

After their mother had gone MIA, Tally had stepped up to the plate and taken control of the situation. Bree had let

anyway. He'd honestly expected her to leave town with him when his last con had gone south. He'd thought all his money and promises to solve her problems would replace her family.

But keeping her family together had been the whole reason to deal with the problems.

Jude hadn't understood that. His idea of love was unconditional devotion. If he loved and cared for her, then she should devote herself solely to him. Bree shuddered to think what her life might be like now if she'd continued down that path, if he hadn't gotten in trouble with the law, forcing her to choose between her family and him.

Lady Luck had been shining on her after all.

So then why was he back now?

Then she remembered Lucas's words upon finding her in his shrubs. *You found the captain's treasure.*

Had Tally's illustrious treasure hunt brought a rat out of the woodwork?

While she honestly didn't think Jude would ever physically harm her, she knew he wasn't above using her for his gain.

Bree was so lost in thought that when the cabbie said, "Hey, lady, you going or you want to sit here with the meter running?" she nearly jumped out of her skin.

A glance proved they'd reached their destination. Feeling stupid, she paid the man and hopped out of the cab.

Krewe du Chaud shared valuable warehouse space on the river, compliments of a generous member who owned a shipping business. The man didn't actually live in Court du Chaud but was a long-standing aficionado of anything and everything Captain Dampier.

Bree felt edgy, like an open target on the street. She

didn't want to wait for someone to answer the buzzer and open the front gate to let her in, so she circled the building to get out of the street.

Resisting the urge to glance over her shoulder, she maneuvered the narrow concrete alley between the warehouses toward the river. She scanned the wharves for any signs of unwelcome faces, and finding no one around, she bypassed the back entrance and headed to the water.

With a foot on the slimy seawall stairs, she knelt carefully and pulled Jude's letter from her bag.

Love of my life…not in this life!

She tore the paper and envelope into tiny pieces and let them float down onto the muddy water for the fish.

If Jude thought he could intimidate her, he had another think coming. She needed to go to the police. Even though Jude hadn't actually done anything, there was a warrant out for his arrest. The police definitely would be interested that he was back in town.

They'd be so interested that she'd get dragged into the precinct station to file a report and answer questions. They'd send officers to Court du Chaud to question her neighbors about whether anyone had seen Jude hanging around.

That scene wouldn't be pretty. Tally would start worrying. Christien would want to help and likely use his police connections to have every cop in New Orleans keep an eye on her. Josie would wind up finding out and doubling up the Neighborhood Watch shifts.

She might even mention the trouble to Lucas, and for some reason Bree didn't like the thought of him learning about her past, even if she wouldn't see him until his next visit from California.

Then there was Toujacques and the promotion announcement next week….

Argh!

Even if she reported Jude anonymously, Bree knew she'd be at the top of the list of people the police would track down to interrogate. Since she'd issued official statements, they'd also be thinking revenge. All she didn't need was for Lana to get wind of this.

"Is everything all right, Bree?"

The voice made her jump—tetchy today, wasn't she?—and she had the mocking thought that this man's voice probably shouldn't have been so familiar after only one conversation.

Not only was Lucas's voice familiar, but hearing it brought a sense of calm she had absolutely no business feeling. Suddenly her heart didn't pound quite so hard and she didn't feel so all alone on this busy riverbank.

Glancing over her shoulder, Bree found Lucas showcased on the wharf above her. He wore clothes today. His well-worn jeans rode low on trim hips, and his sweatshirt hinted at the muscles of his toned body below. Despite the clothes, she could still envision what he looked like in his towel.

After last night, that image was burned into her psyche.

"Playing the knight on the dock today?" she asked, her best defense a good offense.

"Only if the damsel needs rescuing."

"She doesn't, thank you."

His gaze followed the bits of paper littering the water, and with the bright sun throwing his chiseled features into sharp relief, he looked as if he didn't believe her.

But when he extended his hand, Bree took it, resisting the urge to roll her eyes at the jolt she got when his warm fingers closed around hers.

He helped her to her feet. "How are you feeling today?"

"A little sore, but I'll live. So what are you doing down here?"

"Pinch-hitting for my sister."

"You mean the woman who guilts everyone she knows—even under the most tenuous acquaintance—into joining the krewe?"

"Guilt, hmm?"

"You're kidding, right? It was an honor to even be invited to join, don't you know? Krewe du Chaud is very exclusive. FONOF, and all that." She gave an unladylike snort at the acronym for Fine Old New Orleans Families and stepped up onto the dock. "I am *so* not a joiner. Never even a Girl Scout. Besides, I'm really too busy right now for this."

"So I heard. Talked to my sister, and she mentioned that you work two jobs."

Tossing her hair back, Bree hiked her purse higher on her shoulder and met his gaze levelly. "Only when I'm not pinch-hitting for krewe presidents who run off with their new husbands instead of finishing their parade floats."

"You do know that Josie has been waiting to get Max to herself since she was ten years old, don't you?"

"Seriously?"

He raised his hand. "On my honor."

"Well, I suppose that would explain the rush."

"That and Valentine's Day. My sister has a thing for holidays."

"What a nice big brother you are, Lucas. Your mother must be very proud of you for stepping in to help your sister so she could catch her man and have the wedding of her dreams. But didn't you say you were leaving today?"

"Changed my plans."

"To help get our float ready? Whew! You really do get good-big-brother points."

Lucas only gave a shrug as a chilly wind blew off the river, ruffling his hair and plastering his sweatshirt against his chest. "Actually, I wanted to see you again."

"Oh." Given the positively intent way he was staring, she supposed she shouldn't be surprised. Not by his candor, anyway. That was typical rich-guy behavior.

I see you.

I want you.

I stake my claim.

It was inevitable, really.

What did surprise Bree was how she found his bright gaze even more startling in the daylight. What surprised her was the way swallowing suddenly became difficult with her tongue stuck to the roof of her mouth.

"I asked Josie about you," he said. "She didn't think you were dating anyone."

"Not at the moment." She had not met the love of her life yet, thank you.

"Were you planning to go to the krewe coronation ball?"

"I don't believe I jotted it down in my day planner."

"Does Josie know? She gave up a honeymoon trip to Indonesia to get back in time for the ball. I would have thought she'd have guilted you into that, too."

"Like I told you last night, I don't know your sister all that well. Even knowing what I do, I couldn't begin to understand her priorities. An Indonesian honeymoon would win over Krewe du Chaud's coronation ball in my book."

Lucas laughed, a rich, velvet sound that proved you could take the man out of the Big Easy, but you couldn't take the Big Easy out of the man. There was just some-

thing sultry about a Deep South male laugh, something that hinted at lots of bare skin and the promise of sex. It was a sound that raised more goose bumps on her arms than the river breeze.

"Okay," she conceded with a heavy breath to blow the hair out of her face. "I had to promise I'd be a masker on parade day and do my bit with the throws."

"Then I'd like you to reconsider the ball, so I can take you. I coerced Josie into giving me a place on a float. We can make a whole day of it."

"You've really extended your trip. The parade isn't for another week." She eyed the warehouse. "Good thing, too, because this new float isn't close to being ready."

"She will be. Can't sail without the captain's ship."

"Okay, Mr. Nice Guy, I have a question. If you want to ask me out, why are you waiting until a ball that's a week away?"

"Because it's Mardi Gras, and I have respect. I'm asking you to celebrate with me and not your friends, so I figure you'd want to make sure I'm worthy of the honor. Now you've got some time to get to know me."

Bree laughed. "Very smooth."

When he lifted his hand toward her face, she knew he meant to brush away the hair from her cheek, but her breath caught in her throat as she waited for him to touch her.

It was only a simple stroke of callused fingertips across her skin, yet she stood frozen with her throat constricted around that breath, her body intensely aware of him.

Given their chemistry, Bree wasn't surprised by his offer. Lucas was obviously used to getting what he wanted, and right now he wanted to monopolize her time for the duration of his stay. She was attracted to him, too,

and hadn't had any decent sex in too long. Everything about Lucas screamed, *Stellar sex!*

So why shouldn't she enjoy the moment? Just because Jude had decided to show his face again didn't mean she should let him throw her life into turmoil. Lucas Russell was an attractive man, so far out of Jude Robicheaux's league....

The thought stopped Bree short.

Even Jude would recognize he didn't stand a chance of winning her away from Lucas.

Glancing back to the river, where the torn bits of a letter she hadn't wanted to receive still floated along the surface, Bree stared at the pieces.

Jude had a special talent for scenting vulnerability, and if he thought she was still the same impressionable young girl she'd once been then he'd never leave her alone.

What better way to show him she wasn't that girl anymore than by not letting him rattle her? She'd just keep living life as if he didn't faze her. She'd contact the police—after the promotion announcement and after Lucas went home.

Peering up into Lucas's face, she found him watching her. He wanted her. It was in his eyes, in the stony set of his jaw. Lucas had dealt straight with her so far, and a part of her felt as if she should deal straight back. But what would she say?

I've got some guy stalking me, so make sure you don't turn your back for too long.

That would lead to questions about her past and explanations. She hated explanations. They always made her look weak. And feel weak. How stupid could one person be?

She didn't like to dwell on the answer.

Lucas wanted to spend time with her. He was talking

about a week, so explanations really weren't necessary. She liked him. He liked her. She had the Jude situation under control. So why shouldn't they have a good time together?

Bree couldn't think of one good reason.

4

"I'D LOVE TO GO TO THE ball with you."

Lucas felt the promise in Bree's acceptance like a live current through his body. "And spend time together to decide if I'm worthy?"

"That, too."

"Good. We can start with the krewe." Slipping his hand around Bree's elbow, he led her toward the warehouse with a parting glance at the paper littering the river. He wondered what the white envelope had contained to earn a watery grave but didn't ask. Bree seemed unconcerned about it.

Lucas pegged her as a private woman, the type who could reveal everything and nothing in a glance. She peered up at him from beneath her lashes, those soft, dark eyes holding secrets. This woman distanced herself with those sultry glances and her sharp wit, and no one was more surprised than Lucas to find that distance so intriguing. Even in the daylight he felt goaded to win her responses.

"Watch your step." He moved aside so Bree could climb the stairs.

She treated him to a quick smile, then took off, ascending with a light step and gifting him with the sight of her backside clad in denim. Her long hair swung jauntily down

her back, shiny strands catching and dragging over her sweater, and he found himself admiring the view from her well-worn Timberlands up the sleek terrain of her curvy body.

Informal attire did nothing to minimize the casual glamour of this woman. Sequins or faded jeans—Bree Addison wore them equally with style.

After slipping through the open gate, she moved along the cavernous interior of the warehouse that had been transformed into a den to store the krewe's parade supplies.

The den might be a new location from the one that had served Krewe du Chaud while Lucas was growing up, but a quick glance proved that many of the floats hadn't changed.

"Would you look at this? It's Gator Bait." He paused to run a hand over the rough surface of the alligator lying in twenty-foot-long pieces of scaly green fiberglass. "You're running him this year?"

Bree nodded. "He's number three in the lineup."

"So he's got some life left." Lucas laughed. "I suppose I shouldn't be surprised Josie keeps him going."

"Just a guess, but he's a favorite of yours?"

"Oh, yeah. This old boy's been around since I was a kid. He was the first float the krewe had designed by an engineer. We ran car washes and fish fries for a year to raise the money to build him, then barely had enough left over to buy throws for the parade. Before Gator Bait we were making our floats out of cardboard and papier-mâché."

Bree folded her arms across her chest, drawing his attention from the old alligator to the way her sweater clung to the swell of her breasts. "Sounds pretty grassroots.

From where I stood in the crowd, Krewe du Chaud's parades always looked so crème de la crème."

"We're one of the older krewes," he said. "Haven't been around quite as long as Endymion or some of the parading organizations like Rex and Bacchus, but we're old-school. I'm curious to see if your sister's treasure hunt sparks some new interest in the captain and some new members."

"I wouldn't be surprised. Her treasure hunt has sparked a lot of interest."

Something in Bree's tone made Lucas think the interest hadn't all been good, but before he had a chance to grab onto something in that statement, she said, "First Cupid, now Gator Bait. Did you expect your visit to be a trip down memory lane?"

Josie's attic had been a trip down memory lane. Standing inside this den with Bree Addison was something else entirely. When he stared down into her beautiful face, he felt a rush of awareness that made him realize just how lifeless he'd been feeling lately. But ever since finding this woman in his bushes, his body had been on hyperalert.

Like right now. She faced him with her nose tipped impudently and her full mouth pursed, staring at him with those mysterious eyes. He wanted nothing more than to close the distance and kiss her.

With every throb of his pulse, he could imagine how she would feel pressed up against him. It was a wildly romantic thought for a man who wasn't disposed to romantic thoughts.

When he stared into Bree's face, he felt wildly romantic.

Time seemed to stall. Her chest rose and fell on a shallow breath. She lowered her arms to her sides as if

suddenly unsure what to do with them. She darted her tongue out to moisten dry lips. Her expression softened, and as Lucas watched, all the mysteries fell away. He'd hoped Bree had been fighting their chemistry, not wanting him to know she was attracted, but he hadn't been sure. Now he was sure.

She looked at him like a woman who wants a man.

And when she swayed forward in silent invitation, heat coursed through him, the blaze soldering his brain cells so it took him a second to make his move.

Time slowed to a surreal crawl as he wrapped her in his arms. Their bodies came together first, full breasts against his chest, smooth stomach cradling what only needed permission to become an erection, thighs wedging together. She sank full-bodied against him, warm, yielding, undeniably right.

She tipped her face upward, sending her hair tumbling down her back and over his arms in a cool silk wave. He stared into her face, impossibly beautiful at close range, utterly impossible to resist.

Lucas tightened an arm around her, locked her even closer, amazed at how pleasure rode through him hard, a tangible sensation that spurred him to slide a hand up the sleek arch of her spine, into the curve of her neck. He speared his fingers into her hair, cupped her head in his palm....

Their mouths came together with no less fanfare than their bodies. Her lips parted under his, welcoming. Their tongues collided, as effortless and natural as breathing.

He'd never known he could feel a kiss everywhere, and he was a man who appreciated kissing. But this kiss...this kiss surged through every nerve ending in his body. This kiss sent need plunging through muscles that grew tense.

They shared a breath. He inhaled her warm gasp only to return it as he slanted his mouth over hers harder, wanting to taste more of her, wanting to explore this incredible feeling.

A screech of excitement emitted from somewhere in the warehouse. They broke apart, startled, staring at each other while registering the sound that had stolen the spell.

Bree recovered first. "Wow."

"Agreed."

A smile tipped those full lips, still tempting him, making him unwilling to let her go.

"I'm glad you decided to extend your trip, Lucas."

"Me, too."

"Shall we?" She gave a light laugh and stepped back. "The new float's in pieces in the back room."

The moment was over, and the pang of regret he felt at its loss came as another surprise. He only nodded and followed her along the path of Gator Bait's massive body, wondering about the effect this woman was having on him. One thing was for sure—Bree Addison was scrambling his brains big-time, and that in itself was a new experience.

The music blaring through overhead speakers was another blast from the past. Krewe du Chaud's anthem was a song called "Just Love Me for Me"—the theme song from the 1950s musical comedy *Downtown Pirates* about the illustrious captain himself.

"Mood music?" he asked.

"Your sister doesn't miss a trick."

He didn't get a chance to reply as they swung a corner and emerged in a cavernous room flooded with light and activity.

"I'm impressed," was all Lucas said.

Captain Dampier had sailed a two-masted schooner because the shallow draft had let him easily navigate shoal waters. He could hide in the coves while outrunning navy frigates and sloops to bring his merchandise into New Orleans during the war.

Josie had mentioned the krewe's new float, but seeing the pirate ship coming together under the bright fluorescent lights brought back a feeling of long-forgotten excitement. Memories of Gator Bait, the winking captain and a youth filled with Mardi Gras celebrations sharpened the edges of a mood that had started with a late-night intruder and hadn't subsided since.

"Real rigging, too," Lucas said. "Josie wasn't kidding. This is first-class."

Bree's gaze traveled over the fiberglass pieces littered at odd angles around the warehouse—a section of faux-wood hull, a bowsprit, the crow's nest. "Maybe when it's all together."

"Hey, Bree, about time," a feminine voice called out, so familiar that Lucas actually blinked when he saw Bree's twin circling the ship's hull and heading toward them. "I thought you were going to skip. John just got here with the doubloons."

"Be still my heart." Bree winked. "Lucas, this is my sister, Tally. Tally, Josie's brother."

Lucas extended his hand, his gaze zeroing in on this beautiful doppelgänger. The dark eyes. The wide smile. The refined features and cloud of shiny hair made them almost impossible to tell apart at first glance.

But Lucas had made his career analyzing details. There were differences, subtle but definitely there.

Tally's face was more symmetrical, a classical oval, while Bree's smile angled into a dainty chin and made her

face heart-shaped. Both had high cheekbones, dark eyes and arched eyebrows, but as he stared into Bree's eyes, he noticed starbursts of deep golden-brown. Her left eyebrow arched in an expression all her own.

Their mannerisms were as individual as two women could be. Tally struck him as all intensity and boldness as she shook his hand and eyed him with open interest. Bree was quieter, more contemplative as she folded her arms over her chest and watched them thoughtfully. He'd already encountered her dry wit.

"I'm impressed, Lucas," she said. "Not even one comment about how we're so alike we could switch places?"

"Get that a lot, do you?"

Tally rolled her eyes. "You'd be surprised. For some reason people think identical twins have nothing better to do all day than impersonate each other."

"I can see the novelty," he admitted. "If someone isn't able to tell you apart."

"Meaning you can?" Tally asked.

He nodded.

"Really?" Bree arched that doubtful eyebrow. "So you don't think we could fool you?"

Lucas reached out and caught her hand. Bringing it to his lips, he brushed a kiss across her knuckles, smiled when her eyes widened. Inclining his head toward Tally, he said, "She doesn't make my heart pound."

That was the biggest difference of all. Tally Addison might look like the woman who sped his pulse into over-drive, but she was just that woman's sister. Her sweater might be just as clingy, her jeans fitting perfectly curvy hips and sleek thighs. They had no chemistry.

"I am *so* not believing this," Tally said in a gush. "When did you two meet, and how come I haven't heard about it?"

"Long story that'll have to wait until later." Bree gave a dismissive wave when Lucas released her hand.

The awareness lingered, though, a sensation that filtered through him until all his nerves were back in overdrive.

Tally eyed Bree with an accusing gaze, and something in Bree's tone suggested she wasn't all that eager to rehash the night's events. Lucas wondered if Tally would get the unabridged version of Bree's visit to his yard. He was pretty sure he hadn't gotten the whole story.

"I thought you said John brought the doubloons?" Bree said. "Where are they?"

"Come on, then." Tally looped her arm through his and got them moving. "If you're Josie's brother, all this must be old news for you."

"I grew up with the krewe, but it's been a long time since I've been around. I come home for Mardi Gras as often as I can."

"Josie threatens to come get you, does she?" Bree asked.

Lucas laughed. "Sounds like you know my sister pretty well, after all."

"Josie's wonderful," Tally said. "I can't believe everything she does. And she's been incredibly helpful as I'm getting the captain's gallery up and running at the museum."

"Josie hasn't mentioned anything about a museum gallery."

"She's had a lot on her plate with the wedding," Tally pointed out. "I'm taking the captain's treasure and celebrating his role in protecting New Orleans. Not only is he

getting his own gallery at the museum but also a society that offers scholarships for people who want to attend college."

"And there's the Blue Note," Bree added.

"That's my nightclub. One of the best places in New Orleans for food and music."

"My sister isn't biased at all."

"Absolutely not." Tally laughed.

Seeing these sisters together was going to take some getting used to, Lucas decided. Just then a young man approached carrying a box of what turned out to be the new doubloons.

"Hey, John." Bree smiled in greeting. "Those the new doubloons?"

John nodded and handed one to her. "Check them out."

The young guy never even glanced Lucas's way, and it took all of about two seconds to realize the kid was overwhelmed by the women surrounding him. Lucas couldn't blame him. Bree and Tally were a sight. So similar. So impossibly gorgeous.

Bree held out the doubloon and flipped it for his perusal. One side showed a striking profile of the captain in his plumed hat, the other side his ship.

"Nice." Lucas extended his hand to John. "Lucas Russell. I'm here to help out until Mardi Gras."

"Russell?" John shook, but his expression melted into a frown and he shot a confused gaze toward Bree, who nodded.

"Yep, Josie's brother."

That seemed to shake John from his daze. "You're the one she had me design the pirate game for. Gotta say, when I found out who you were, I wasn't sure I wanted to. I mean, you're into big-league programming. Have

you had a chance to play the game yet? What do you think?"

"I'm very impressed," Lucas said honestly. "Lots of twists and turns and some slick programming."

John looked so pleased that he didn't seem sure what to say.

"Software games, John?" Bree said. "You're multitalented. And here we all thought you were just the brains behind our rigging."

The kid got so flustered he actually blushed.

Bree didn't miss a beat. Pressing the doubloon back into his hand, she rose up on tiptoes and kissed his cheek. "You did a fine job on the doubloons, too. They look great."

Tally flipped another of the doubloons back into the box. "And wait until you see the throws. They're treasure chests."

"In honor of Tally and Christien." John finally found his voice.

Lucas nodded. "Looks like my sister has a strong team in place this year."

"Oh, we're definitely the best," Tally said.

"Your sister managed to surround herself with an entire crew to design and construct the new float," Bree added. "Told you she doesn't miss a trick. Is that a family trait?"

Lucas simply smiled.

Tally sliced an appreciative gaze between them. "As long as you're here, Lucas, John could use a hand."

"Got a short in the electrical system," John confirmed. "I wrote the software to make the rigging move. It's not moving."

"You should see it when it does, though," Tally said. "It's awesome. I'll bet we make the news."

"Oh, joy." Bree was smiling, but her smile didn't reach her eyes. "Electrical grief sounds right up your alley."

Lucas nodded. "I'll help."

"Great," John said. "I can finally show off my program to someone who'll appreciate it. It's the first one I've ever written for a parade float."

"And speaking of sails," Bree said, "they won't unfurl unless I get busy. I don't have all day."

"What shift are you working tonight?" Tally asked.

"Five to three."

Tally slipped her arm around her sister and gave an affectionate squeeze, apparently the krewe designator in his sister's absence. "Then get busy."

"So you're the talent behind the rigging?" Lucas asked Bree.

"Talent is relative, of course." She shot him a dry look. "Everyone else around here has ten thumbs."

Tally rolled her eyes and John gave a hiss of feigned indignance. But Lucas just laughed as Bree tossed her hair over her shoulder and said, "Have fun, boys."

She headed across the den toward a brightly lit area where pristine white sails hung like blankets over a clothesline on wash day. Tally followed and Lucas watched them go. There was no doubt it was Bree's long-legged strides and swaying backside that started up the sizzle of heat inside.

"They're sure something, aren't they?" John asked. "That Christien Castille is one lucky bastard."

Didn't take a rocket scientist to figure out John must be referring to Tally's new fiancé.

"They sure are," Lucas agreed. "Seriously something."

That kiss had been seriously something, too, and it just so happened he was feeling like a lucky bastard himself right now.

5

BREE HEADED OUT OF the Cane River Poker Room, where she left a client holding with a ten of spades on the table and a queen of hearts in his hand. As soon as the dealer turned the next card, she knew her client would be one happy camper.

Exactly the way she tried to leave all her guests.

With her smile screwed on tight, she made her way past Louie's Lounge, an open-floor bar where guests could step away from the tables and the various gaming rooms yet still watch the action. Silver-Tongue Sammie, nicknamed not for the way he spoke but for the way his tongue worked magic on the saxophone, was wailing away on his third set of the night.

She winked while walking by, always amazed at how the talented musician smiled around his mouthpiece without missing a beat.

New Orleans was an adult playground of gaming establishments, but Harrah's and Toujacques were the most renowned. Harrah's reminded Bree of Vegas, all flash and show, a New Orleans theme park for gamers. Toujacques, on the other hand, was pure New Orleans.

Steeped in local culture and history, Toujacques had broken ground on the fringes of the French Quarter during a bygone era. Two Jacques—father and son—had built the

place as a hub for gamblers sailing down the Mississippi from Natchez.

They'd been two French Acadians with a dream, and Toujacques' smoke-filled gaming rooms had weathered all sorts of history since. The Civil War. Prohibition. Desegregation.

The original location had evolved through the years, too, transforming from a gambling hall into a saloon, a landmark restaurant and finally, with the advent of new gaming laws, back into the gambling hall it had begun life as. While ownership had changed hands through the decades, management always kept alive what made Toujacques special—tradition.

Silver-Tongue Sammie's doleful jazz tune faded beneath the electronic buzzing and beeping of the slots as Bree passed through the rows of machines. She smiled at a perfectly coifed matron who glanced up from a video poker machine.

The woman—eighty if she was a day—most likely hailed from one of the gorgeous old mansions along St. Charles Avenue, yet she looked at home in front of the computerized gaming machine, the display lights flashing off her diamonds.

Sure, tourists came from all over the world to game here, but like this wealthy matron, the clientele understood the differences between old world and Las Vegas spectacle.

Toujacques bathed its guests in the pride of the old South. Fine old families and gentlemen who gambled with honor. The whole atmosphere made Bree imagine men riding into the bayou at sunrise to duel.

She saluted the bouncer who stood guard in his tuxedoed finery at the entrance to the hallway leading to the employees-only suites. "Evening, Giles."

"Evening, Bree." He tipped the rim of his top hat.

Then she sailed through the door he held open with a smile.

Even Toujacques' employees were special, she thought while heading inside the hostess suite…well, most of them, anyway, she clarified, coming face-to-face with Lana, who'd apparently just arrived for her shift.

Pausing in her primping, she met Bree's reflection in the mirror. "Mr. Takimoto wasn't happy with you yesterday."

"Hello to you, too, Lana." Bree could afford to be generous as she was on her way out.

"Not interested?"

"I'm interested in everything about our guests."

"Then you'll want to know that when I came on shift, Mr. Takimoto kept going on about how you wouldn't find him someone to have dinner with."

Bree smiled harder. Lana was bitchy whenever she pulled the morning shift. Something about her face not waking up properly until noon. "I'm sorry Mr. Takimoto was unhappy."

"You couldn't find the old guy an escort."

"He didn't want an escort. He wanted me to procure for him. The last I looked, my time card didn't say Madame Bree."

"You're paid to make the arrangements to keep our guests happy. That's your job. If you can't be discreet about it, then you're not much of a hostess."

No doubt Lana had been happy to rush straight to management with that opinion. But if she wanted to run afoul of the law in her dealings with clients, she'd better be more than discreet. Bree didn't think upper management would appreciate their names splashed all over the headlines for suspicion of prostitution.

She wasn't going to take Lana's criticism to heart either. If the bosses had had a problem with her, they'd have called her upstairs the second she'd walked through the door to start tonight's shift.

"You got mascara in your hair," Bree said instead, continuing toward her locker.

Lana turned her attention back to her appearance, looking for the errant mascara, which stood out like a fly on a stick of butter against all that bleached-blond hair. Why this ex-Vegas showgirl had chosen to work at Toujacques instead of Harrah's was still a mystery....

Then again, Lana wasn't exactly a teen anymore, and pushing forty meant the twilight years between the blush of youth and a facelift. Judging by her ever-ready tube of hemorrhoid cream to keep the eye baggies at bay, Lana knew age was heading her way.

Not that she looked old. In all honesty, Bree hoped to age so gracefully. For all Lana's double-processed hair and UV-protection makeup, she was a very striking woman.

Hostesses came in all ages because guests came in all ages. The management at Toujacques understood that. Contrary to popular belief, not every older man was comfortable interacting with a woman twenty or thirty years his junior. Management paired guests with compatible hostesses—not that Lana cared. All she worried about was the imagined slight to her appearance.

Bree had heard her go on a twenty-minute rant about how only the junior department carried her size but the clothes teenagers wore weren't suitable for an almost-forty-year-old woman whose breasts needed help staying where they belonged.

Bree had thought about suggesting implants but had bitten her tongue. She had actually related to this

argument. Not because her body parts weren't cooperating—thank goodness!—but the trendier fashions weren't the classy stuff VIP hostesses were expected to wear.

While VIP hostesses made decent money, they didn't earn the kind necessary to take off months of work to recover from cosmetic surgery or to shop in upscale boutiques like Toni Maxwell's, where basic-black slacks cost upward of two hundred and ten dollars with a discount.

"Toodles, Bree." Lana completed the reparations to her appearance. "I'm off to do damage control."

Keeping this smile on her face was beginning to hurt. "You have a nice day, too, Lana."

With a jaunty toss of those bleached curls, Lana strutted out of the room on her stilettos.

Bree exhaled a dramatic sigh and spun the combination on her locker. She couldn't wait to get out of here. After four days straight of ten-hour shifts, she deserved some time off. She needed to put the memory of yesterday behind her and take a break from worrying about running into Jude around every corner.

Maybe she could talk Lucas into a quick trip away. She knew the perfect place. If they could get some work done on the float later today, she just might entice him with the promise of a day hiding away from the world for some stellar sex.

And it would be stellar if that kiss they'd shared in the den was any indication. She wanted to try another one just to make sure. Not only could she use the distraction, but maybe with a little luck, Jude might have cleared town by the time she returned. She wouldn't hold her breath, but she could hope.

Grabbing her coat, Bree closed up her locker, slung her purse over her arm and headed toward the door.

Tonight she'd be taking a cab.

But just as she reached the door, a knock sounded and she found Giles with a message.

"Bree, you've got company up front."

"Who?"

He shrugged. "The hostess just said some hunky guy asked for you at the desk."

Hunky guy? Great.

"Thanks. I'm on my way."

He flashed a quick grin and held the door while she stepped through.

Bree forced herself to move into the casino, when wisps of ice twisted up her spine. For a blind moment she considered beelining into the kitchen to escape out the back door.

But did she really want to leave Jude alone here?

No telling what trouble he'd cause. He might have people start looking for her until it became obvious she'd sneaked away. Lana would love raising questions about why Bree would hide from such an attractive man.

There was nothing to do but face him. Damage control, as Lana had said.

Taking a deep breath, Bree resigned herself to the inevitable. She refused to let the thought of the upcoming encounter rattle her, even though each and every step felt as though she dragged her feet through bayou mud.

Jude was bound to catch up with her sooner or later, and as much as she didn't want that confrontation to be at Toujacques, she wanted it to take place in a dark street at three in the morning even less.

If Bree was slick, she might be able to lure him out front so they'd be away from Lana and the shift managers yet still under the watchful eyes of the bouncers. Surely Jude

wouldn't try anything in front of a small army of men around who looked like linebackers.

With that thought to brace her, she headed past the faro tables and made her way to the hostess desk, ignoring the blood throbbing in her ears.

She could handle this.

"Hey, hey, Bree, girl," the hostess said, then dropped her voice to a whisper. "Got a Mr. Yummy here for you."

"Thanks, I'll—" Bree's heartbeat skittered as she caught sight of Mr. Yummy. "Lucas?"

He fixed her with a deep green stare. "Have a good night?"

Getting better every second. "What are you doing here? Did you come to try your luck at the tables?"

"I came to walk you home."

That stopped her. For a prolonged instant she could only stare, that stupid adrenaline paralyzing her—this time with a relief so intense her knees actually went weak. "Thank you."

"Ready?"

She was so relieved not to be standing here with a man she hadn't seen in years that she blew the hostess a goodbye kiss. Then she beamed up at Lucas, and he beamed back, one of those quiet smiles that did amazing things to his sculpted features.

Too many emotions skyrocketed inside her, making a breath flutter inside her chest. She felt hot and cold all at once, blown away.

Too blown away.

She was relieved he wasn't Jude, relieved he'd thought of her and put forth effort to ensure she'd get home safely.

Too relieved.

And just the thought made her internal alarm system

go wild. She had to be careful. As much as it bit to admit it, Bree had a knack for letting the people in her life take over. Jude had been the extreme, but she'd also come to recognize how she always let Tally run the show, too.

Of course, Tally hadn't had much choice. Someone had needed to assume the responsibility after their mother had left. But that didn't change the fact that Bree needed to rely on herself, make her own choices, solve her own problems and not be so quick to let others step in to help.

Jude was her problem, not Lucas's.

She hadn't even been honest with the guy. She'd side-stepped the real reason she'd landed in his bushes, and he'd been gentlemanly enough to let her. Here he was tonight, and if Jude showed up again, Lucas would be smack in the middle of a confrontation with no clue what was going on.

Which, Bree thought with a mental sigh, wasn't fair.

Returning the valet's wave, she glanced up at Lucas to find him frowning. Following his gaze, she spotted the trouble. Shift change meant bouncers were milling around the front entrance watching them with their best "Me Tarzan, you Jane" expressions.

"This is Lucas, boys." She snuggled close to the man at her side. "Y'all have a great day now."

"One of them should have walked you home last night," Lucas said.

"Then I wouldn't have you to walk me home tonight." Bree looped her arm through his and led him away. "Come on. There's something I want to tell you about last night."

To Lucas's credit, he didn't grill her, probably guessed she wanted to get out of earshot before talking. He was proving himself a patient man, and Bree found she liked that.

"Listen," she finally said. "I really appreciate you showing up tonight. Much better than taking a taxi."

"You weren't going to walk?"

She shook her head. "Not tonight. When I told you that I'd noticed someone following me last night, I didn't mention that it was someone I preferred not to run into."

"Someone you know?"

She nodded. "I try to avoid confrontations whenever and wherever I can. Especially on a dark street at three in the morning. I just thought you should know."

"That's it?" He stared down at her looking all serious and worried.

"Trust me, I have everything under control." She gave him a reassuring smile. "Were you worried about me?"

"Yes, and I wanted to see you again."

"As in, we're on a time limit and you don't want to waste any?"

"As in, I saw the perfect opportunity to get you all to myself so I jumped all over it."

"Sounds self-serving."

"Very. I'm not one to pass up an opportunity."

No surprise there either. "You do know that contrary to appearances, I'm not really a damsel in distress, don't you?"

"I do. So why'd you walk home last night?"

They were back to the questions again. Lucas clearly wasn't satisfied with her explanation, and he deserved one, at least one that would get them through the week.

"A few reasons. First and foremost is I lent my car to my brother. He's home from college for the weekend and he flew in. I'd have taken a cab home last night, but before I left work, I found out I was being considered for the head hostess job. Since I was pretty keyed up and it's only a

couple of blocks, I figured the fresh air and exercise would calm me down."

"Congratulations. Is this a promotion you hope to get?"

"Absolutely. Upper management has needed to create this position for a long time. I'm the best person for the job."

He tucked her closer against him and led her off the curb to cross the street. "Think you'll get it?"

"I don't know. We're run by a corporation that holds a number of other interests. Management can be pretty unpredictable sometimes."

"Which is why they need to create your position?"

"You got it. Businessmen control the VIP hostess staff, and they don't always have a bead on what we're doing with the guests. They understand keeping the tabs paid all right. And they know the gaming laws, too, but they sit inside their offices making decisions that don't necessarily translate onto the floor. We need someone on the management staff."

"Sounds like you're the perfect woman for the job."

"Agreed."

He smiled, and the street lamp spilled golden light onto his face. Suddenly she could remember how his mouth felt on hers when they'd kissed. It was a tingly, fluttery feeling that made her heart beat quicker, which she thought completely ironic since they were in the exact same place where she'd noticed Jude following her. Her heart had been beating hard then, too.

"So what sorts of decisions get made to complicate your work?" he asked.

She exhaled a heavy sigh, masked her breathlessness beneath exasperation. "They change things with the other departments and don't tell the hostesses. When we're on

the floor, we're the ones dealing with transportation specialists, outside security, the vault cashiers, the change clerks and the cocktail servers. We're the liaisons between our guests and the casino staff."

"I can see where that could get complicated."

"Trust me, it can be chaos. Especially since we're usually running back and forth off the floor to arrange our guests' accommodations outside the casino. Making sure their friends and families are entertained so they can gamble. Setting them up with whatever they want to see around the city. And if we're dealing with celebrities or well-known politicians, we've got privacy issues to deal with. Can't leave these guys standing in long lines waiting to get inside the clubs."

He looked unimpressed.

"Then there's the whole clarity issue." She gave a huff, this time the exasperation real. She just couldn't help it when thinking about Lana.

"Clarity about what?"

"About job description. What hostesses can and can't do. Not twenty minutes ago, I defended myself for not procuring for a guest. I mean, really. Do I look like a pimp to you?"

Lucas's laughter echoed through the dark street, filtered through her and made her so aware of him and the promise of what his bare skin might feel like wrapped around her.

"Definitely not," he said. "But I was under the impression Louisiana's gaming control laws were strict. Or have I just been living in Pescadero too long?"

She shook her head. "See, this is where clarity comes in. My coworker has a looser interpretation of our job description than I do. Anything goes as long as she doesn't get caught."

He seemed to consider that, falling into silence while dragging his thumb across her knuckles, an idle gesture that made her notice his warm hand wrapped around hers.

They walked in silence for a few minutes, a companionable stretch that made her oh-so-aware of the way he tucked her against his body almost possessively, timed his long strides to accommodate hers—a thoughtful gesture, as she was strolling along in high heels.

Bree smiled into the darkness, marveling at the timing of meeting Lucas. Under normal circumstances, she wouldn't have given him a second thought no matter how much chemistry had brewed between them. She didn't date privileged, power-freak men and she'd dodged enough to spot one a mile off.

But to be entirely fair to Lucas, he wasn't exactly her run-of-the-mill rich guy. There was just something different about him. His candor maybe. He didn't try to schmooze her, didn't deny that he'd invited her to the ball so he could spend time getting to know her beforehand. He'd shown up tonight to see her home safely and hadn't made any bones about it. No, Lucas hadn't tried to play her. He'd been playing his cards straight, and she liked that.

"Sounds like you have a very interesting career," he finally said. "So how'd you become a VIP hostess?"

"Are you always so curious? Or do you usually know more about a woman before asking her out? I don't imagine you've picked up many dates in your flower beds before."

"You're my first." He chuckled, a whiskey-smooth sound that filtered through the night like his warm hand over her skin. "I'm interested in you."

"Well, then, I sort of fell into hostessing. I started at Toujacques as a cocktail waitress but soon discovered

that plying our guests with alcohol to get them to part with their cash wasn't my thing." She'd seen enough people drink themselves into numbness without making a career of it.

Lucas inclined his head and didn't ask about her formal education. Or lack thereof. So many men loved to talk about their alma maters, as if degrees from prestigious universities actually endorsed their characters.

Not true, as Bree well knew.

Josie was currently wrapping up her doctoral program, so Bree figured that Lucas probably had as much or more education. She'd rather not admit that she'd given up a scholarship to keep her family together. She did not want to get into any explanations about her mother. Like Jude, her mother had no place in a week-long fling.

She'd rather just enjoy herself, thank you.

"It's interesting work," she continued. "No two nights are ever the same, and I enjoy the puzzle of figuring out what my guest needs. I have contacts all over the city for business, entertainment, leisure activities."

"Sounds like a hotel concierge."

"The work is similar, with a few exceptions."

"Such as?"

"I'm dealing with high rollers, which means big bucks. Sometimes guests get carried away at the tables and gamble more than they're prepared to pay. It's my job to make sure they don't skip town before settling their debt."

"So you're law enforcement."

She just laughed. Leave it to Lucas to come up with that. But she supposed in a way he was right. She had honed her skill at spotting deadbeats and sidestepping potential trouble. In Toujacques and out.

Luckily Bree hadn't spotted any deadbeats tonight. And

since Jude didn't appear to be anywhere around as she and Lucas crossed the street to walk along Court du Chaud's wall, she thought her luck might be holding. She saw nothing out of the ordinary, no tailing cars, no suspicious shadows.

They rounded the corner in companionable silence and soon were strolling past Café Eros. The place had been battened down for the night, the doors locked and the tables empty on the patio and balcony.

A light glowed from somewhere within—a security spotlight or perhaps Chloe was hard at work cooking. She'd be Tally's sister-in-law as soon as Tally walked down the aisle with Christien, and Bree couldn't help but wonder if there wasn't something in the water at Court du Chaud.

Lust seemed to be making the rounds lately, which could explain her off-the-charts attraction to Lucas.

And although she was focused on her career goals and not looking to get involved in anything heavy, Bree was glad she hadn't been left out.

Stellar sex sounded like just what the doctor ordered.

She waited while Lucas unlatched the alley gate one-handed, an easy move that hinted at a lifetime of living here. The court at this hour echoed with their footsteps as they walked along the sidewalk. She could see the flowers draping her balcony railing above them, dark against the starlit night.

Lucas escorted her into her yard and onto her portico. He stood on a lower step, a vantage that brought them almost eye to eye. He had to tip his head just a bit to gaze into her face, and Bree admired the unfamiliar view of his sculpted features, the light-drenched lashes that made his eyes seem lushly fringed in the darkness.

"I'd like to see you tomorrow." Glancing at his watch, he smiled. "Later today, really. When will you sleep?"

"Now. It's been a long night. I'm due at the den at one. How about you?"

"I told John I'd be there, too. I didn't say when. What time do you to work today?"

She smiled, a slow smile she wanted Lucas to notice, wanted to make him think of kissing again. And he obliged. His gaze fixed on her mouth, and an awareness flared in his eyes.

"It so happens I'm off. How lucky is that?"

"Very lucky," he agreed and went right for the kill. "Let's spend it together."

"Getting the float ready?"

"I can think of other things I'd like to do with you."

Mmm. "Like what?"

That melting look on his face brought to mind more thoughts of lingering kisses and bare skin. Suddenly she was all sensation. The late-night air seeped beneath her coat. The dewy chill kissed her cheeks, moistened her lips.

And made Lucas's hair wave sexily.

Although he wore a typical businessman style—short, neat—this slightly ruffled look softened his hard edges, looked so thoroughly touchable that she wanted to slide her fingers through the glossy thickness. She could imagine what he would look like when he first awoke, his strong features relaxed with sleep. She wondered what he would look like lazy with desire or with his features sharpened by need.

Bree was surprised by how much she wanted to know, so she made the first move, slipping her hands over his shoulders, curling her fingers into the lightweight fabric

of his jacket. She wasn't a woman who needed a man to make the first move, so she used touch to bridge the distance, to create a physical connection that bound them together in the stillness.

"I was hoping to get enough work done on the float later so I could sneak out of town for the night," she said. "I want to get away before all the craziness starts with the krewe."

"Where?"

"A plantation south of here. Félicie Allée."

"That place was a historical site when I was growing up. I didn't realize it was a hotel now."

"It's not. A private company hosts business functions there. I have some work connections with the owners and visit whenever I can. We might luck into a room tonight. Depends on what they have scheduled. Interested?"

Lucas slipped his fingers along her jaw, cradled her face in his warm hand. "Yes."

His touch sent a spray of goose bumps along her skin, or maybe it was the intensity in his expression, the quiet that surrounded them as if they were the only people on the planet.

He thumbed her chin with a light touch, traced her lower lip. His gaze fixed on her mouth again, and she wondered if he was remembering their kiss.

She was.

"You'll make the arrangements?" he asked.

"Just keep your fingers crossed that they'll have something available."

"Consider them crossed."

He dragged his thumb over her lip again. It was a sexy touch, one that inspired her to part her mouth and taste the faint roughness of his skin. Lucas created with his hands.

Law-enforcement software. The electrical system of a float. He'd even bandaged her wounds.

She sensed his hands would be equally skilled at pleasure.

It was in his touch, simple, bold, a touch that understood how sexy intimacy could be. Because that's what this was—intimate. Here they stood on her front doorstep with the night fading around them. Their bodies close yet not touching. His fingers against her face in a featherlight caress. His gaze embracing her from that unfamiliar vantage.

Everything about Lucas aroused her, and she found that realization thrilling and effortless in a very intriguing way. Their kiss in the den had been this way, too. Natural. No permission. No deliberation. No warning. Just…inevitable. As if they couldn't stand close together and *not* kiss.

They were standing *so* close now.

Bree wasn't sure whether she moved first or he did, but suddenly they were melting against each other. Her arms slipped around his neck. His hard body unfolded against her, chasing away the night's chill, sheltering her in a possessive embrace.

Their mouths came together almost gently at first, and they shared a breath that tasted so much like yearning, a sigh of relief at finally giving in to the inescapable. Lucas's mouth on hers felt so simple, so inevitable, so right.

He pushed his tongue inside, a hot stroke that held no urgency, as if he had forever to explore this lazy pleasure that happened when they were in each other's arms.

Bree had no frame of reference, had never known this sort of languid intimacy with any man. She only knew that when she threaded her fingers into his hair, measured the feel of those sexy waves against her imagination, the

moment felt like a privilege. Touching his hair. Such a simple thing.

But nothing about this moment felt simple.

Her hands trembled.

Her mouth parted wider, wanting.

And low, oh-so-low in her belly desire kindled, exquisite heat that throbbed in time with her pulse. She kissed him with abandon, giving in to the winding pleasure that made her sigh against his mouth, press her body hungrily against his.

The night fell away even though some dim part of her brain registered that their heated breaths echoed in the stillness. They were wrapped in each other's arms on her front doorstep without a care for who might be watching.

This sort of wanting shouldn't be possible.

But she wanted. To stretch out beside this man naked. To explore their bodies with no time limits, no interruptions. She wanted to breathe an invitation against his lips. *Come inside. Make love to me.*

But she had no idea when Mark would be home from his girlfriend's. He seemed more comfortable sleeping at her place since Christien had come onto the scene. Bree could have suggested they go to Lucas's place, but she stopped herself. She knew what this man really wanted.

A challenge.

Falling into bed within the first twenty-four hours of their acquaintance would be too easy. Not a conquest but a disappointment. Much better to get him out of familiar environs and create a fantasy he'd remember forever.

But it was hard to hang on to that thought when his mouth devoured hers hungrily, when his tongue pursued hers with a leisurely insistence that made it difficult to think or to wait when she knew her bed was just up the stairs.

A part of her wanted Lucas to be the one to cross that

boundary, to simply be so eager for her that he couldn't wait. If he asked, she wouldn't say no.

Not when she wanted to arch her body against him, to ride the length of his thigh, to feed the needy little ache growing between her legs.

Bree managed to keep the invitation from her lips, not because of self-control but because she'd have to stop kissing him to talk. She couldn't keep from rocking her hips from side to side, trying to nurture the ache inside, tipping her hand at how hot she burned for him. Taunting him.

Lucas replied in kind. Slipping his hand down her back, he took full advantage of the moment, dragged his outstretched palm over the curve of her bottom. He pressed her so close that she could feel the length of his erection, knew she wasn't the only one yearning right now. It wasn't an invitation but an admission of how much he wanted.

That hardness caught her in exactly the right spot, and it was so easy to lose herself. To forget they stood on her front step. To forget that Tally or Christien or Mark could show up. To forget this man was practically a stranger. To forget she should challenge him.

The next thing she knew, he was breaking out of the tangle of their bodies. She exhaled a sigh that was part protest and part relief and peered into his face to recognize a restraint as tenuous as her own.

"Tonight." The word tumbled from her lips unbidden.

"Tonight." He smiled, a promise. "Sweet dreams, Bree."

Funny, she thought when he turned and strode down the steps with long, sure strides, his deep voice still lingering in her ears. Bree knew her dreams tonight would be very sweet.

GABRIEL SAT ON THE GATE linking his careless descendents' front lawn with the alley leading to *le Vieux Carré*. The French Quarter. No matter how much this magnificent city had grown and changed in the centuries since he'd walked the streets in life, certain things remained infinitely more civilized in French.

He would cling to those things, the only things he had left in this cursed hell of an afterlife.

His pride, gone. His peace of mind, too.

Especially as he watched Lucas stroll back into the court trying to look normal. His swagger told a different story. No matter how long he'd been dead, Gabriel hadn't forgotten what it felt like to walk with his crotch as hard as a mainmast.

And he was pleased with the progress of Breanne and her lusty new beau. He wasn't pleased that desire seemed to have addled both their brains. Would that they had taken all their passion upstairs into the bedroom!

Instead these two had indiscriminately fondled each other, then had gone their separate ways. Now Lucas strolled past the alley, oblivious to the man standing in the shadows of the piazza hedges. An intruder who'd been waiting in those shadows ever since Breanne and Lucas had returned, watching their passionate antics.

Gabriel's instincts were one of the few things that had followed him from life into death, an echo perhaps or a memory that he clung to, deluding himself that something of the man he once was remained. He refused to analyze this too closely, didn't really want to know which it was. Some things he was content to simply let be.

This intruder in the shadows was not one of them.

An overgrown wisteria vine shielded him from the light of a street lamp, but he had a crow's-nest view of the proceedings on Breanne's front doorstep.

The intruder seemed very interested and very displeased.

Which was why Gabriel sat here and waited to see what the fellow did next. With a vested interest in both Breanne's and Lucas's continued health at the moment, Gabriel needed to keep lookout. First he had to keep *belle grand-mère* from starting up her nonsense to keep Breanne from Lucas the way she had tried—and almost succeeded—to keep Tallis and Christien apart. Now this intruder.

If only Lucas had scooped Breanne into his arms and taken her straight to bed. Gabriel guessed by her vibrant aura that Breanne wouldn't have resisted, and the sooner they got on with this business, the better for all of them.... Oy, but he had made a muddle on his hands.

The intruder didn't attempt to waylay Lucas. He simply watched Lucas disappear inside Number Sixteen, then crossed the lane as if he had every right to be in this court. Pausing by Breanne's gate, he stared up at her doorway with an expression filled with surprising longing.

Gabriel exhaled a sigh of relief. Even if this intruder's actions didn't cast him in suspicion, his aura confirmed he had more darkness in his soul than light. Auras never lied. Not to the dead, anyway.

Unfortunately the living only saw outer appearances, and this fellow looked nothing like his aura. Women would surely swoon over his dark good looks and piercing eyes.

He retrieved a cellular phone from his pocket. Modern developments had transformed New Orleans since Gabriel's time. He found himself fascinated with some, unimpressed with others.

Technology impressed him. A lot.

Scooting along the gate in an effortless motion, he sidled closer to the man to eavesdrop on this conversation.

"Good, you're there," the dark-souled man spoke into the phone, his voice a low whisper. "I need you to get me some information about who lives in Number Sixteen Court du Chaud."

A rumbling voice replied in a mumble that Gabriel couldn't make out. He thought he heard the words *trip, back* and *home.*

"I'm still here. No, no trouble so far. I'm lying low," Dark Soul said.

Some more garbled sentences in an accent Gabriel couldn't place before Dark Soul snapped, "Don't worry about it. I'm handling her. Just get me that information."

Her? Breanne?

As Gabriel had been cursed to haunt Court du Chaud in the afterlife, he couldn't follow. And damned he was. All he could do was stare after Dark Soul, who took his conversation into *le Vieux Carré,* leaving Gabriel to wonder if he meant trouble for Breanne and her new beau.

6

"WE USED TO TAKE CLASS trips here when I was a kid," Lucas said while driving down the shady, oak-lined alley that led to the old bayou plantation, Félicie Allée.

A sense of unreality claimed him as the plantation loomed in the distance, two-storied and majestic with tall columns surrounding wraparound verandas. Wisteria, azaleas and Spanish moss splashed color against the pristine white structure. The windows sparkled beneath the shafts of sun slicing through a lattice of tree branches. A long-forgotten but familiar sense that he was leaving the real world hit him, and when Lucas looked at the gorgeous woman sitting beside him, he knew he was heading into a fantasy.

"I visited with school, too," Bree said. "The company that bought the place has done a lot of restoration."

She sounded casual, but he didn't miss the way she'd been staring through those windows, looking thoughtful.

He wanted to ask what was so special about Félicie Allée but perceived that privacy about her again, marveled at the way she could effectively close herself off so a simple question felt like an intrusion. She seemed comfortable sharing only certain parts of herself, and he wondered why.

That was a question he intended to answer this week. "Wrong pirate."

"Hmm?"

"Félicie Allée belonged to Julian Lafever. You're descended from Captain Dampier. Isn't that conflict of interest?"

"Naw, it's cool. Those old pirates used to hang together. Lafitte. Lafever. Dampier. They all stood and fought for New Orleans when it counted." She gave a wry laugh. "That's Tally's obsession—our pirate captain's lack of recognition."

"Yeah, Lafitte got a national park, didn't he?"

"Lafever didn't fare so well, though. He left Félicie Allée, of course, but, hey, we've got Court du Chaud. More centrally located." She turned to him, and her dark gaze flashed with such amusement that the tight interior of his brother-in-law's showy sports car suddenly felt intimate, as if catching Bree inside and containing her all to himself was an accomplishment to be proud of.

He was almost sorry when they reached the circular front drive and wound around to the parking lot.

"Keep your fingers crossed that they came up with something good for us tonight," Bree said as he pulled open her door.

"You don't know?"

"Worried?"

"I've got you all to myself and the keys to your ride home. What's there to be worried about?"

"Guess you have the upper hand." Everything about her tone implied she'd soon prove how much of the upper hand he *didn't* have.

He looked forward to whatever Bree had in store for him.

"Everything looks the same as it did in the third grade." He led her down the walkway toward the front entrance.

The doors opened, and a tall man in a black cutaway suit out of a history book appeared to usher them inside.

"Olaf." Bree flashed a sudden smile. "Working the door?"

"Only for you."

She rose up on tiptoe to kiss the man's cheek, treating Lucas to a head-to-toe glimpse of the way her sweater and almost-floor-length narrow skirt hugged her long curves.

"Lucas, this is Olaf, one of the owners of Southern Charm Mysteries. Olaf, Lucas Russell, potential client. He owns a business on the West Coast with lots of programmers."

Lucas extended his hand, amused by how Bree tossed him to the sharks.

"I'll be sure to load you up with promotional material," Olaf said in a richly accented voice that Lucas couldn't make out the origins of. "Let me know if you want the grand tour and an official sales pitch."

"Will do."

Olaf led them inside the three-story octagonal rotunda that showed the recognizable effects of much restoration. Once-faded walls now contrasted richly with highly polished woodwork. Art and antique tapestries Lucas couldn't remember seeing before were showcased in museum-style displays.

"So how's it going, big guy?" Bree asked. "And the wonderful wife?"

"Still wonderful, I think. She's been holed up in her office, crushing a deadline."

"No, thinking about it," a feminine voice rang out.

Lucas glanced around at the woman approaching. She was dressed in contemporary clothing, an interesting, if clearly adoring foil to the tall man she came to stand

beside. "Make a correction—*should* be holed up in her office."

"Then get to work." Bree hugged the woman. "I haven't had anything decent to read since your last book came out. Lucas, meet Susanna St. John, *New York Times* bestselling author."

He greeted this illustrious personality and found himself the recipient of her open perusal.

"You brought a guest?" Susanna eyed him curiously. "This is a surprise."

"Lucas is only in town until Mardi Gras," Bree explained, leaving him to assume she usually came alone on her getaways.

He liked knowing that. He also liked knowing she found him worthy of meeting people she obviously cared for.

"I know you're partial to the Sky Suite, but I've got a full house. Training a sales force out of Baton Rouge," Olaf said. "I put you in a guest cottage. Hope you don't mind."

"Oooh, like we'd complain." Bree smiled at Lucas. "The guest cottages are the penthouses around here."

"Unfortunately the penthouses mean you'll have to shuttle back and forth to the main house for meals," Olaf said.

Susanna patted her husband's arm. "I'm sure Bree and Lucas won't mind the walk."

"Not at all." Lucas liked the idea of privacy.

"Then you know the drill," Olaf said. "Hit wardrobe before you head out, and I'll have everything sent to the cottage with your bags."

"Wardrobe?" Lucas eyed Olaf's cutaway jacket.

"Southern Charm Mysteries hosts business training.

The sessions are all based on the history of this place," Bree said. "We won't participate, but we do have to blend in."

"It's all part of the fantasy we create around here." Susanna turned to her husband. "Honey, why don't you have Jerry grab Bree and Lucas's bags? I'll take them upstairs."

She led them up the winding staircase, but they hadn't made it to the first landing before Bree said, "All right, Susanna. What gives? You usually toss me a room key, tell me to get dressed and send me on my way. Why the five-star treatment? Because I brought Lucas?"

"Because we need a favor. What Olaf didn't tell you is that he's giving you the cottage gratis for as long as you want it if you'll bail him out of a rather delicate situation."

Bree paused with her hand on the balustrade. "Spill."

"You know that sales force from Baton Rouge?" Susanna lowered her voice, explaining how they couldn't find costumes for one of the guests.

"She's nine months pregnant, Bree, and no one thought to mention it," Susanna whispered as they turned the second-story landing and started toward the third. "I didn't ask, but I think she must be having twins. Or triplets. The larger-size costumes are the only ones she can get on, but they're tight around her middle and hanging everywhere else. She feels awkward because she looks ridiculous.

"She told me privately she's already having trouble with some of her coworkers. The bigger her belly gets, the more they're treating her like an invalid. We can't leave her like this for the rest of the training. I put in a call to Toni, but she's out of town. Olaf refused to ask you, but I told him I'd make sure you didn't feel obligated."

"Bribing me with a free cottage is just incentive, right?" Bree said drily.

"I know how much you love a good deal. Will you help?"

"Of course."

Lucas still wasn't clear on how Bree would help this situation, but he listened with interest as they reached the third floor, where they passed a door with a gold nameplate announcing the Sky Suite. Apparently, Bree's favorite.

They continued down the hall toward a door at the end with a nameplate marked Wardrobe.

The room proved to be an enormous dressing room with a surplus of historic costumes in all shapes and sizes. Susanna pointed toward the walls of garment racks. "We've got day wear, formal wear. You name it and we've got it. Except maternity. I don't know what your plans are, so just pull out what you need. I'll have Jerry bring it all over."

Lucas glanced at a costume that should be in a museum.

Bree must have caught his expression, because she glanced over her shoulder and blew him a kiss. "Fantasy, remember?"

His fantasy involved bare skin, not brocaded waistcoats, but he shuffled through the racks until producing two likely choices—a casual suit for day, another more formal for night.

Here's hoping he wouldn't need them.

When he turned back around, Bree was turning a voluminous dress inside out, inspecting a seam, and he began to get an idea of why Susanna had solicited her help.

"Piece of cake," she said. "As long as you don't mind me dismantling a few dresses."

"Have at it."

"I'll need her measurements. When can we get together?"

"Want to settle in first?" Susanna asked.

Bree cocked her head, considering, sending rich, dark waves tumbling sexily down her back. "No. The sooner the better."

Susanna nodded. "Then I'll go find her now. I'm sure she won't mind."

Bree moved to stand with him. Looping her arm through his, she pulled him close to whisper, "Why don't you go get ready to start our fantasy?"

Awareness sizzled through him, a physical reaction to her warm breath against his ear, the graze of her cool silk hair against his cheek. "Don't be long."

Her expression melted into an inviting smile, and she pressed her mouth to his cheek. "Promise."

That was a promise he would hold her to.

BREE LOVED THE COTTAGES. There were four, connected by a cobblestone path that meandered through the live oaks and azaleas. They sat tucked on the banks of Bayou Doré, within easy distance of the plantation yet far enough apart to be private.

She'd never gotten to avail herself of the luxury because the cottages were new additions to the property, modern accommodations that had been designed to mirror the plantation's architecture on a smaller scale.

They'd been built exclusively for the owners of Southern Charms Mysteries. Olaf and Susanna lived in one, a lovely place with a spectacular view of Bayou Doré, beneath the shady overhang of trees and sunny sky.

Bree understood that two of the company's partners lived up north, and the cottages allowed them to visit the property or house potential clients without disturbing the training sessions taking place inside the plantation.

Figured Susanna would use them as leverage. Not that Bree minded helping out. Olaf was a doll to let her visit at a special rate whenever she needed a break from the real world, and her work for Toni Maxwell helped make ends meet. Bree didn't have a degree in design, but Toni let the quality of her work speak for itself. Pinch-hitting for her largest costume account was the least Bree could do to repay her trust.

Hopefully Lucas wouldn't mind the interruption. Staying inside a cottage gratis wouldn't impress him. Although she'd issued the invitation, Bree would be surprised if he let her pick up the tab.

It was an unwritten rule among rich men—they always footed the bill. So unless she missed her guess, he wouldn't let Olaf comp their stay. That would smack too much of his date working to pay their way. Another rich guy no-no.

As she hurried along the path, arms overflowing with gowns, she mentally calculated how best to tackle the work ahead. She'd found the mom-to-be a size that wasn't absurdly large. With a few creative adjustments she could hide beneath a lace jacket and flounces, Bree could redesign two gowns and solve the problem fairly quickly. She'd squeeze work in around fun.

Finding the cottage door unlocked, she juggled her armful, turned the knob and slipped inside.

The living area could have been a mini antebellum plantation with floor-to-ceiling windows draped in white sheers and decorative friezes over the arched doorways. Buff-colored walls and elaborate wicker furniture made the place charming and homey, and Bree smiled while draping the gowns over the sofa to avoid wrinkling.

She wondered what Lucas thought of their fantasy getaway…actually, Bree wondered where Lucas was.

She found him inside the courtyard that had been built on the side of the cottage to take advantage of the bayou view. He sat inside the steaming spa, a glass of red wine within easy reach and sultry jazz music filling the air.

The water only reached midchest, treating her to the sight of his yummy upper body with silky dark hairs nestled in all those muscled hollows and ridges. Wet skin that would be slick to run her hands over.

Mmm. And she'd soon get her chance.

"So you got started on our fantasy?" She sounded breathless, felt breathless as he raked an inviting gaze over her, lingering over places that grew all tingly in reply.

"My fantasy didn't involve costumes."

"So I see. You look pretty naked in there."

"I don't know about pretty, but the naked part is true."

The words hung in the air between them, and the quiet grew so thick it could have been fog rolling in.

"I didn't expect to get hit with work when we got here, Lucas. I hope you don't mind."

"Not a problem. The whole point of spending time together was to get to know you."

"In the biblical sense?"

"In every sense. If you need to work, too, just tell me if I can do anything to help."

Help?

She hadn't expected that. Maybe because he made getting to know her sound so important, when she'd have thought getting her into bed would have been top priority for their fantasy.

"When you said you had work connections, I assumed you meant through Toujacques." His husky voice sent another sizzle through her. "You do some sort of costuming?"

"I moonlight for Toni Maxwell. She's a designer with

a boutique in the Quarter. Félicie Allée is a huge account, so she hires me to sew. Gal's got to make a living."

"So you're an entrepreneur and a seamstress. You minimized your talents. Sounds like you got your fair share."

"Well, thanks." Her smile suddenly felt too big, too eager. "And I appreciate your offer. I figured I could alter in between the fun stuff."

"The fun stuff?"

"Mm-hmm. The whole reason I invited you here. We're on a time limit."

True enough. She didn't have time for standing here feeling like a young girl with a crush. She'd meant to challenge Lucas, hadn't expected him to challenge her back.

But Bree liked knowing he wasn't as predictable as she'd expected, wasn't her run-of-the-mill power freak. "Mind if I join you?"

"I've been waiting." Lucas brought the wineglass to his lips and sipped while he eyed her over the rim.

His deep gaze became a dare, and she knew exactly what would heighten this man's anticipation.

Tossing her hair back over her shoulders, Bree reached for the fastening at her waist....

THE WINE SEEMED TO solidify in his throat as Lucas watched Bree cross the small courtyard, her steps measured and graceful, her hips swaying gently. His breath caught, too. The courtyard was only partially walled, and Bree strolled over to the wrought-iron gate to gaze out at the bayou. With her back to him, she provided an attractive display of graceful motion as she worked that zipper down, down, down....

Anticipation got the better of him, and Lucas swallowed hard before he choked. He didn't want to make a sound to

distract her when she began slithering down that narrow skirt to reveal long legs encased in silky black hose.

Stepping from the circle of fabric almost absently, she knelt to retrieve her skirt from the terrace.

Time slowed to a crawl as Lucas watched. Her hair shone dark against the fading sky as waves threaded sexily along her shoulders and down her back, clinging to her sweater. Muscle played along her thighs as she knelt to give him a prime shot of her heart-shaped bottom.

Lucas had no doubt she was playing to her audience, but he was an appreciative one. Josie had called this woman sweet, but he saw nothing but fire. Boldness. Excitement. A woman who knew her power over a man and took great pleasure in wielding it.

She knelt there for a moment, giving him a chance to admire the sight she made with her body compressed tightly as she sat propped on her strappy sandals, her hair flowing down her back.

Then she rose in a fluid move and asked casually, "Did you unpack yet?"

He nodded, and she met his gaze easily, as if she hadn't noticed she wore nothing but sheer black panty hose and a clingy red sweater.

But he noticed with every nerve in his body and was glad the circulating water hid his reaction. "Join me."

She smoothed the wrinkles from her skirt and draped it over a chair. "I plan to."

"Naked."

"Of course."

Her expression was pure indulgence, and as fascinating as it was to watch her beautiful face, his gaze slid down to the manicured fingers deftly working the buttons of her sweater.

The downy fabric parted at her throat, then her chest,

to reveal the swell of her breasts barely contained in black lace. And her fingers kept going….

He hardly knew this woman, yet he watched her as if he'd waited forever to get her naked. His chest constricted around a breath. His crotch surged with a wildfire heat. What was it about Bree that nailed him everywhere it counted?

Lucas could barely think, let alone analyze the situation. He could only try to keep from drooling when she peeled the sleeves down her arms, baring her upper body, all golden skin and sexy black bra.

He knew she taunted him when she turned her back to unfasten her bra, sliding the straps down with a few provocative motions that made her hair play peekaboo with her skin.

She tossed her bra at the chair, and he might have wanted her to turn around so he could enjoy the show. But that would mean missing the sight of her from behind, and when Bree slipped her fingers inside the waistband of her hose, Lucas wouldn't have missed this show for anything.

He forgot the steady heat of the spa. The jets that pounded at his back. The fading light as the sun sank in the sky. He forgot that he'd only just met Bree Addison.

Lucas only knew that he'd never watched a woman peel away her panty hose with as much élan. That he'd never felt so damn lucky to see each inch of any woman's leg revealed. But he already knew the feel of those legs, remembered the shape of her calves, her knees, her thighs. He knew where each scratch had marred her because he'd touched her already.

Now he wanted to explore her.

And when she pulled away the last of the hose and turned partway toward him, his crotch gave one hard throb. His gaze scrambled to take in everything—those long thighs, the

curve of her backside, the slope of a hip, a flash of silky hair between her thighs, the smooth expanse of her stomach.

Then she granted his wish and turned fully around.

Bree Addison was incredible. Her skin was golden, not tan but a rich, healthy color that looked as if she'd been poured of honey. The long lines of her body were lush, not model-thin or emaciated. She had the muscle tone of an active woman. Her breasts were full, her nipples rosy, and he wanted to discover all of her with his hands, his mouth.

Bree smiled, clearly enjoying the way he watched her. She wasn't shy or coy. She was…natural, facing him as easily as she had in a glittery gown or worn jeans or a clingy skirt.

A wind kicked up, lifting strands of hair off her shoulders and whipping them around her face. She gave him another prime shot as she piled her hair onto her head and fastened it with a clip. "Brr, chilly."

Not from where Lucas was sitting. Sweat rolled down his temple when she hugged herself to ward off the chill, plumping full breasts over her arms as she hurried toward him.

Lucas was smiling again. And holding his breath.

"Oh, let me in. I'm freezing." She was close enough for him to see the spray of goose bumps over her skin and want to warm her up.

He sat up and extended a hand. She took it, levering herself as she slid onto the rim of the spa. Her knees came together gracefully, hiding glimpses of everything between her thighs as she swung her legs around and slid into the water.

She sat on the seat opposite his. Her dark gaze flashed across the distance. "So here we are, Lucas. Naked."

7

"NAKED," LUCAS AGREED.

The sound of the word sliding off his lips gave Bree a thrill. Or maybe the feel of his hard legs slipping between hers was responsible for the way she felt right now.

Decadent. Daring. As if she'd found something special where she'd least expected and needed to make the most of every second before it got away.

Settling back on the seat, she nudged her foot between his legs, forcing Lucas to part his thighs so she could wiggle her toes up enticingly close to some private places she hoped would respond to her boldness.

His muscles shifted and her foot slid home, and she met his gaze to find him watching her with that quiet expression.

"*Very* naked," she said.

He inclined his head, and Bree smiled, deciding she liked to watch his face. There always seemed to be more behind his expressions than he let on, which made her wonder what he was thinking.

"Did you think I was a prostitute the night I fell into your yard?"

His strong hands slid down her calf, a move that made her jump. He inspected the scratches on her knee, which were already healing. "I wondered what you were doing

out so late dressed to the nines, but then I recognized you."

"Josie told you about me?"

"No. I noticed you at the wedding." He dragged his hands down her calf and massaged her ankle with his thumbs. "Hard not to. You're a very beautiful woman."

She sank down a little in the water so he couldn't see her nipples growing hard. Wouldn't do to let the man know that his smallest touch was making her react now, would it?

"I'm glad you think so. Tell me, what did you notice about me first? Was it my dress? What did I wear to Josie's wedding?" She cocked her head to the side and considered. "Oh, my turquoise slip dress."

"Actually, I'm not sure I noticed you. Might have been Tally."

Bree laughed. "I thought you said you could tell us apart."

"I can now." His green eyes twinkled. "But then I hadn't gotten close enough to know we had chemistry. I don't remember what you were wearing."

"So much for the turquoise slip dress. Guess I'll retire it if it's not making a lasting impression."

"You made an impression." He eased his thumbs toward her foot, whether because he wanted to stop her from teasing all his private places or because he had a thing for feet, she couldn't say, but he suddenly had the control.

"Did I?"

He stroked her instep luxuriantly. "You did."

"Well, if you didn't notice a tall, handsome Cajun man nearby, it's safe to say I wasn't Tally."

"I would have noticed him. So you want to know what caught my attention?"

She nodded, although she wasn't entirely sure why she was so interested in what he thought about her. She simply was.

"Not your dress, obviously. And all I'd heard about you was that you were one of the twins who'd bought Number One. I kept trying to meet you, but every time I made a move in your direction, some relative caught me. Josie must have invited everyone she's ever met. Even cousins seven times removed."

"It was her wedding. A wedding is supposed to be a big, fun celebration."

His hands stilled their sultry motion, and he considered her thoughtfully. "Is that what you want your wedding to be?"

"Haven't really given my own wedding much thought, to be honest." She smiled. "You weren't kidding when you said you wanted to get to know me."

In a move she didn't expect, Lucas lifted her leg. She automatically braced the rim of the spa to catch her balance, but he did nothing more than lift her foot from the water.

Toward his mouth.

Suddenly their gazes met across the steamy distance. His eyes were bright with purpose, and just as Bree realized the man meant some sexy business, she felt his mouth trail along her wet skin in a velvet caress.

"I want to know everything about you, Bree."

His warm breath burst across her instep, and she had the wild thought that the meticulous grooming habits Tally always teased her about had paid off big. Sure, she'd devoted time to learning how to give herself a decent pedicure, but when Lucas slithered his tongue between her

toes, he made every second she'd spent with a pumice stone worth the effort.

Definitely a foot man, Bree decided when he sucked her pinkie toe inside his mouth.

Who knew how good *that* would feel?

There was just something about the sight of this man with his beautifully rugged face making love to her prettily painted toes that made the bottom drop out of Bree's stomach.

Suddenly the whole moment became all about intimacies, about the way his hands felt on her skin, about the way his hot mouth sucked luxuriantly on one toe then the next, about how only the stretch of their legs separated their bodies.

The water caressed her skin in silky currents, heightening every sensation until it became an effort to simply sit and watch. Tingles shot up her leg and made her sex clench greedily. Had she been closer, she'd have grabbed his feet and started up a search expedition of her own.

Was he a fanatic about grooming details like so many other rich men? For some reason, Bree couldn't picture him sitting in the massage chair of some upscale salon with his feet soaking in a pedicure spa. Maybe it was his oh-so-male face. Or maybe he'd thrown her with his candor. She wasn't sure. She only knew that the thought of touching him excited her, made her grow breathless and edgy.

They'd jumped from kissing to naked in a single leap, but she felt comfortable in a way that came as such a surprise she was forced to ask why she felt so comfortable around Lucas. So eager.

She'd been ultraselective about the men she'd gotten involved with since extricating herself from her bad-news

ex. Was she just comfortable with the way Lucas had stepped boldly into her life and cleared a space for himself?

Was she ignoring her instincts? Making more out of a fling than she should? Wanting him felt so effortless when it really shouldn't be. He was everything she typically didn't go for in a man. Except for the little thoughtful things he did that made him not fit the privileged mold the way she expected.

She sighed, hating the way she had to question her every reaction, wishing she could just trust herself to enjoy the moment. "Why are you so easy to be with?"

"I've been asking myself that very question about you since we met."

"Have you?"

He swirled his tongue around her big toe, a hot motion that made her breath hitch. "I have."

"I want you. You want me. It feels so simple when it really shouldn't be. We don't know each other at all. And here you are nibbling on my toes."

"Turning you on, I hope."

"Mmm-hmm. I wouldn't have pegged you a foot man, though."

"Never was, but you've got sexy feet. One of the first things I noticed about you in the bushes."

"I'm flattered." Maybe she shouldn't bother repairing that dress. She would definitely clean up the shoes, however. They'd made an impression.

He ran his tongue along her instep lightly.

She shivered. "That tickles."

"I like touching you. Everywhere."

"How opportune, Lucas. I like when you touch me everywhere."

She'd meant to be playful, but Lucas clearly felt

goaded, because before she realized what was happening, he'd reached out with his free hand and grabbed her.

Her foot drifted back into the water, and the handsome man who'd been contentedly nibbling on her toes looked as if he hadn't eaten a good meal in forever.

"Lucas," she gasped on a surprised laugh, but that was all she got out. The next thing Bree knew, she was being dragged across the spa, the hot water caressing her in a way that made her feel just how naked she was. Just how naked Lucas was. And just how quickly he closed that distance between them.

Three…two…one…

Contact.

She landed against him, and his strong arms wound tight, maneuvering her until she draped across his lap, legs spreading to straddle him. His warm, wet skin was suddenly everywhere, his arms holding her close, his broad shoulders providing leverage to hang on, his hard thighs nudging her closer until she could feel his erection against her thighs.

"Couldn't wait any longer," he murmured in that husky voice.

They exchanged a breath a split second before their mouths came together.

All the calm of the moment disappeared.

He devoured her in a kiss, and she found herself responding with the same urgency, an eagerness to know everything, to touch everything. But while the calm had gone, that uncanny sense of effortlessness remained, breaking down all boundaries.

She wanted him. He wanted her. It really was that simple. They were in each other's arms finally, and there was no longer any good reason to hold back.

So they didn't.

Threading her arms around his neck, Bree arched her body into his until she could feel him everywhere. Her breasts crushed into his chest. Her thighs poised above his, so perfectly aligned that she could have sunk down and eased this ache that had her sex pulsing in time with her heartbeat.

He anchored her close with a whipcord arm around her waist, but his other hand was suddenly spearing inside her hair, dragging down her back, her waist, her hip, digging into her bottom. His fingers molded her butt, flexing as if he struggled not to pull her down and join them together as one.

She liked that he was struggling, enjoyed watching him react. To entice him, she broke her mouth away, trailed her lips over his face. She tasted him, learned the curve of his jaw with her kisses, the sculpted line of his cheek, the soft pulse that pounded as hard as her own.

"I want you, Lucas." She blew the words into his ear, was rewarded when his erection swelled in reply, grazing her private places and making her burn.

If she expected Lucas to get on with it, Bree should have known better.

Dragging his hands along her ribs, he fitted them around her waist, exerting enough strength to make her arch backward.

And place her breasts at his mercy.

His mouth latched onto a nipple with a surprisingly gentle force, a slow pull that sent pleasure curling through her in a lavish wave. Her sex spasmed lazily, hungrily, and she was forced to hang on as muscles she hadn't realized were there grew weak with wanting.

Threading her fingers into his hair, she occupied her

hands, tried to divert herself with touch so she didn't sink down on top of him—unprotected as they were—and assuage this growing ache that made it nearly impossible not to respond.

Lost cause.

All Bree could do was press her breast into his mouth so he could work that magic filtering through her. She rocked her hips so his erection teased her intimately, a rhythm that made her melt in his lap.

She'd been worried about letting him know how deeply he affected her, but restraint right now was a joke. Every nerve ending sparked hotly, and she could only focus on one thought.

Satisfaction.

One upward thrust and Lucas would have been home. She didn't know how he was controlling himself. Yet he feasted on her breasts with a single-minded focus, thumbing the undersides until she tingled, tasting her nipples with such thorough skill.

He stoked a fire deep within, and while she wanted to explore him, wanted to take back some control, she could only surrender to his touch. To do anything else would have meant stopping this sexy foreplay to deal with protection.

She didn't want to stop, couldn't ever remember struggling so hard to think—and she needed to think so she could capture every second of this incredible sensation in her memory. His mouth plucked at her nipples until she could barely stay still.

But Lucas kept that arm locked around her, anchoring her close and controlling the moment, savoring, pleasuring, refusing to be rushed in his pleasure.

He wanted to explore her, so he did.

Pressing her cheek to the top of his silky head, she let him control their pace, indulged him with an unfamiliar feeling of tenderness that made her brush kisses into his hair.

What was it about Lucas that made her feel as if he'd waited forever to touch her?

That was exactly how she felt right now. Wanted. Cherished. As if she were a gift that he intended to savor at his leisure.

As if her pleasure was his pleasure.

It was a singular sensation, one that touched her in places that went far beyond the sexy excitement of the moment, places that inspired her to sigh his name, to let him know that she cherished their closeness, too.

And something of her mood must have reached him, because suddenly he was dragging his hands up her back, pulling her down until she was tucked neatly into the folds of his body, sheltered by his strong arms and nestled against his chest.

With one shift of his hips, he maneuvered his erection to lie flush between her thighs, nestled cozily between her moist folds, safe from temptation. Then he tipped his face toward hers and captured her mouth in a kiss.

Bree yielded to the moment, so sudden in the midst of the arousal flaring through her—flaring through him, too, if that thick ridge between her thighs was any indication—so unexpectedly tender.

So very right.

Bree didn't know why, but their kiss became about much more than sex. This kiss was a welcome. On some instinctive level she recognized this man, *knew* his feel, his scent, his taste. It was crazy. Maybe lust had numbed her brain. She'd seen that exact thing happen to her sister. Lust had

Tally seeing ghosts and Bree feeling as if she finally belonged.

She'd take belonging any day.

Bree wasn't Tally, who didn't have trouble letting others overshadow her. Bree needed to remember. But it was so hard to think in Lucas's arms, so hard to do anything but abandon herself to the moment. She kissed Lucas with an excitement that swelled from within, a feeling so pure and right that she suddenly couldn't stop from laughing against his mouth, sharing his warm breaths, tasting the throaty laughter that tumbled from his lips in reply.

"Let's make love," she breathed the words on a breath. "Tell me you brought protection."

Lucas tightened his arm around her waist, trapped her tightly against him as he reached behind him to a pile of clothing on the floor beside the spa.

He'd obviously stripped, then jumped in, and when he produced his wallet from a pocket she said, "Thought of everything, did you?"

He flashed her a roguish grin, and she laughed again, liking the way she felt, all breathless and edgy and excited.

Rising up on her knees, she gave him room to take care of business, and he managed the task easily. Suddenly his gaze caught hers as he took aim, and she felt snared by the gentleness in his face as he pressed inside her.

Slowly, steadily, he stretched and filled her until a low moan escaped, the sensation forcing the breath from her lungs and making her body dissolve around him.

She half expected lightning to strike as he slid all the way home. There was just something so climactic about the way they came together, how perfectly their bodies fit.

And Bree knew she wasn't the only one feeling this way.

Lucas's expression softened in a way she'd never seen before. He grew so still she didn't think he was even breathing.

Time seemed to stall as they poised there, bodies joined intimately, savoring the feel of coming together, of wanting and waiting and finally knowing that they hadn't imagined the amazing way their bodies felt together.

He raked his gaze over her face, his expression telling her things that needed no words, convincing her she wasn't the only one feeling awed and humbled by their naked bodies joined in pleasure.

His face hid nothing, and she liked that he shared himself so easily, felt encouraged to share back, not to hide that what she felt right now was so unexpected.

She was the first to move.

Spearing her fingers into his hair, she urged him to lean his head back until she could stare down into his face, memorize the wanting expression that softened every hard angle and plane.

"Lucas," she breathed his name and couldn't have resisted kissing him if her life had depended on it.

Their mouths came together as he arched upward, pressing inside her, starting up a hot beat that took over.

Suddenly Bree knew nothing but the feel of him inside her, the touch of his hands on her body, the taste of his mouth as he kissed her with a bold possession.

He rocked beneath her, pressed inside her. He slid his hands onto her hips, guided her pace, thrust into her with short driving strokes that caught her everywhere.

It had never been this way before. Pleasure swelled inside, a rise of sensation so intense that she broke her mouth from his, so overcome that she couldn't kiss him, couldn't touch him, couldn't do anything but bury her face in his neck while ecstasy mounted and crested in her.

Her breath stalled. She knew only the feel of his rocking hips, the strong arms that held her, the pounding rhythm unraveling her in places untouched before him. She grew dizzy and urgent while meeting his powerful thrusts, heard herself sobbing his name as the first spasms broke.

Lucas went with her, his mouth buried inside her hair, a low growl breaking from his lips as he clung to her as if he would never let go.

She couldn't breathe, couldn't stop rocking her hips to ride the crest, even when her strength began ebbing. Still, she couldn't stop arching against him, unsure if she was going to pass out, stop breathing or die in his arms as the sound of his laughter rang out loud and strong over the bayou.

8

LUCAS DIDN'T KNOW WHAT the hell had just happened. He'd never had sex that felt anything like what he'd just done with Bree, an explosion of the senses that sapped every ounce of his strength. He could only hang on to this woman and savor the way she collapsed against him, how their hearts raced together in frantic time and how her sex clutched him in erratic bursts.

The only thing Lucas knew right now was that he wasn't letting her go. She'd been right. It had been simple. He wasn't sure why, had no clue what was happening between them, but he knew without question he would hang around to find out.

Lucas had never believed all the romantic stuff about soul mates that his sister bought into, but after these fireworks...well, maybe there was something to Josie's way of thinking after all.

He hadn't realized anything had been missing in his life. He'd just known that he'd been burying himself deeper and deeper in work because life had started feeling stale. Bree had recognized that almost as soon as they'd met.

He felt alive right now, eager to know everything about her, to understand why he felt so content in her arms.

Stroking away the waves that wisped around her neck, he asked, "What are you thinking about right now?"

"How much I like having sex with you," she said with a dreaminess to her voice that made him smile.

He pressed a kiss to her forehead, a sentimental gesture that should have felt too intimate but somehow felt like the thing to do.

She sighed, which he thought was also the thing to do.

They fell into silence again, a sated silence and a companionable one. He liked how easy it was to be around her.

The sun had set while he'd made love to her, casting the courtyard into duskiness with only the sounds of the bubbling spa jets and the bayou—wind rustling through the oaks, the wildlife making its way home for the night.

And an unfamiliar grumbling that took Lucas a moment to recognize.

"You're hungry," he said, not a question.

Pushing herself up, she heaved another sigh, as if moving required effort. "I forgot to eat today. By the time I woke up, I had to rush to get to the den."

She kneaded her stomach, and all her movement caused what was left of his erection to slide out.

"Oops." She laughed, and he winced as she scooted back on his lap, the water cold after her body heat. She squinted into the courtyard. "I think we might miss dinner. By the time we pull ourselves back together—"

"No problem. I'll cook. It's the least I can do since you made all the arrangements."

She arched her eyebrow. "You cook, Lucas?"

"I do. You eat?"

"I do."

"Then we're a match made in heaven. I checked out the kitchen when I got here and it's stocked. I'm not sure with what. How picky are you?"

Sinking onto her knees, she eyed him as though she was considering him for a meal. "Very picky."

He laughed. Then she slithered off his lap and rose from the waist-deep water like a vision from a dream. Water sluiced down her golden curves and dripped off her swaying breasts as she shimmied to the side and onto a seat.

His mouth went dry at just the sight of her in motion, and for a man who'd just had sex that had made the lights go out, he probably shouldn't have felt life signs so soon again.

He did.

"Okay, Mr. I-thought-of-everything, where are the towels?"

He forced himself to move, leaning over the side to grab towels from the step behind him.

When he felt her fingers caress his butt, Lucas knew he wasn't the only one with sex still on the mind.

"Did anyone ever tell you that you have a great ass?" she asked.

"Not in quite that way."

"Then let me be the first. You've got a great ass." She skimmed her fingers inside his thigh, made his dick jump at her light touch. "Great other things, too."

He wasn't sure what to say to that, so he only passed her a towel. Drawing her legs up in front of her, she treated him to a show while drying off her feet. Then she maneuvered out of the spa in another of those fluid moves.

He climbed out and dried off, wrapping a towel around his waist. When he turned back around, he found Bree eyeing him.

"I'm having déjà vu here," she said.

"All we're missing are some twigs in your hair."

"Tee hee." Wrapping the towel around her, she cut off the spectacular view. "Come on. Let's get moving on that food. I've worked up an appetite."

He reached out and threaded his fingers through hers, liking the feel of their clasped hands as they walked through the cottage to the kitchen.

"When I peeked in this kitchen before, the only thing I noticed was the gorgeous woodwork on the cabinets," Bree said. "I didn't give one thought to what might be inside."

"Sounds like we've got all the bases covered between us."

"Got an answer for everything, don't you?"

"Not everything."

He had no answer to why he was reluctant to release her hand when they arrived at the fridge. He had no answer to why such a simple gesture had felt so right. They'd made love and had fireworks, but standing together felt more powerful than he imagined two people touching should have.

"I don't have an answer about why your friends thought we'd have to walk to the main house for meals."

"They've got a five-star chef on staff," Bree said as if that explained their rationale.

Perhaps it did, but Lucas would rather cook if it meant keeping his charming companion all to himself—and naked.

Or close enough to naked to make him smile at the sight she made with her long bare legs as she leaned inside the fridge to inspect the contents.

"Doesn't look like we'll ever have to leave," she said.

Be still his heart. "See anything that looks promising?"

"Yeah, but what about you? Now that I know you like to cook, what do you like to eat?"

"You."

"I walked right into that."

"You did." He leaned beside her and peered inside. "Steak looks good."

"I was thinking of eggs."

"Breakfast?"

"Didn't you ever have backward days? Tally and I used to all the time. Mark loved them."

"All right, I'll bite. What's a backward day?"

She cast him a sidelong glance. "Pancakes and cereal for dinner. Pizza for breakfast."

"Gotcha."

"And omelets are fast, too."

"Perfect for a starving woman." He grabbed the egg carton. "Bring me what you want in your omelet. You've got your own personal chef tonight."

"Who has a vested interest in making sure I get my energy back, hmm?"

He caught her just as she stood and dragged her full against him. "You're going to need a lot of energy tonight, Bree. Trust me."

She kissed him with laughter tumbling from her lips, and when they finally parted, she was hanging on to her towel. His own towel stuck out as though he had a tent pole underneath it.

She headed back into the fridge, and within minutes the makings of a respectable omelet appeared on the counter. Portobello mushrooms were apparently a favorite, along with mozzarella cheese. Onions were a debate.

"I love them cooked," she said. "Do not eat them raw. Where are you on the issue?"

"I'll cook them."

She gave a satisfied smile and plunked the onion down

on the counter. Then she was off again, tucking her towel tightly around her as she dug through the cabinets to set the table.

Lucas got busy, too, locating a skillet and a cutting board, admiring Bree in his periphery as she decided they should eat on the veranda and ran in and out with her arms filled with utensils and plates.

Backward day sounded like a way to entertain a younger brother. Mardi Gras parades. A twin sister and a pirate treasure. He didn't know much more about this woman who made him react to her so intensely. No word about parents or any hints about her upbringing.

She'd been keeping their conversations light, and he couldn't decide if light meant she only thought of him as a lover who would be around for a week—which he basically was—or if she simply just didn't share herself with many people. The fact that Josie didn't know much about her either told him something.

She finished setting the table about the time he got the mushrooms on the fire and had started on the cheese. Once in the kitchen, she propped herself against the counter and watched.

"You weren't kidding," she said. "Look at you. Grating cheese. Spices. What are you doing with the mushrooms?"

"Sautéing them."

Setting down the shredder, he pulled the skillet from the burner and crowded her up against the cabinets.

"Lucas," she laughed. "Dinner."

"Breakfast." Grabbing her around the waist, he hoisted her onto the counter. "The chef needs inspiration."

She inspired him. Slipping her arms around his neck, she toyed with the hair at the back of his neck, an idle motion that assured him she liked touching him.

He liked touching her, too, and couldn't think of a better way to start bridging the distance between them. They had the whole night together. He would make the most of it.

Grabbing the hem of her towel, he tugged it open.

She didn't shy away from her nakedness. She was all golden touchable skin and tempting curves, and he liked how comfortable she was with her body, liked that she shared herself with him.

"I've wanted to see you like this since the night we met," he admitted.

"You want to use me for a plate?"

"No. I was thinking more along the lines of motivation."

"Me sitting butt naked on the counter motivates you?"

"You sitting butt naked on the counter turns me on. Touching you motivates me to turn you on."

"But you haven't—"

He brought her protest to a sharp stop by catching her nipple between a thumb and forefinger and giving it a squeeze. She exhaled a half gasp, half moan that made her expression melt. He watched the nuances of her reaction while tugging on that rosy peak. Her mouth pursed in a sexy moue. She arched her back to press into his touch.

There was no resisting this woman in her wanting, so he indulged himself by handling her beautiful breasts until she leaned back on her hands and closed her eyes.

"Like that?"

"Mmm." Her soft moan filled the quiet.

Lucas leaned down to flick his tongue across her nipple, then turned his attention back to their meal.

"That's it?" She cracked one eye open and eyed him narrowly.

He answered by slicing an onion half with solid strokes that echoed in the sudden silence.

"You with that knife is almost scary."

He chuckled. "I'm hoping to impress you."

"You don't really need the knife for that."

"No." He used a knife to clear the onions into the skillet. Then he washed his hands and reached for his wineglass.

She never flinched beneath his constant perusal, just sat boldly and proudly before him. Her body beautiful in its need. Back arched to taunt him with all her smooth curves. Her nipples flushed from his attention, tight peaks spearing upward, asking for more. The dreamy edges of her expression as she watched him bring the glass to his lips.

Her hunger aroused him. A simple glance and she could make him want. And as he sampled the wine, swirling the mouthful over his tongue before swallowing, Lucas realized how much he enjoyed her wanting him, wanted to spike her hunger even more.

He sipped the wine again, only this time he let the sweet liquid chill his mouth.

She gasped when he braced his hands on her thighs. She let out a throaty laugh when he knelt down before her and wedged his shoulders between her thighs.

"So I'm dinner?" she asked.

He swallowed, and without preamble he dragged his tongue through her heated desire.

The first stroke of his mouth brought her up off the counter. Her thighs quivered. Warm, sleek skin enveloped his face, surrounded him in intoxicating sweetness.

His own need spiked with her response, and he sought out the hard knot hidden inside her warm folds, teased it.

She moaned and spread her thighs wider, inviting him to explore all her sweet places.

Lucas obliged until he heard her breathing come raw and shallow, until her thighs quivered. Then with a final flick of his tongue, he backed away and stood up.

"Don't stop," she said.

"I thought you were hungry."

"I am. For you."

He had no clue such simple words could have such a potent effect.

She was hot, wet. He watched her arch backward as he slid his finger in deep. She hid nothing of her passion. Her mouth parted on a sigh. Her fingers dug into his shoulders as she clung to him and urged him on.

Cupping his palm over her mound, he worked that hard knot as he slid his finger inside for another slow stroke. Her sex clenched tight, a trembling spasm that hinted of the climax building, and he couldn't help but spear a hand into her hair, dragging her head back to taste her low moans on his mouth. He couldn't keep his tongue from moving, from miming each stroke as she rocked her hips to knead her orgasm into breaking.

When she climaxed, his name burst from her lips, a half laugh, half sob that sounded so sweet and made him wonder what he'd found with Bree.

Whatever it was, Lucas knew it was special.

How Gabriel could assist a romance when his stubborn descendent had run off with Lucas and did not return home was beyond him.

Félicie Allée. *Bah.*

He still didn't know what to make of Breanne's fondness for Lafever's mansion. Coincidence or a divine

joke? Gabriel was leaning toward the latter. Someone had a sense of humor in the afterlife, but he never got to laugh at the jokes as he was usually the butt of them.

Which explained why he chased a headstrong chit who would rather run from her troubles than face them.

And Breanne had trouble. The dark-souled man he had first seen in the court last night had returned.

This time up to mischief.

From Gabriel's vantage on the wall surrounding Court du Chaud, he could not make out exactly what sort of mischief, but it involved an unfamiliar device and Breanne's auto, which her brother had just returned tonight.

With a sigh Gabriel glided onto Breanne's balcony, making his way into the room she used for work.

Mark—Breanne and Tallis's brother and Gabriel's youngest many-generations-removed grandson—lay sprawled over the couch in a deep sleep. The youth was a handsome lad who favored his sisters in coloring and the strapping Dampier men in size. Those broad shoulders and smile surely made the chits swoon.

From what Gabriel had heard from the twins, Mark had also been blessed with the Dampier passions, which translated into embracing what life had to offer with both hands—eating, wenching, *sleeping*... Tonight that blessing seemed more of a curse because the young man looked dead to the world.

Glancing around the room, Gabriel took in the lamps, the machines Breanne worked with—a serger and a computer. He decided on the keyboard device attached to the computer. Small enough that he should be able to move it. On the desk, so it should make a racket when it hit the floor.

Gathering all his concentration, Gabriel focused his energy on the keyboard, reached out to touch it....

"Old fool and your parlor tricks."

The shrill voice made him jump ignominiously, and his hand passed right through the device. Spinning toward *belle grand-mère*, he growled, "Rather than ridiculing me, why do you not float back to wherever you came from so I can concentrate and get about my business."

"A fool's business."

"Begone." He had had an eternity to bandy insults with this one. Now he didn't have the time.

Forcing the thought to clear his head, he tried to set aside his awareness of the scowling woman behind him. He needed focus to accomplish the task at hand. A parlor trick perhaps, but one he had mastered honestly.

His vision dulled around the edges until he could only see the letters swimming before him, and Gabriel touched the keyboard, felt it shift, solid, movable.

"Proud ass."

"Madame!" He reared on her with a vengeance. "Is it your wish that our youngest granddaughter join us in eternity?"

Gabriel decided his pride must have tempered just a bit after all, otherwise he might have felt proud to finally provoke some response from this bitter old woman besides venom.

For it was not venom he saw in her withered face right now. Surprise maybe. Or concern. He honestly wasn't sure, but it wasn't the hatred he had grown so familiar with. And that thought surprised him enough so he stared open-mouthed.

"What are you talking about, pirate?"

Belle grand-mère was back to her old self again in a flash. Gabriel was slower to recover.

"There is a man outside in the street tampering with

Breanne's car," he said slowly, unsure why he was both-
ering to explain. "He has some sort of device—"

"A bomb?" She swept toward the window with a
flourish of billowing shawls and peered out into the night.

Gabriel had heard about bombs on the television, and
apparently so had *belle grand-mère*. "I have never seen
this device before. I can only make out the letters GPS on
the box. I want to awaken this one." He motioned to the
slumbering youth on the couch. "So he might frighten off
the mischief maker."

"That man should not be down there," she murmured.
"I have a bad feeling about this."

Belle grand-mère knew the man. And here Gabriel had
thought she existed only to torture him. "Who is he?"

"Breanne's old beau. I saw pictures of him in Tallis's
photograph books and overheard her telling Christien
about him."

"An old beau? Surely he wouldn't bomb her."

"I'm not so sure. I heard Tallis say there was bad blood
between them. Something to do with the police. She
believes the best thing Breanne ever did was get away
from that one. I mean, open your eyes and look at his soul,
pirate."

"That much I knew. So why is he back?"

She shrugged. "Wake that boy."

Urgency spurred Gabriel to summon his concentra-
tion. Urgency and, yes, his pride. To prove to this old nag
that he had been putting his eternity to good use, too.

The keyboard clattered to the floor with a blaring
racket, and *belle grand-mère* followed suit by tossing a
book off a shelf.

Mark didn't move.

With another impressive burst of energy, Gabriel sent

a computer sound speaker flying off the desk. This landed on the sofa and hit the boy's arm before thumping to the floor.

Mark exhaled heavily, and for a hopeful moment Gabriel thought he had accomplished his task. Then the boy just rolled over with a scowl and continued sleeping.

"Is this some sleep sickness from your side of the family?" *belle grand-mère* demanded.

Gabriel thought it more likely young Mark had been enjoying the good life between his college studies. But Gabriel wouldn't let this woman provoke him. In desperation, he summoned his energy and poked Mark.

"Wake up, boy. Come on." Bah, no good. "Are these youngsters always so headstrong?"

"You passed that trait along, pirate. And you claim that I cursed them."

He wheeled on the grand-mère with a scowl but found her frowning into the street.

"'Tis all for naught. That black heart has done what he came to do and leaves." She scowled at him accusingly. "We must find out what he has done to Breanne's car."

We?

Gabriel blinked.

We.

He opened his mouth to tell the old crone he would rot in this hell of his own making before he helped her. She hadn't seen fit to do anything but torture him for two centuries.

He closed his mouth again. There was more at stake here than his pride, and he might use the old crone's help. Just this once, he might do better to exercise some self-control.

No matter how much it hurt.

9

"SO WE'RE BACK TO TWENTY questions?" Bree raked her gaze down the yummy terrain of Lucas's legs to his feet, which seemed respectably cared for yet not pampered.

"Can't sew and talk? Not much on multitasking, are you?"

She admired the sight he made, his butt in clingy jersey shorts, as he knelt to plug in his laptop. "I can sew and talk just fine, thank you. Do you mind music while you work?"

"Prefer it."

"Good." Heading to the sound system, she glanced at the selections and chose a new release of a popular folk artist she always enjoyed listening to after live-wire nights at the casino.

Then she spread out the rudimentary sewing equipment that Susanna had produced from her own cache of supplies with an apologetic "I don't do much sewing."

Bree glanced at the household scissors, spools of black and white thread and bargain portable sewing machine and gave a mental shrug. Enough to get the job done.

Sinking onto the couch, she dragged the gown into her lap. "All right, what do we have here?"

This particular gown, a day dress with a roomy skirt and flowing jacket, wasn't one she'd originally worked on, but she recognized the pattern. A close inspection of the

seams confirmed her hope to refashion the waistline and cover the alterations with the jacket.

Since Toni would need to come up with a new design for the next pregnant woman to show up at Félicie Allée, she'd brought along a notebook to sketch and make notes.

"Now tell me what it is that brings you out here when you run away from New Orleans," Lucas asked.

"It's close."

When he didn't reply, she glanced up to find him frowning, clearly not considering her answer much of one.

"All right. I fell in love with the place during those school field trips. I'm partial to pirates, and it's like a different world down here. *And* it's close."

"Susanna and Olaf?"

"Met them through Toni. I recognized Susanna from the photo on the back of one of her books. Turns out I've been reading her for years. Now she autographs every book for me."

"What does she write?"

"Romances. Sexy historical ones."

Bree thought about Susanna's latest, a pirate tale that had been set in this very bayou, and made a mental note to thank her for the inspiration. When Bree had read that red-hot romance, she'd never dreamed of bringing her own sexy lover into the bayou. Now here she was.

And Lucas was infinitely sexy, she decided, watching him slide onto the floor to set up shop on the coffee table. It took an effort of will to drag her gaze back to the gown in her lap and slice through seams with Susanna's painfully dull stitch remover.

"So you're partial to pirates." Lucas glanced at her above his laptop display. "Understandable. Does being here remind you of the captain?"

"In a way, I guess. I was never as caught up in the whole ancestor thing as Tally, but I am fascinated by the era. I love the French Quarter and Plantation Alley. So much history."

"Your sister seems pretty caught up, too."

"She intends to see the captain get his due. Lafitte wasn't the only privateer around here."

"Finding that treasure was a coup."

"She'll put it to good use." Bree laughed softly, still amazed that Tally had done what she'd set out to do. Who knew? Maybe Bree should put a little more stock in her claims about the ghost. "She's had a lot more faith than I ever did."

"Why?"

"Color me more practical. I just can't seem to make the leap from treasures to ghosts."

And in all fairness, she'd had ample opportunity. Bree had watched her mother spend her life chasing a treasure and trying to capitalize on the family connection to the captain. The chase had crushed her mother's spirit, and the effects on their family hadn't been pretty.

Except for Tally finding the captain's treasure, nothing good had ever come from chasing rainbows, and that was a lesson Bree had learned the hard way.

But this wasn't anything she wanted to share with Lucas. He'd grown up in Court du Chaud, surrounded by the whole ghost myth along with others who'd lived there, yet he hadn't gotten sucked into any dysfunction. He hadn't given up his family or career to hunt treasure or prove ghosts existed. Even Josie, who was wrapped up in the krewe and the history of the court, channeled her energies in useful ways, as Tally was doing.

They lapsed into a silence filled with good music and

the rhythm of his fingers on the keyboard, a companionable moment. So many men would have insisted on her undivided attention, but Lucas rolled with the punches, enjoyed their time together. He wasn't turning out to be at all what Bree had expected, and she couldn't decide if that was good or not.

One thing she did know was that he wasn't the only one who could play twenty questions, so when he stopped typing and reached for the bottled water on the table, she asked, "What are you working on?"

"Deadbeat parents."

"What about them?"

"I'm creating software that will database them nationwide. With this program, a court in Miami can run a name and find out if a parent skipped out on payments in Paducah."

"Sounds useful."

"Only if the law-enforcement agency has the technology to run the program."

"I take it that means a lot of them don't."

"Not nearly enough."

She couldn't miss the resignation in his voice and wasn't surprised when he launched an explanation of the work he did on several national committees that pushed for legislation to obtain funding for state law-enforcement agencies.

It was a good cause and one Lucas obviously believed strongly in. And one that unexpectedly brought to mind Josie, who crusaded for so many causes of her own. Bree didn't have to be Josie's best friend to know she felt things passionately—her work for the krewe, Court du Chaud's homeowners association and, based on hearsay among their mutual acquaintances, her career in social work.

Lucas wrote software to help kids and single parents, but he saw loopholes in the system and wasn't afraid to lend his energy and time to try and effect changes where he saw a need. He obviously had enough faith to think he could change things, and she liked what that said about him.

Faith.

Something about that stopped her, and Bree couldn't help but think of Tally, who'd had enough faith to pursue the captain's treasure even though she'd had no reason to think she could succeed. Generation after generation might have talked about the existence of the treasure, but there'd been no proof. Even their own mother had tried and failed. Yet Tally had still believed.

And that belief had led to a buried treasure.

Bree had told Lucas she was practical, but she had to ask herself if she'd ever believed in anything the way he and Josie believed in their causes. The way Tally had believed in the treasure.

Had Bree ever allowed herself to believe in anything?

Glancing down at the gown in her hands, she tied off the last basting stitch on the seam, considering.

What did she believe in?

It took a moment to create a mental list, but there were things. She believed in keeping her family together, believed she deserved the promotion at work.

And when she poked the sewing needle into the pin cushion, Bree also believed in her sewing skill.

Inspecting the gown in her lap, she surveyed her work with a critical eye. She'd removed a flounce from the hem of the gown and refashioned it into a panel to expand the waistband and had managed to match the pattern repeat almost exactly. Now all she needed to do was stitch and press the gown to make sure the jacket would smooth the

lines of the expanded seams, and Susanna and Olaf's pregnant guest would have a perfectly altered gown.

She'd believed in her ability to accomplish this task, just as she'd believed in her ability enough to talk design with Toni Maxwell during a fateful conversation while Bree had been scouring the sale racks in Toni's boutique.

That belief had led to a job.

Okay, Bree felt better. While sewing wasn't as earth-moving as legislation for deadbeat parents or as dramatic as locating pirate treasures, keeping her family together was important.

Setting aside the gown, she grabbed the notebook to document the changes she'd made and must have been engrossed, because she didn't notice Lucas leaning over the table until they were practically face-to-face.

"What are you doing?" he asked.

"Sketching out the changes I've made for Toni. She'll need to see what I've done so she can figure out the way to tackle a maternity design for this time period."

"Looks like you did that already." His gaze darted between the sketch and the gown draped over the sofa. "Where did you learn to sew?"

Bree hesitated. Explaining how she'd learned by necessity, that sometimes she'd been so hard up for clothes she'd bought consignment and altered them to fit felt like too much personal information.

"Just something I've always liked to do."

It was an evasion, Bree knew, but she was suddenly fighting the impulse to flip over the notebook so Lucas would stop inspecting her work.

"The untalented one in the family, hmm?" he asked, but there was no missing the irony in his tone.

Bree just shrugged, feeling…exposed. It was stupid,

really. She shouldn't be comparing herself to anyone, shouldn't feel as if her crusades didn't measure up. Then again…when Bree thought about it, no one but Tally and Mark had ever seen her sketches.

And there it was again—that feeling.

Something about Lucas had her looking inside herself, wondering how she held up in his eyes. She shouldn't care what he thought about her beyond how good she was in bed….

Or in the spa and the kitchen, as it were.

She shouldn't feel she had to sidestep explanations about her past, about her family, about Jude, but she did.

And as Bree stared up into Lucas's face, into his expression warm with approval, Bree knew what was happening here—she cared what Lucas thought about her.

Whether she should or not.

LUCAS WAITED UNTIL Bree hung the hanger on the doorjamb—the only place high enough to accommodate the voluminous dress—then moved behind her and slipped his arms around her waist. "Looks like you're saving the day around here."

When she snuggled back against him, all her curves molding his in exactly the right places, life signs began in a languorous wave that told him while the hour might be late, the night was just beginning.

"Well, I don't know about that," she said lightly. "But I haven't seen you in a costume yet. I'd have thought a man who's been hanging around Krewe du Chaud long enough to know when Gator Bait was hatched wouldn't mind wearing one."

"Have zero problem with costumes. Have a big problem with getting dressed. I want you naked."

Tipping her head back, she peered full into his face. Her dark eyes flashed.

"Mmm. Ready for bed?"

"Yes."

The word burst from her lips on the edge of a breath, sending a sizzle through him that inspired him in ways he'd never been inspired before.

With one rush of motion, he hoisted her into his arms.

"Lucas!" she gasped out on another breath and folded her arms around his neck.

Her skin made contact with his and turned that sizzling into an open flame. Cradling her close, he inhaled deeply of her sultry, spicy scent and carried her from the room.

Bree had changed into a dress that barely reached the tops of her thighs. It was made of some clingy fabric that looked comfortable and left no curve to the imagination. He'd been imagining the variety of ways he could strip it off her.

Bringing her to the bed, he let her slide out of his arms slowly, enjoying the moment as she sluiced down his body. His throat constricted around a breath when she knelt before him on the bed, a living fantasy. He caught the clip in her hair and unfastened it, watching in awe as her glossy dark waves tumbled down around her bare shoulders.

The night before them filled with promise, and, without a word, he reached down and caught the hem of her dress. The fabric was just as soft beneath his fingers as he'd imagined it on her curves. Almost reverently he shimmied it up her body.

She was naked underneath.

He finally exhaled that breath as he took in her gol-

den beauty, the image of her stretched across the bed in his arms.

She seemed caught up in the promise of the moment, too, because she rested her hands lightly on his shoulders and arched backward, giving him a breathtaking view of her lush breasts and rosy nipples.

He couldn't resist touching, but the sight of her was almost overwhelming. He didn't know where to start. A dim part of his brain reasoned that they'd already gotten naked. They'd already made love. He shouldn't be so awestruck by the idea of touching her again.

But some instinct warned that Bree was unique, the only woman who would ever have this effect on him. Somehow he knew that touching her every time would be as momentous.

He'd honestly never given much thought to Josie's soul-mates theory before and had laughed when she'd sworn Max was hers, but with Bree kneeling before him, her bold beauty making desire pound inside him like the surf, Lucas found himself reconsidering.

What was it about her that made him tremble when he reached out to touch her? That made a simple touch send a current straight through his body?

She sighed as he cradled the soft fullness of her breasts in his palms, quivered when he thumbed her nipples, and he found himself determined to convince her that what they had could be special. Skimming his hands downward, he traced the V of her ribs, the trim waist, let his fingers caress the curve of her hips. He wanted to learn this woman by heart, wanted to understand why he felt as if he'd waited forever to touch her.

Wanted her to feel the same about him.

When she swayed forward to press a kiss on his

shoulder, Lucas thought he might get his wish. There was a tenderness about the moment, a familiarity that needed no words.

Bree might be a very private woman, might shield her feelings behind bold challenges and charming smiles, but he could sense her intensity. She was caught up in the power of the moment, too. And when she said, "Come to bed, Lucas," he forced himself to move, to turn off the light and slant the plantation shutters.

"I want to watch the moonlight play on your skin," he said.

"You make me feel beautiful when you look at me like this."

"You are beautiful." Such simple words. Words he knew she'd have heard before, but they were the right words for what he felt.

He was carried away by a need to stretch out beside her, to explore her at his leisure, to prove that he meant what he said and to understand why she made him feel so awed and so urgent. Dragging down his shorts, he kicked them away and joined her.

They'd shared the surprise of their attraction, the stunning newness of becoming acquainted. But now their need was laid bare. He wanted to convince Bree to open up, to explore the possibilities of what they might have found with each other, but he didn't want to come on too strong and scare her off.

What he felt was so intense.

There were no games in this moonlit darkness, only admission. He wanted. She wanted. It really was simple.

Bree pulled aside the bedding, and he slipped between the sheets, his body relaxing into the softness of cool silk. Without a word she settled into his arms, her long body

stretching out against his in a fluid motion, lithe curves unfolding, slim legs twining between his.

Their lovemaking in the spa had been the climax of the mounting tension since the night she'd dropped into his life, a rush of red-hot passions, a breathless exploration.

Now the intimacy of holding her close in the darkness humbled him. Bree lay in his arms as if she'd climbed into bed beside him forever, as if they belonged snuggling close with nothing but the bayou night and the moonlight between them.

Urgency yielded to the privilege of holding her, the freedom to bury his face in her hair and inhale deeply. Her fragrance tinged his every breath, and he knew a contentment just embracing her that made him feel content in a way he'd never known before.

She nestled her face in the crook of his shoulder with a sigh, no sense of impatience about her either. Her mouth parted softly around his pulse, a warm, velvet kiss, not of exploration but of welcome, of satisfaction.

She traced her fingers idly down his back, over his butt, as far as she could reach down his thigh. He felt no rush to respond in kind. He pressed his open palm into the curve of her waist to anchor her close. He let her explore at will, savoring the simplicity of the moment.

Two bodies close in the darkness.

Two souls recognizing each other.

Lucas had no good words for what he felt, the sense of awareness, the intimacy, just an unquestionable sense of completeness. But he knew that this was...*right*. And nothing else mattered when he held Bree. Not that they'd met only days ago. Not living on two coasts. Details.

Nothing mattered but holding her.

His desire began to build, the feeling mounting inside

of him and spreading to her. She began rocking her hips, a slow rhythm at first, as if she'd found a pleasure point and needed to feed the ache.

He matched her barely-there rhythm, their bodies swaying against each other like the ebb and flow of the tide.

There were no words, just need. No explanations, just the rightness of knowing they were meant to be together. Two bodies that recognized each other on some instinctive level. He wanted to kiss her, but every thought in his head, every cell in his body, was focused on the pleasure of their bodies, of the liquid heat building inside.

That need grew. His erection surged against her, nestled so enticingly against her smooth skin, stroked by each slow glide of her hips.

And Bree understood how potent his need, knew she could take control by just gliding her hand between them, slipping her warm fingers around his hot flesh.

She gave a slow, sexy pull, and his entire body gathered in reply, his erection surged in her grasp. Her throaty laughter filtered through him with a power that would have driven him to his knees had he been standing. He couldn't stop from rocking his hips and riding her warm grip, closing his eyes as sensation rolled through him.

Bree knew she had the power within her grasp and ran with it. Her fingers dragged another slow stroke, and as he was sucking air into his lungs to recover from the last jolt, she slipped her other hand between them to fondle his balls.

Lucas bucked unceremoniously, but there was no place to go. Their legs were entwined and their bodies clung together.

"Like that?" she whispered.

He dug his fingers into her firm backside, pulled their bodies close and trapped her hands between them. "Better make sure you can take what you dish out."

"Sounds like a threat."

She could still manipulate her fingers and gave his balls a squeeze.

He groaned.

She dragged her open mouth along his throat, kissing and nipping her way along his skin. Part of him wanted to flip her onto her back and feel her soft and yielding underneath him. The other part wanted to let go and let her have her sexy way.

Bree didn't give him a choice.

Nibbling her way along his collarbone, she bit him hard enough to make him tense. Almost instantly he realized that her maneuver had had the desired effect because he'd shifted enough for her to free her hands and start up a rhythm that answered the question about who was taking control.

She laughed throatily and dragged her tongue over his shoulder. She followed the rhythm of her hand with her hips to create a hunger that had him riding each sexy stroke as pleasure mounted inside.

Through the haze that forced out rational thought, he knew he wouldn't last long against this assault, so he braced himself against her, used his leg as leverage....

With one show of strength, he flipped her over. She unfolded underneath him, all supple curves and laughter.

"No fair," she protested. Her eyes glinted and her teeth flashed white in the darkness.

"Yes fair," he replied.

He lowered his face to catch a kiss, and their mouths

came together. He tangled his tongue around hers, explored the soft recesses of her mouth before pulling away. "You took me for a ride before. Now it's my turn. I want to feel you underneath me. I want to hear you sigh my name."

"Oh, Lucas."

He laughed, sinking between her thighs to lever his erection for a sultry stroke against her moist heat.

The move proved to be a double-edged one. She wrapped her legs around his waist to pull him closer, and he had to close his eyes to manage the onslaught. He could feel her everywhere, the need to take aim and sink inside her was overwhelming.

But Lucas wasn't ready for this night to be over by a long shot, so he levered himself up on an elbow and thumbed her pleasure point with lazy circles.

This time Bree wasn't laughing.

He started up his own rhythm, and suddenly her hands stilled and fell away. She raised her arms above her head and arched languorously, giving him a breathtaking view of her body.

"Like that?" he asked.

"Mm-hmm."

He stroked her until her thighs quivered in reply. "You do realize that two can play your game."

"What game? The one where you take unfair advantage by flipping me onto my back?"

"What's unfair? I was on my back in the spa."

"I liked you there."

"I like you here, too." He dropped a kiss onto one rosy nipple, smiled when she shivered. "Perfectly matched, wouldn't you say?"

But Bree wouldn't say anything—or couldn't, he sus-

pected—as she nestled against the pillows and closed her eyes.

The shutters fractured the moonlight and spilled slices of light across her beautiful body, and Lucas found himself as caught up in the vision she made as he was in the feel of her. She was languid and quiet, and he couldn't resist touching her everywhere.

Slithering down on the bed, he wedged his shoulders between her thighs.

"Lucas." She breathed his name on a sigh and arched in trembling reaction when his mouth zeroed in on his target.

He'd never known this sort of power—not power over Bree, but the power of pleasing her. He felt in tune with her every tremor, every hot clench of her sex as he speared his tongue inside her heat, and she responded to his touches with a wild boldness that charmed him.

His own need mounted when she began to ride his face in an enticing swaying, and he lost himself in the unfamiliar sights and sounds of her body as she rode him to pleasure. She cried out his name as her climax broke, and he tasted her orgasm in every shiver and spasm of her beautiful body.

Suddenly her hands were everywhere, his hair, his neck, his shoulders, as she tried to pull him into her embrace.

"Come here." Her voice held a breathless quality that made him smile, and he worked up her body with his mouth and his kisses, savoring the way she gasped along the way.

When he finally settled his hips between her thighs, he gazed down into her face. Her eyes were misty, her smile dreamy as she slipped her arms around his neck and offered her mouth for a kiss.

"Do you want to know what my new favorite thing is?" she asked.

"Yes." His reply was a soft gust against her lips as he resisted the urge to make her mouth his own, to take advantage of the closeness that left her exposed to him.

"Making love to you."

Her admission struck some chord deep inside, a physical reply that made him begin to vibrate from the inside out. He had no other answer than the need that ravaged the last of his restraint. With a low growl he claimed her mouth.

Taking aim, he sank deep. The world fell away. It was only him and this woman, a woman who taunted him with her bold daring, a woman who touched him in places that had never been brought to life.

Bree.

His consciousness narrowed to the feel of her wrapped around him, the way she lifted against him to meet each thrust. Together they rode this magic they made together, his body gathering with an urgency that fueled his strokes, met her demand with a demand of his own.

Excitement mounted, and her low moans broke against his lips as she neared the breaking point again, only this time when she went, she took him with her.

That was all Lucas knew. He had no idea how long he lay there holding her, feeling their heartbeats racing together, their ragged breathing filling the darkness, he only knew that he didn't want to let her go.

"I'm afraid you won't get to see me in that costume." His voice ground out a gravelly sound.

"Why's that?"

Rolling to his side, he took her with him. "Because you won't be leaving this cottage, so we don't have any reason to get dressed. What do you think about steak for breakfast?"

10

LANA CAUGHT BREE ON the floor just as Bree was heading out the door after her shift.

"Leaving alone tonight?" she asked.

Bree shrugged. "Appears that way."

"Well, you can't expect to have every gorgeous man panting after you, can you?" Lana tossed her bleached-blond locks over her shoulder and continued into the VIP lounge.

Bree watched her go, wondering what that was all about.

Lucas had wanted to pick her up after her shift ended, but as she didn't get off until 6:00 a.m., she'd insisted he get some sleep. After two days away, they'd be pulling double duty on the float today, and if he covered the early detail, she could actually catch some sleep, too. With a few hours apiece, they just might stand a chance at recovering.

To make love before her shift tonight.

She hadn't needed the ride anyway. Her brother had returned her car according to plans, so she'd driven herself to work tonight. Hopping into her Jeep, she waved to the bouncer who watched her leave the building. Backing out of the lot, she thought about all those long, luscious hours in bed with Lucas with his warm, hard body wrapped around her.

She hadn't been able to stop thinking about him all night, her thoughts bouncing between memories of stellar sex and plans for the remaining nights of his stay. It wasn't until the dancers had gone on stage in the show bar that Bree realized she had a problem.

No costume for the coronation ball.

Had she not finagled her way out of the ball, Josie would have made the arrangements for her costume. Toni Maxwell held Krewe du Chaud's business, compliments of Bree. In fact, she'd completed Tally's and Josie's costumes back before Christmas.

So in between coordinating Toujacques' security with her celebrity rich guy's private protection team so Mr. Rock Star could hit the Quarter, she'd debated her choices.

Unfortunately, she didn't have many.

There wasn't a costume shop within a hundred-mile radius of New Orleans that would have a decent costume available for rent. Bree considered calling Susanna. There was a surplus of period costumes at Southern Charm Mysteries that would suffice.

But Krewe du Chaud's coronation ball was all about the glitz and glam of the golden pirates' age. She'd look like the wilted butterfly in the dresses Félicie Allée's guests wore to their corporate training. The ball would be the climax of her time with Lucas, and she didn't want to *suffice*.

She wanted to shine.

Bree couldn't explain when it had happened, but sometime during the past two days things had changed.

Lucas would be leaving—that much was a given. But she didn't want him to just leave. She wanted to give him a fabulously incredible denouement that he'd never forget.

The way she wouldn't forget him.

She wanted to dress so that whenever Lucas closed his eyes, he'd be tortured by visions of her in her finery. It would be a fitting comeback to spending their days at Félicie Allée naked. And Bree so wanted to haunt the man's dreams.

The problem: the ball was only days away.

Even without her obligations to work and the krewe, the time frame would be a push. Not to mention that she had no intention of sacrificing one second of playtime with Lucas to create and sew a costume.

But the vision inside her head… This time there would be no forgetting what she was wearing.

Bree could already see the spectacular design, a fantasy of flowing lines and shimmering lace. A light color to highlight her darkness, of course. Maybe a pale yellow that would sparkle in the sun as they rode on the float and glow beneath the twinkling lights of the banquet hall at the coronation ball.

It would be particularly fitting since Lucas had first noticed her in a banquet hall.

The idea gained speed in her head as she drove out of the fading dawn, but it wasn't until she drove past Toni's boutique that she figured out a way to make her costume happen.

She was working on a costume for Toni…she'd already pieced and sewn the entire underskirt. With a few simple alterations, it could easily work for the dress she had in mind.

Which meant she would only be sewing half a dress.

Half might be doable. Especially if she could pilfer the accoutrements and trim from the supply closet in the krewe's den to save some more time. They stored all sorts of paraphernalia from Mardi Gras celebrations past. And

from what Toni had said, this customer wouldn't be wearing the gown until some summer Garden District masque anyway, which would give Bree plenty of time to remake the undergarment and lining.

Maybe she wouldn't sleep this morning, after all.

Casting a quick glance at Café Eros, Bree drove past an empty spot near Court du Chaud's alley and continued to Canal Street. If she hurried, she could drop by the den and see what she could come up with. She wouldn't get a chance later, not with Lucas there, and she wanted her dress to be a surprise.

The wharves were already up and running with shipping and deliveries as the sky faded to dawn. Even so, Bree found plenty of space on the street in front of their warehouse.

She didn't think that anyone from the krewe would be in to open up quite this early, and sure enough, the doors were all shut. She parked close to the entrance as a precaution and let herself inside.

Beelining straight for the security panel, she disabled the system, tapped on a few lights and headed back toward the workroom and the storage closets.

She knew exactly what she wanted—a tiara, the plaster jewels the krewe queen had worn last year and some of the glittery gold throws from the captain's talking Yo Ho Ho float. She could trim her lace with the filigreed beads— save herself more time—then return everything after the ball.

Striding around Gator Bait's tail, she felt excited and eager, when she should by all rights be passing out from exhaustion. It wasn't until she could see the silhouette of the dark doorway across the dimly lit expanse of the warehouse that she heard a sound behind her.

The sound brought her up short. Excitement dissolved like a bayou mist beneath the summer sun. Suddenly she could feel the darkness, a tangible thing that wound through all the shadowy places inside the warehouse and reminded her how alone she was.

Bree hadn't forgotten Jude was in town, not exactly, but when she heard the sound echo through the warehouse, a chill skated down her spine. Adrenaline turned ice into scalding heat.

There might be wharves filled with dockworkers all around, but none would hear her from inside this warehouse, no matter how loud she screamed.

Suddenly the massive shapes of the floats, pieces that were already being lined up for the parade, looked ominous and shadowy. Hiding places lurked in every nook and crevice, and she warned herself not to freak. The noise was probably nothing more than a big rat that had gotten inside. Or some jousts or beams settling somewhere overhead.

Bree might have bought it, too…but her instincts were on fire. She couldn't miss the scent of trouble, overpowering. Hurrying toward the workroom and the next light switch, she wove her way around another float, her feet leaden and clumsy in her near panic.

She imagined the sound of breathing in the shadows behind her, cursed her stupidity in coming to the warehouse before anyone else had shown up.

Stepping inside the workroom, she smacked at the light switch, but before her fingers connected, strong arms caught her, dragging her back against a rock-hard chest.

A scream slipped from her lips only to be cut short when those arms squeezed tight, the sort of strength that always stressed the differences between male and female.

"You look scared, *chère*." That bayou-sunset voice

sounded against her ear, a tone that rippled through her, familiar, lethal. "You were never afraid to be alone in the dark with me."

Fear shot down her spine in violent reply, dispelling the sensation as every muscle in her body paralyzed with surprise.

Alone in the dark with Jude.

No place she had ever wanted to be again.

Bree forced herself not to struggle. To show this man her fear would be to give him the upper hand and the opportunity to run roughshod all over her.

Never again. *Never.*

"What do you want, Jude?" She forced steel into her voice and was surprised to sound calm and in control. Her heartbeat drummed so hard in her ears she thought she might be sick.

"I was back in town, so I thought I'd say hello to my favorite girl."

My favorite girl.

Once upon a time, she'd melted at those words. Now they only sounded sleazy and manipulative.

"Let me go."

To her surprise, the arms bracing her close slackened and he took a step back.

Her breath had solidified in her lungs, but she forced herself to inhale a hard breath, to turn around, to face the man who'd once had so much control over her.

The years hadn't changed him. He had some new creases around his eyes, some deeper laugh lines around his mouth, but on Jude Robicheaux's face they only added character, made him even more startlingly beautiful, the kind of beautiful that made women stare like deer caught in the headlights.

He was dressed all in black, a color he'd always favored—the extremes, black and white, two sides of a coin, the outside and the inside, the good and the bad. Even in the shadows she could see the way the tailored shirt and slacks hung perfectly on his body, a physique as beautiful as the rest of him.

On the outside, anyway.

His translucent gaze traveled over her, taking her measure, his eyes caressing every inch of her in the way he'd once caressed her body, hot and possessive. If she hadn't known what a poker face this man had, she might have imagined something there, some fondness, some pleasure to see her again.

Jude had a poker face unlike any she'd ever seen.

"If you'd only wanted to say hello, you could have dropped by the house like a normal person," she said. "Not stalked me."

He gave a low whistle. "That's harsh, gorgeous."

"What do you call it then?"

"Casing the situation. I didn't want to knock on your door until I'd given you fair warning. You might have a husband and kids by now. I didn't want to drop by and screw things up if you didn't tell your husband about me."

A lie. He would know whether or not she was married. But the lie did what it was meant to—plant a seed. Of doubt, of control. She wasn't sure which. But she was convinced that he knew she hadn't told anyone he was back in town.

"I wanted to feel you out, gorgeous. After all, we parted under…unusual circumstances."

Unusual?

The word would have made her laugh had the situation not been so *un*funny. After trying to alienate her from

everyone and getting angry when she wouldn't leave her family to run off with him, he'd left her holding the bag for his misdeeds.

Unusual?

She'd wound up making statements against him to clear herself of any complicity, and she wanted to toss those facts in his face. But Bree knew better than to provoke him while they were alone in the dark.

She honestly didn't believe he would hurt her, not physically, but she reached out to grip the doorjamb to steady herself, to get her hand within proximity of the light switch. A measure of control. Not that light would protect her, and the darkness would probably work better if she decided to run.

The home-team advantage was hers in this warehouse.

But Bree wasn't going to run. She'd already set her plan with this man, wouldn't let him know he rattled her.

She wasn't the same girl he'd been involved with before, and now was as good a time as any to let him know it. "If you just wanted to say hello, Jude, then hello. Glad to see life's treating you well. I'm great, too. Take care. Goodbye."

She delivered that all on one breath—so much for not letting him know he'd rattled her.

He inclined his head in a gesture she knew so well, contemplative, keeping the balance of power on his side, and then he smiled, a dazzling smile that flashed through the darkness, a smile that had the power to blind.

"Have a nice life." She propelled herself away from the doorjamb. If he wouldn't leave, then she would.

But he lashed out and caught her face. His hand tightened around her jaw, his fingers digging into her cheeks, not quite hard enough to hurt but enough to stop her in her tracks.

In one fast move he crowded her against the wall, his body close, everything about him so intensely familiar and so utterly and completely *wrong*.

Bree recognized his scent, the faintly stubbled texture of his jaw, the angelic curve of his lips as he smiled down at her.

"Breanne," he drawled her name in that lazy bayou voice. "You're even more beautiful than I remembered."

"What do you want from me?" The question rushed out, almost a plea in the dark.

His gaze cut through her, and he opened his mouth—

"Yo, Bree, you in here?" another voice called out, startling the moment, making her jump.

Jude shot a gaze in the direction of the voice. Some part of her brain that could vaguely function past her spiked heart rate and throbbing pulse beat registered John's voice.

Jude's grip tightened, dragged her face to his. In that split second every muscle in her body galvanized as his mouth came down on hers hard, fast.

"I want you." He ground the words against her lips. Then he let her go and stepped into the shadows, disappearing as suddenly as he'd arrived.

"There you are." John suddenly appeared around Gator Bait's tail, his lanky silhouette backlit by the office lights.

"Found her, Lucas," he called out, then stopped and eyed her in surprise. "Hey, are you all right? You look like you've seen a ghost."

That might have been funny if she hadn't been shell-shocked. But she was. She was barely registering the fact that Lucas was here.

For a moment Bree could only stare, trying to shake off her daze. Should she tell John that Jude was on the loose?

Where was Lucas?

Turning, she found him emerging from the shadows by the Yo Ho Ho float.

He was frowning. "Bree, what happened?"

Striding toward her, he flipped on the light, and she blinked against the sudden glare to find herself staring into his emerald-hard eyes, a look she'd never seen before.

"Bree?" he prompted, peering around as though he was looking for a threat.

She opened her mouth to reply, but pride stopped her. Jude was long gone. If he'd wanted a confrontation, he'd never have taken off. He would have left her to introduce him to Lucas and John, to figure out some way to explain their relationship. Or he could have attacked both men with the element of surprise on his side.

But that wasn't Jude's game.

Without a doubt he was slinking out the same hole he'd arrived through, and she hated the thought of Lucas knowing she'd been involved with such a lowlife, was still involved with such a lowlife, although not by choice any longer.

She didn't want him thinking she couldn't stand up to Jude, that she didn't have the situation under control.

But did she really?

Suddenly Bree wasn't so sure. The only thing she knew for certain was that she didn't want to admit her past had returned to bite her in the ass. She didn't want to explain the gory details of Jude Robicheaux's involvement in her life.

Even Lana and Toujacques finding out suddenly didn't feel as important as Lucas spending their last few days together protecting her.

And that's exactly what he would do.

"No, everything's fine." It took every ounce of energy to force the words out. "I got it under control."

Lucas's gaze narrowed, searched her expression with eyes that tried to see inside.

"Are you sure, Bree?" John asked doubtfully. "We thought—"

"We thought you might need our help," Lucas cut him off. "But if you're okay…"

"Everything's under control. Trust me. I just dropped by to pick up some paste from the storeroom for the ball. I was hoping to work on my costume this morning."

So much for that surprise.

She'd had enough surprises for one day, thank you.

LUCAS WATCHED BREE closely, unsure if she was lying to him or to herself. From where he was standing it didn't look as if she had anything under control. He'd seen the car parked beside hers outside. John hadn't recognized the car as one belonging to a krewe member, so Lucas had glanced at the tag. A rental.

The light revealed the faint red marks on her cheeks— marks made by someone's fingers. Yet she smiled up at Lucas with that beguiling smile and told them nothing was wrong.

John seemed willing to accept whatever she told him.

Lucas wasn't.

He stared into her face, the intimacies of the past few days shielded behind an expression that masked everything she was thinking inside that beautiful head, the truth about those marks on her face hidden behind a smile.

But he could see past the mask. Two days with this woman, and he recognized the wild light in her eyes, the way she shifted her weight from one foot to the other.

She was agitated, big-time.

Lucas felt in tune with Bree in a way he'd never been with anyone else, and when she launched herself into motion as if she couldn't stand still another second, he knew everything was wrong and she wanted to hide it.

"I'll be back," he said.

"Don't go," she said quickly. "I need help getting some things from the storeroom. That's why I'm here."

"I'm just going to take a look around."

"Lucas—"

"John will give you a hand. I'll be right there."

Lucas didn't give her a chance to reply but took off. He walked the perimeter of the warehouse, between the floats, searching for anyone who might be crouching in the shadows, someone who might have left those finger marks on Bree's cheeks.

After reaching the offices, he peered through the vertical blinds to see that, as expected, the rental sedan was gone. He spotted a caddy with paper and pens on the desk, helped himself and jotted down the tag number before he forgot.

Then, satisfied they were alone inside the den, he headed back to the storeroom. He found Bree buried inside, with John standing sentinel outside the door, chatting about her plans to attend the coronation ball.

"Tally told us that you'd changed your mind and were coming," John was saying. "I'm glad. You worked so hard on the float and the costumes. You'd be missed if you weren't there."

John wore his heart on his sleeve, and Lucas squelched an unfamiliar irritation that had him scrutinizing the over-eager look on the kid's face, how he blocked the doorway so Bree couldn't get out without passing mighty close.

When Bree caught sight of him, she asked, "You okay?"

He only nodded, feeling anything but. He wanted answers, but Bree was keeping them to herself.

And he didn't have the right to demand any.

"So what brings you two by so early this morning?" she asked, obviously having had enough time to regain her balance.

"John and I wanted to discuss a volunteer venture for the krewe before we got started on the electrical system."

"Really? Is this top secret or can you tell me?"

John laughed. "It's not top secret, but we haven't told anyone yet. Kind of need to take it to the board first."

"Got it." Bree made a cross over her heart, then pressed a finger to her lips. "What if I promise I won't breathe a word?"

"Not even to Tally?"

"Scout's honor."

John darted a glance Lucas's way. "I wrote a program for a video game about the captain. Lucas thought we could sell them and give the proceeds to the krewe. Great idea, huh?"

"Just a guess, but Lucas's company would manufacture the game?"

Lucas nodded.

"Well, then, I think it's a great idea. Josie is always looking for new ways to raise money."

John beamed and Lucas watched as Bree gathered an armful of beads and jewels and maneuvered herself around to stand. Lucas brushed John aside and grabbed her arm to give her leverage. She peered up at him beneath her lashes and smiled.

The finger marks had faded completely.

Backing out of the storeroom, he felt his pulse accelerate when Bree rose up on tiptoes to kiss him. "Good morning."

"So what are you wearing to the ball, Lucas?" John asked.

"What are you wearing to the ball?" Bree repeated. "I know you won't find a costume anywhere in this town."

"I've got stuff in Josie's attic."

"Your mom the pack rat, hmm?"

He nodded and helped Bree grab a box off a nearby shelf. "What about you? Didn't give you a problem, did I?"

"That's why I'm here. I'm working on something." She transferred all the bright jewels and a tiara into the box and said, "Well, that's it for me, gentlemen. I'm beat. I'll be back again at noon, if anyone asks."

"I'll walk you out." Lucas took the box from her.

"See you later, John," she said.

"'Bye, Bree," the kid called back, and this time Lucas definitely heard a sigh.

Bree looked contemplative but completely recovered as they wove through the warehouse, and if he hadn't seen the marks on her cheeks or the car in the parking lot, Lucas might have second-guessed himself. But someone had been inside the den with her this morning, and he intended to find out who.

"Have a good night?" he asked.

"Same old, same old. How about you? Get some sleep?" Her smile flashed, and he felt that same punch-to-the-gut awareness that he always did, that same rush of need that made him want to pull her into his arms.

But now there was something else, a sense of possessiveness that felt both raw and defensive, as he watched

her unlock her car door, take the box from him and deposit it on the seat.

He wanted a straight answer but could come up with no way to get her to be honest. He could confront her about the car he'd seen in the parking lot but wondered if he'd only force her to lie. He might have made love to Bree, but he was only a temporary part of her life. This whole situation had driven home that point loud and clear.

Unsure how to handle the situation, Lucas only knew he didn't want her to go home alone and felt powerless to stop her. He'd seen Christien's and Tally's cars parked on the street when he'd left the court not twenty minutes ago. That meant Tally would be sleeping off her night at the Blue Note, Christien was off duty and Mark was back from his girlfriend's. Bree wouldn't be alone in Number One. It would have to do.

But it wasn't enough, he realized. Not nearly enough.

"Are you heading straight home?" he asked.

"Uh-huh. There's a bed with my name on it." Slipping her arms around his neck, she pressed close. "Wish you were going with me."

He just pulled her close and caught her mouth in a kiss.

She melted against him, all warm and wanting. Their tongues collided as if they hadn't been together in forever, a rush of need so intense he might have lost himself in the taste and feel of her…if he wasn't so troubled by the morning's events.

"I'll try to get this electrical situation resolved today so I won't have to come back early tomorrow," he said. "You're coming back at noon? I'll come get you."

"Are you sure?"

"I'm sure. We'll get dinner and I'll drop you off at work for your shift."

She eyed him as if she might argue, but something in his expression must have convinced her he'd made up his mind.

"It's a date." She slipped inside her car and blew him a kiss. "See you later."

He shut the door and watched her back out.

Lucas was still standing there as she pulled into the street and disappeared in the traffic.

The only thing he knew for certain was that whatever was going on in her life, Bree didn't have it under control.

Maybe she didn't want to involve him because they'd only signed up for a weeklong fling. But things were changing between them. He wasn't sure what that meant to their relationship yet…he only knew that there'd been someone in that warehouse who'd touched her hard enough to leave marks. And that didn't really leave him a choice about what he would do next.

Lucas had made his reputation by combining his interests in law enforcement and computer technology. He'd rewritten the software for the National Crime Information Database, which collected and dispatched information on felons and stolen items to the FBI and other agencies around the country. He'd founded his company developing programs used to track sex offenders, missing children and deadbeat parents.

If Bree wouldn't pony up, Lucas would find out what was going on for himself.

11

WHEN THE SIGHT OF Lucas vanished from her rearview mirror, the events of the morning finally overtook Bree. Exhaustion, stress and anger combined to make her insides vibrate, her hands tremble on the steering wheel.

She sucked in deep gulps of air to fight the dizziness clouding the edges of her vision, to focus on the road as the car in front of her braked unexpectedly in a flash of bright taillights.

Bringing the Jeep to a quick stop, she willed herself to control her physical reaction.

Jude Robicheaux would get nothing else from her.

Nothing, damn it.

She'd cried enough tears when the man had skipped town, leaving her to hold the bag with the police.

Touching the gas pedal, she brought her car up to speed again, forcing herself to concentrate on the early-morning traffic and wishing she was already home.

It wasn't so much seeing Jude that upset her—although she still didn't know what he wanted—but that ugly reality had intruded on her perfectly idyllic week with Lucas.

He'd known something was wrong, had wanted to know what, and she'd sidestepped the issue again.

But involving Lucas would only invite him to get his macho-man hackles up. She wanted the man's passion, his

respect. No matter how much she'd enjoyed his whole knight-in-the-skimpy-towel routine, she didn't want him charging in on his horse to save her for their remaining days together. She wasn't a damsel in distress. She was perfectly capable of handling Jude.

Should she go to the police, forget about waiting?

Bree considered it, found to her surprise that she was more bothered by letting Jude know he'd rattled her than she was by the thought of Lana and Toujacques finding out about her past.

The bastard had been so smug. She didn't want him thinking she was the same girl who'd once fallen for his every line. She wasn't. She was a woman who wasn't letting any man bully her.

And shutting out a man she cared about in the process. "Argh!"

Wheeling her Jeep into an open spot on the street, Bree glanced around to ensure there were no surprises waiting before she unlocked her door and stepped out.

Here she was trying to convince herself that she could handle the situation when she didn't know what to do about Jude—go to the police now or wait two days?

She didn't know what to do about Lucas either. Should she spill her guts and let the pieces fall where they may? And what did it matter, really? He was leaving in two days anyway.

The bottom line: Bree didn't have a clue.

The only thing she knew was how much she hated walking down the alley to her home feeling as if someone was watching her. Just the slightest sound had her glancing back over her shoulder to see who might be there.

A week ago she'd felt safe in Court du Chaud.

Now she wanted to rush inside her house and turn on the security system.

Bree didn't get the chance. When she reached for the doorknob, she found her outer door unlocked.

She and Tally always locked the door. Mark and Christien, too, at their request. Instinct would have sent her backing away, but she caught a glimpse of wild color inside and pushed the door open warily.

A massive arrangement of hothouse flowers sat in front of her door. Had it not been for the unlocked outer door, she might have thought the gorgeous arrangement a surprise from Lucas.

But the adrenaline rush told her differently.

Her fingers trembled as she reached for the card.

The love of your life.

Bree crumbled the card. This day was crashing from bad to worse, and that was saying a lot. She had a hard time imagining anything worse than facing Jude inside a dark den and pretending to Lucas that everything was A-okay.

Now Jude was declaring open war. He must have run straight from the den for the flowers. At the French Market probably, because not too many floral shops opened before nine.

This was his first step out into the open, and she knew he wanted to intimidate her. If Lucas had been with her when she'd arrived home or if Tally, Mark or Christien had chanced across the flowers, she'd have been hard-pressed to explain who'd sent the obviously costly arrangement.

She didn't have to think twice about what she was going to do with the flowers. Setting her small box of costume paste on the floor, she collected the arrangement and headed outside, groaning beneath the weight of the

ceramic bowl filled with the surplus of tropical blooms and lush greenery.

The overpowering scents of stargazer lilies and hydrangeas mingled sweet and thick beneath her nose, fragrances she normally adored that now only made her head throb.

Maneuvering out her gate, she headed into the court.

"He will not ruin my last few days with Lucas," she said, needing to hear the sound of her own renewed determination.

"STUBBORN CHIT!" GABRIEL spat out the words from his seat on the piazza's hedge. "What in God's name is she doing?"

Unfortunately Breanne did not have to answer the question for Gabriel to piece together a general idea. Instead of running to Lucas for protection against this man from her past, she was stubbornly dealing with it herself.

Damn! Just how was he supposed to convince her otherwise when he couldn't materialize and talk some sense into her?

Ambition before love.

Oy! What was a ghost to do?

Belle grand-mère expected him to fail at this task, and he found, much to his surprise, that along with the host of other reasons he could not fail, proving to the old crone he was not as inept and corrupt as she believed was one of them.

One would think after two centuries pride wouldn't matter. Alas, it appeared to be his cross to bear, in life and in death.

Gabriel launched himself from his seat to follow

Breanne across the court, racking his brain for some way to warn her that her old beau was up to no good.

Parting ways with Breanne as she circled her yard, Gabriel swept inside her second-story bedroom and stood beside the window, listening to the sounds of her entering downstairs.

He mulled his too-limited choices, even considered a few ideas the old crone had tossed his way—how desperate had he become to consider anything that one had to say?—and found himself back to cursing his stupidity for not realizing he could only materialize to two people.

Breanne's arrival distracted him from his self-pitying thoughts, and Gabriel watched as she withdrew clothes from her dresser and retreated into the bathroom. She looked tired, her aura the bleached gray of old timbers.

On her arrival home yesterday she had looked equally tired but so very content. Her aura had brightened from lifeless gray to a blue-gray color that reminded him of the sea at sunset. He wanted to see her aura gleam as bright as the summer sky—the way her twin's did.

In life, Gabriel had not understood how much another's pain could hurt. He'd been unable to see past his pride enough to care how things affected anyone but himself. In death, the dull aura of this strong and beautiful young woman and the melancholy that clung to her like a mist ached inside him.

If nothing else in two hundred years of limbo, he had learned to feel. He supposed he could thank the old crone for that.

When Breanne emerged from the bathroom garbed in a pair of men's pajamas, Gabriel watched her pull her hair into a tousled nest on the top of her head and secure it with some sort of clip.

The lines of her face and neck were drawn delicately, and her features were both graceful and refined. He found himself amazed that after so many generations he could still see his exquisite Madeleine in their lovely descendent.

Ah, Madeleine.

How much would he give for a chance to hold her once more in his arms, to apologize for being the ass he was?

Gabriel knew, as he watched this sad young girl who was but one in the strong and amazing bloodline they had created together, that he would gladly give another two centuries of eternity.

No, he would give it all.

His ever after for the peace of knowing Madeleine understood he had not left because he had not loved her seemed a small price to pay. He had loved her. More than life itself. But he hadn't understood love, nor had he known how to show her. He hadn't truly believed she would give up her life to be with him because he had not believed himself worthy of her love.

Damn his pride!

Had he believed, had he trusted, he might have chosen the same path as Julian Lafever. Alas, it had taken two hundred years and a pair of headstrong twins to help him see the truth.

And one nagging old crone who had loved enough to sacrifice her own eternity to curse/bless their whole family.

But now he understood. He had brought this fate upon himself with his pride and blindness.

Only he could make amends.

But the task before him still seemed impossible as he watched Breanne draw her knees up under the covers and make notations with a writing tool in her book.

She had not bothered drawing the curtains, and he gazed down into the street that was coming to life with daytime activity, stared at her car with the mysterious technological device that worried him and knew that if he accomplished nothing else in his death, he must find a way to reach this girl.

Finally setting the book aside, Breanne slipped under the blankets and snuggled into her pillows with a sigh. Gabriel glanced at the book she had left open on her night table. Some sort of journal. He stared at it and frowned, something niggling at the back of his brain....

Then inspiration struck.

Why had he not thought of this before?

Would that he could prove to *belle grand-mère* even parlor tricks could serve a noble purpose. What nobler purpose was there than warning their headstrong descendent of danger?

UNDER THE PRETENSE of taking a lunch break, Lucas left the den. Hopping inside Max's car, he wove through traffic to a nearby riverfront park, where he found a picnic table and unpacked his laptop computer.

He logged on to the Web via satellite uplink and maneuvered his way to the Orleans Parish law-enforcement Web site to run an active search of violators.

He typed in Bree's name, race and age, then waited.

No match found.

The reply blinked on the screen in bold text, and while he hadn't expected to find any prior criminal record or outstanding warrants on her, he wasn't sure that he wouldn't find a restraining order on file against someone else— someone who would leave marks on her face.

That was the name he wanted.

There was nothing in Bree's character to lead him to believe she would have been involved in some sort of domestic abuse or with some unsavory character.

When he Googled her name, he came up empty again, so, flipping open his cell phone, Lucas speed-dialed his personal assistant, Lorelei, who answered on the second ring.

"Well, hello, stranger," her cheery voice rang out over the connection. "You ever coming home?"

"Verdict's still out. You ever think of relocating to New Orleans?"

"Only if there are more good-looking single men than available women."

Lucas laughed. After going through a nasty divorce last year, Lorelei had recently declared her mourning period over. In her midthirties, she was attractive and incredibly efficient, with a biological clock admittedly ticking louder each day.

"I'll check while I'm here," he offered. One thing was for sure, he wouldn't let Lorelei get away. She was the reason he could work in riverfront parks and on Pacific bluffs and extend vacations long past his return flights. "I need Shawn Danko's direct line."

Shawn Danko was Lucas's contact person with the FBI, an associate deputy director he'd worked with while rewriting the software for the National Crime Information Database.

As with all his contacts, Lucas didn't travel with private numbers. He preferred the safety of his encrypted software inside his office. Client confidentiality. Wouldn't do to have his laptop stolen and some overeager hacker break his encrypted algorithms to find the private numbers of seriously top-level names in the nation's law-enforcement agencies.

Lorelei sent it via encryption directly to Lucas's laptop, and when his e-mail server flag popped up, he said, "I'll give you a call if I run across Mr. Right."

He severed the connection and dialed Shawn Danko.

"Why do I know you must want something from me, Russell?" the associate deputy director asked gruffly.

"Your balls are itching?"

"That and you don't call to chat out of the blue."

"I need you to run someone through our baby. Unless you want to provide the protocols so I can do it myself."

"Oh, you're a laugh a minute. Let me get there." During the pause, Lucas could hear the muffled sounds of a busy office. Then everything went quiet, as if Shawn had made it to his office and shut the door behind him. "All right, go."

"Breanne Addison. Provide a search string for the parishes around New Orleans. I want to know if she comes up anywhere in the system."

"You know what's coming next."

"Yeah, yeah. I have only the most honorable of intentions."

"How honorable? You're asking me to lay my job on the line by abusing my security clearance."

"You're an associate deputy director, and I wrote the program. That's got to count for something."

"Only if you give me a damn good reason."

Lucas stared out at the river, where a bayou cruise boat pulled away from the dock, and voiced a truth that felt both strange and right. "I'm getting involved with this incredible woman and I think she's in trouble."

Shawn snorted. "*Involved? Incredible?* Shit, Russell. You're the one in trouble."

"No argument there."

There was a beat of silence on the other end. "Well, not even national security can stand in the way of love, and I'd know, having been married…how many times is it now?"

"Four the last I heard."

"Big trouble, buddy. Sure hope she's worth it."

"She is."

"Then hang on and let me see what comes up. You won't mind if I don't want to leave an electronic trail?"

"Not a bit."

The line went silent, and Lucas watched a bayou cruise boat maneuver past a tourist steamer that sat at anchor waiting for the lunch crowd to disembark from the two-hour-long ride. Across the river he could see an industrial barge emerging from under the bridge.

Business as usual on the Mississippi. The whole scene struck a familiar and long-forgotten chord inside him. He'd grown up next to this river, sailing and fishing with his folks and Max, watching the banks change and grow as the years passed.

Lucas had visited home often over the years since he'd left, so how come he hadn't missed the place until now?

Or did this feeling have more to do with meeting the woman who made him feel as if he'd come home?

Only a few minutes passed before Shawn came back on the line. "You got something. Orleans Parish. Three years ago."

Lucas stared out into the busy river, the noon sun glinting off the water, sparking flashes on the muddy current, while Shawn relayed a list of priors from a local con man.

"Small-fry organized crime. Racketeering, commercialized vice, illegal gambling. Nothing stuck until three

years ago when some gaming scam he was running went south. He skipped town and left behind your girl to take the heat."

"Was she involved?"

"They didn't cut her any slack, from what I can see. They wanted her ex in a big way and the investigation went on for months. She came up squeaky-clean. You've heard it all before. Young girl gets involved with a high-rolling loser. You wrote the program to track down the losers, remember?"

But they were talking about Bree here. "Who's the bum?"

"You know what I want to hear."

"Yeah, yeah. I have only honorable intentions."

"No thoughts about revenge? Defending the lady's honor or any other crazy shit like that?"

"Just want to protect her. I think this guy might be back in town."

"If he is, you go to NOPD. There's a warrant."

"Scout's honor."

There was a beat of silence. "The name's Jude Robicheaux."

"I'll take it from here, Shawn. Thanks. I owe you."

"Naw. You bailed my ass out when the system started glitching before the conference."

"So I did."

"But, Russell, let's call it square. Make sure your name doesn't cross my desk because my people are tracking you in and out of places where you shouldn't be."

"Ouch. You know me better than that."

Laughter resounded over the line. "Hence the warning."

Lucas let the subject drop. Shawn knew firsthand the range of Lucas's skills, and he'd be lying to say he didn't intend to use them.

"Nothing stupid, buddy," Shawn said. "Love is blind."

"That's your jaded past talking."

"Watch your ass."

"You know it." Lucas disconnected the call.

Bree hadn't said much about her past, but from what she had said and from the few things Josie had mentioned, he guessed her upbringing had been pretty hardscrabble.

Despite what he'd told Shawn, prying into her past went against his grain. He would have preferred to let nature take its course and have Bree open up to him if and when she chose.

But they were working on a limited time frame here, and he couldn't get past the memory of the healing scratches on her legs and the finger marks on her beautiful face.

His gut was on fire. She wasn't sharing what was going on. Something was holding her back from involving him, and he didn't know how to get her to open up and trust him. Maybe she figured he'd be gone soon and there was no point. Maybe she hadn't connected with him the way he had with her, but Lucas didn't think so.

They might not have discussed anything beyond the coronation ball, but what they'd found together was special. He knew it. He would believe Bree knew it, too.

He respected the fact that she might not be ready to share all her secrets, but if she was in danger, then all bets were off. He wasn't going to sit by and do nothing, which meant he needed to know more about Jude Robicheaux.

He knew just the place to begin.

If Lucas's laptop were a car, it would be a NASCAR-worthy racer. With his own custom software, cutting-edge technology and a satellite uplink, he could run just about any program from anywhere. Right now he was on a

search expedition to locate the registrant of a certain tag number.

Dismissing Shawn's warning about venturing into off-limits systems, he hacked his way into the motor vehicle registry.

Bingo. It didn't prove much of a test to get the name of the rental-car agency or to cover his cybertracks. Even less to access the records from the rental-car company. He started running names of customers starting the day before Bree had come over his wall.

Harold R. Smith.

The name was common, but except for a social security and credit card number, this Harold R. Smith didn't appear to exist. Once Lucas began running those numbers through various government databases, the bogus social security number proved a dead end, but the credit card number led to a phony company, which turned up a winding money trail that did an admirable job at hiding the real name of the man behind the alias.

Looked like Jude Robicheaux was back in town.

12

BREE'S ALARM BLARED a static-filled tune, blasting open gritty eyes to be blinded by the sunlight streaming through the window. Jolting upright, she clumsily jabbed at the alarm to halt the racket. Not enough sleep. Not by a long shot.

When she finally managed to sit up and swing her legs around in an attempt to stand, she stepped on something thin and hard. She squinted through heavy eyelids to find a pen, which had apparently rolled off her night table onto her floor.

With a protracted sigh she leaned over to grab it, hoping to shake off this stupor in the shower. Not only was she obligated to devote a few hours to the krewe since everyone was busting their butts to get ready, but she needed to get her ball gown pieced to take along with her to work tonight so she could sew on her break.

It wasn't until replacing the pen that she noticed her day planner wasn't open to the daily calendar where she'd left it. Now the journal was open to the section in the very back filled with blank pages for miscellaneous notes. Odd. The pages were no longer blank. Unfamiliar handwriting ran across both sides of the pages.

Bree's first thought was that a coworker had gotten a hold of her day planner and written a message as a joke.

Except Bree kept the book locked inside her locker.

Her gaze darted to the security system panel beside her bedroom door. Goose bumps sprayed along her skin in an icy wash of premonition. But the display glowed red for both the upper and lower quadrants.

No one had visited since she'd gone to sleep.

With her instincts soaring to life, she glanced back at the book, at the fine writing, almost afraid to read what was written there.

Breanne,
'Twas never my intent to write. I had meant to speak with you personally as I spoke with your twin. Alas, I find myself reduced to writing, a sorry result of my lack of foresight and the unyielding limitations of both death and the curse that has burdened our family for generations....

"Oof!" Bree cried. She'd been leaning forward so far to read the words that she slipped off the side of her bed and landed hard on the floor.

She scrambled to her feet in an instant, any trace of drowsiness gone. Shooting a nervous gaze around the room, she forced herself to breathe past her throbbing heartbeat.

The curse?

Was this some sort of practical joke? Tally had the security codes, could easily have visited while Bree had slept. That thought propelled her across the room, and she punched in her access codes to pull up the program display.

Four forty-three.

The alarm had been engaged since she'd set it upon going to bed nearly five hours ago. Tally hadn't visited.

Now Bree forced her gaze back to the day planner when every instinct screamed for her to bolt from the room.

Not only does the task fall on me to break this curse once and for all, but I must now warn you of a threat.

While you were away with Lucas, I witnessed a dark-haired man tampering with your car outside in the street. I tried to awaken Mark to send this rogue fleeing, but, alas, he sleeps with the vigor of youth and the passion of a Dampier. Regrettably I am limited to mere parlor tricks in my efforts to make contact with the living world.

This fellow placed some device beneath your car. I do not know what sort, as I am also limited by the physical boundaries of this court, but I fear for your safety.

Heed my words, Breanne! Find this device and avoid this man at all costs. He has a soul so dark I fear he will not be easily redeemed in the afterlife.

Bree had forgotten to breathe again and gazed down at the signature, that breath lodged in her throat, every instinct disbelieving as she read: *Captain Gabriel Dampier.*

"Whoa!"

The word shot from her lips on a panicked laugh as she leaped back from the night table as if her day planner might jump up and bite her.

She laughed again, a nerved-out, desperate sound.

This had to be some trick of Jude's.

But how? And why would he warn her about a device he'd planted in her car?

It simply didn't make sense. She wasn't Tally, who could make the leap of faith to believe a ghost had contacted her. She wasn't her mother, who could spend her lifetime wishing a ghost would.

Bree was the practical one, and, clinging to that thought, she forced herself to think practically now.

No one had disabled her security system in the nearly five hours since she'd gone to sleep.

Fact.

Someone could have written in her day planner before today. Maybe not at work while it had been locked away, but Bree didn't carry the thing around with her 24/7.

Fact.

She also hadn't checked the blank note pages to see if anyone had written on them—she never used the note pages.

Fact.

The note claimed a dark-haired man had placed a device under her car.

Easy enough to find out.

Darting toward her dresser, Bree dragged the pajamas off and pulled on sweats. She raced downstairs, heart thumping in time with each step, and disabled her security. Pulling her car keys off a rack beside her front door, she bolted out into the court, not realizing that she'd forgotten to put on any shoes until her feet hit the pavement.

Her Jeep sat on the street, under her balcony, accessible to anyone who might happen along. She used a Club device to lock the steering column as a deterrent to car thieves and she'd never had any trouble since her move to Court du Chaud.

Now she had the urge to hop in her car and drive away. She could sense eyes upon her, hated the thought of Jude lurking in the shadows as she checked out her Jeep.

But she damn sure wasn't getting in and driving anywhere when those words in her day planner played over again and over again in her head.

I fear for your safety.

Kneeling on the curb, she ran her hand under the body as far in as she could reach.

Nothing.

Following the line of her chassis, she worked her way around the front end, fighting off that feeling of unseen eyes on her, reminding herself that if Jude had wanted to hurt her, he easily could have already.

But some part of her resisted that thought. Jude was a lot of things, but she still didn't think he'd come here to hurt her. Perhaps some pathetic part of her needed to believe he'd cared for her in his own dysfunctional way, that she'd meant something to him at some point, that their whole relationship hadn't been a total lie.

How sad was that?

Bree didn't want an answer to the question as she was on her knees under her car trying to find out what Jude had done.

Again. When her fingers caught on something behind the tire on the driver's side, Bree gingerly grazed the square shape, tried to figure out what it might be.

The wild thought that detonating devices could be so tiny sprang to mind, but she couldn't shake the thought that if Jude had wanted her dead, he would have never made contact with her.

No, Jude wanted something.

Squeezing her eyes tightly shut, she tugged until the device came free. The second she saw the tiny electronic instrument, Bree knew what it was.

A global positioning system.

Her legs turned to rubber, and it was a good thing she was already close to the ground or she might have sunk to her knees. She didn't dare give in to the sensation, though, and forced herself to depress the lock on her key fob, stand up and head back down the alley.

Here she'd thought Jude must have followed her to the den this morning, but it looked as though he'd been tracking her via satellite signal.

Her only consolation was that he hadn't been tracking her for long. Mark had only returned home the night before she and Lucas had. The letter in her day planner had said…

The letter.

Why would Jude have clued her in that he'd hidden a tracking device on her car?

When would Jude have gotten a hold of her day planner to write that note?

The logic didn't work, but neither did the only other explanation she had right now.

Captain Gabriel Dampier.

"No, no, no! That's crazy!" She threw the device across the street so hard it pinged against the gate of the music store.

Then she wheeled around….

And found herself staring at Madame Alain.

"Bree, honey, are you all right?" the older woman asked solicitously, her gaze dropping pointedly to Bree's bare feet.

"I, um…yes, I'm fine, Madame Alain. How nice to run into you."

What freaking bad luck to run into her!

Madame Alain was a nice old lady, even if loneliness had turned her into sort of the court busybody. She'd lived

here for well over half a century, and during the past few years she'd lost her husband and her other longtime friends, including Bree's uncle Guidry and the lady from Number Seventeen.

Bree knew she must look like a train wreck with her bed head and no makeup, a raving madwoman, which is basically what she was right now. She hadn't needed Madame Alain to notice. Bree could just hear the woman now.

Do you have any idea why the twin in Number One would be running around in the middle of the day like she'd just jumped out of bed? She looked upset. Any idea why she'd be upset?

No doubt the questions would be flying through the court by dinnertime.

"You're sure you're all right, my dear? You look flustered."

Argh!

"I'm fine, Madame Alain. Really. I was just working out. Then I wanted to do Pilates, but I couldn't find my video. I've got the greatest workout video. I thought I might have left it in my car, but I didn't. Tally must have borrowed it." She sidestepped the woman with a wave. "You have a nice day."

She could feel Madame Alain's gaze on her, no question, and sure enough, she didn't get far before that tremulous voice rang out, "Wait a minute. I want to say thanks for the flowers."

"Enjoy them," Bree called back over her shoulder before racing back down her walkway.

She didn't stop until she'd made it inside her house and upstairs to where her day planner still sat innocuously on the night table. Staring hard at the message, Bree willed

herself to concentrate, to detect any hint of the handwriting that she'd been so familiar with long ago.

If Jude had sent this message, he'd had someone else write it for him, because it simply wasn't familiar. But the more she stared, the more Bree noticed something else odd.

The letters scrawled boldly across the pages, but the way the ink faded, grew darker, then faded again gave her the impression the writer hadn't used steady pressure with the pen. Had someone tried to mask familiar handwriting?

Or had a ghost had trouble holding a pen?

Argh!

Bree loved her sister more than anything. For so long it had been just the two of them against the world, the two of them shouldering responsibilities that had felt heavier than they could handle alone. She would never have called Tally crazy no matter what crazy things came out of her sister's mouth.

But Bree hadn't believed Tally when she'd claimed to see their pirate ancestor. She'd thought Tally was simply too caught up in the treasure hunt, too head over heels with Christien.

It wasn't even that she didn't believe in ghosts; Bree had never really considered them. Not seriously. Of course she'd taken all the late-night tours through the French Quarter with her girlfriends while growing up, had heard all the stories of hauntings in the Ursuline convent and in the various buildings where murder victims routinely appeared to protest their deaths.

But she'd never seen a thing in all her life to lead her to believe all those gris-gris-wielding priests and priestesses in the Quarter were real.

"There is no such thing as a ghost!" she cried out to no

one in particular, stubbornly, desperately refusing to consider something so ridiculous.

But then, as she stood there alone, her day planner shifted of its own accord and pitched off the night table.

Followed by the alarm clock.

And the lamp.

By the time a pillow flew off her bed, Bree had already backed up against the wall, her heart lodged in her throat.

Or is there?

AFTER WRAPPING UP WORK at the den, Lucas took Bree to dinner. But she wanted to unwind before work, and to his surprise, she hadn't wanted to do that at her home. So they'd picked up Chinese takeout and headed to his place.

"What time do Josie and Max come in tonight?" she asked.

"I'm going to the airport after I drop you at work."

She paused in front of the table and glanced at him over her shoulder. "I don't need a ride, Lucas."

"Indulge me. I want to make the most of our time together."

"I don't get off until six again."

"I'm an early riser."

She plunked down the bag of takeout in the middle of the table and eyed him narrowly. "The last I heard, you worked into the wee hours and forgot to go to sleep."

"Then I'll forget again tonight and pick you up when your shift ends."

This argument was as futile as it had been this morning, and Bree recognized it. She just gave a shrug and began unpacking their dinner.

Lucas let the subject drop, too, content to have won his

way. Bree had arrived back at the den today shortly after his return from the park and had been behaving as if the scene this morning had never happened, as if everything was normal.

He'd attempted to get her to talk about it but wound up frustrated that she kept sidestepping any discussion. She'd finally told him to stop worrying, she was a big girl who could take care of herself.

Lucas didn't doubt she could. Apparently she'd been caring for herself, her sister and her brother for a long time. But he felt shut out.

He didn't like the feeling.

He also didn't know what to do about it, which was another thing he didn't like. He wanted Bree to share what was going on—if he understood the situation, he could help her deal with it.

But Bree wasn't sharing, and that bothered him most, Lucas decided as he grabbed plates from the kitchen.

She gave him a smile, one that should have reassured him, but Lucas could feel this woman straight to his gut. He couldn't explain it, but when he peered into her face, he could see past the cool beauty, feel the raw edge to her mood—a mood that was fueling his own unease.

"Sit," he said, pulling a chair. "I'll grab something to drink. Wine?"

"Water, please. Wine will put me into a coma."

He filled two glasses from the cooler. After setting them on the table, he found himself standing behind her and couldn't resist touching her. Sweeping aside her hair, he ran his fingers over her shoulders, massaged the tense muscles that proved her mood wasn't nearly as easygoing as she'd have him believe.

With a heavy sigh Bree let her head droop forward,

giving him free rein, and Lucas found that touching her helped to soothe his raw emotions, too.

The silence fell around them natural and complete, minutes strung together marked by the sounds of their breathing and the darkness falling outside.

"You're pampering me tonight," Bree finally said, her voice a content whisper.

Here was his chance to play things straight. He could fess up that he knew about her bum ex. He should fess up. Under any other circumstances, he probably would have. He'd never been much for games, had never been in a situation where he'd felt the need to play them with a woman.

Bree was different. Lucas sensed he'd only get her defensive by admitting he'd looked into her past. She'd made it loud and clear she had her life under control. He didn't think she'd appreciate hearing that he didn't believe her.

As much as it went against his grain, he would let Bree lead right now. Until he figured how to get her to open up. He wasn't willing to risk alienating her, not when he only wanted to make sure she stayed safe.

Not when he wanted her.

"You're tired. We haven't done much sleeping since we met, and you're working on top of it."

"So are you."

"I haven't been keeping your hours."

"Fair enough." Another deep sigh. "Don't worry. I'll be fine once I get some food and caffeine in me."

"Any chance you can get someone to cover for you tonight?"

She shook her head, sending glossy waves across his hands, an innocent touch that drove home just how much

he wanted this woman. "Not if I want to take the night off for the ball."

"So I have to choose which night I want you?"

"You already did."

True, but that was before he knew how quickly things would change. A date to a ball seemed like such a small prize when he wanted so much more from her.

Honesty. And time to explore what was happening between them, to indulge his need for this woman that made everything else feel unimportant.

"What if I'd rather touch you than let you eat?"

"I like when you touch me, Lucas."

So did he, and that need drove him to sweep aside that hair to reveal the graceful curve of her neck, to lean over and press his mouth to the wispy hairs at her nape.

She shivered in reply, and he could taste her restlessness. It was in her tense muscles, radiated off her in waves that he could feel as if a tangible force.

Her restlessness fueled his own, or maybe that was just his frustration. He'd never felt so powerless, so uncertain what to do to get what he wanted.

Bree.

He wanted her to square with him about what had happened in the den this morning. He wanted to know why her bum ex was back in town and why she hadn't turned him over to the police. He wanted to know that she didn't still have feelings for the guy that might interfere with Lucas's feelings for her.

They were so new together. Even though they were fast and intense together, they didn't have years of history. He wasn't sure what to say or what to do to help. He only knew that he wasn't going to sit by and do nothing.

Smoothing his hands along her shoulders and down her

bare arms, he willed her to understand everything he didn't have the words for, feared she wasn't ready to hear. Reaching out to her with the only tool he had now, he slipped his hands down to cup her breasts.

"I want to see you naked."

She trembled again, gave a rueful laugh. "Just so happens I have to get undressed anyway so I can dress for work."

"Convenient."

His voice sounded thick and needy, a stranger's voice. Catching his fingers beneath her shirt and the underwires of her bra, he dragged the whole deal up until her breasts sprang free. She leaned back in the chair, arching her beautiful body and resting her head against his stomach. Her breasts lifted upward, full and tempting with arousal, her nipples gathering into taut peaks beneath his appreciative gaze.

He caught those nipples and tugged, so aroused by the sight of that sleek golden skin yielding to his touch. She gave a throaty moan, and, covering his hands with hers, she encouraged him to explore, joined him as he rolled her nipples and tugged again, hard enough to earn another moan. Such simple touches and she was coming unglued.

What was it about them together?

Lucas didn't know. He couldn't drag his gaze away. With her eyes shut, her lashes created lush semicircles on her cheeks. Her full mouth parted around a shallow breath.

He only knew that his crotch had never ached like this, his own need so powerful at the sight of their clasped hands pleasuring her with a steady, erotic motion, at the sight of her melting in pleasure.

He played with her breasts until she couldn't sit still, until her hips rocked back and forth. Then he slithered a

hand toward her waist, popped open the button of her jeans and slid down the zipper.

She threaded her hands up his arms and hung on, angling her bottom until he could slide his hand inside. His fingers grazed over the curve of her sex, her jeans loose enough so he could slip between the seam and her warm thighs.

He sank a finger deep inside her moist heat, couldn't help but smile when she came up off the chair.

"Lucas," she gave him the word on a low groan.

"Shh." He leaned over her, pressed his mouth against her ear, speared his tongue inside.

Another sigh and a shiver, and he caught her earlobe between his teeth and nipped hard enough to bring her off the chair again.

He idly worked her breasts with one hand, first one nipple then the other, as he slid his finger inside and out of her wet heat. Using his palm, he kneaded that sensitive bundle of nerve endings at the apex of her thighs, pinned her to the chair when she went wild trying to break away.

He wasn't letting go. Not until she came. Not until she understood they were magic together. Right now was about convincing Bree that what they had found together was unique, worth putting aside rationality, worth trusting. And if he couldn't tell her with words…

He coaxed her orgasm into breaking, and her sex clenched him in hot spasms. He breathed kisses against her ear, against her cheek, everywhere he could reach, and when she tipped her face to his, dragging his mouth into an eager half kiss, Lucas thought he'd come unglued right there.

But he held on tight as she rocked to the fading echoes of her orgasm, savored the way their tongues tangled together and he tasted the sweet intensity of her climax.

She was unrestrained in her pleasure, and he loved her bold joy in her body, her generosity in sharing. Resting his cheek against the top of her head, he inhaled deeply of her familiar fragrance and waited for her to come back to herself.

She finally tipped her head back. "What do you do for an encore?"

Lucas didn't know what shook him more—the throaty, wasted sound of her voice or the sight of her looking so dreamy and content. Whichever it was, he found himself vibrating, unable to control his need a second longer. Dragging the chair around, he lifted her toward him, feeling raw and out of control.

In a few impatient moves he tugged the jeans over her hips and brought her thong down, too, until she stood before him exposed.

He swept aside the dishes and the cartons of cooling takeout and hoisted her onto the table. She gave a laugh that jolted through him like a live current, braced back on her hands and gazed up at him boldly.

The breath caught in Lucas's chest at the sight of Bree in her excitement. Her blouse and bra were a tangle beneath her arms, her breasts thrust outward, nipples tight and rosy, her legs spread wide for his pleasure.

He lost it right there. Without even willing himself to move, he had his jeans down. Then he sank his fingers into her thighs, spread her wider.

They came together as if their bodies had waited forever.

Perhaps they had. All Lucas knew was that he would never get enough of this woman. The more they made love, the more desperately he wanted her.

Wrapping her legs tightly around his waist, she opened

herself completely to him, and he plunged inside hard, lacking control. She brought one arm to dangle loosely around his neck, hanging on as she abandoned herself to the full-bodied motion of his lovemaking, her breasts bouncing in an erotic rhythm, her body tilting seductively as she lifted to meet his every thrust.

Lucas wanted to tell her to trust him, to trust *them*. They could work out whatever was happening in her life as long as they were together. As long as they believed in each other.

They were meant to be together.

If Lucas knew nothing else, he knew that without any doubts. When he plunged deep inside this woman, he knew the details didn't matter. Not the past. Not the present. Only the future from this moment on. His body knew her. His soul knew her. His heart knew her.

And when he felt her breaths bursting out in tiny gasps, felt her quickening her pace as her climax built again, he willed Bree to recognize him, to recognize the magic.

Their mouths came together hard, their breaths clashing and their moans colliding. They became one then, reaching pleasure at the same moment, their hearts racing in a breakneck pace.

Together.

13

IF THE DAY'S EVENTS weren't enough to pitch Bree over the edge, she'd had to contend with Lana all night, who was covering another hostess's shift for a chance to suck up to the big bosses by proving what a team player she was.

Under normal circumstances, Bree might have cared, but at the moment she only had enough brain cells firing to contend with the mystery of her day planner. Or try to. She still searched for some way to rationalize that message in her head.

She desperately wanted to believe that Jude was yanking her chain, but no matter how she came at it, she couldn't figure out how. Or even why.

Lucas knew something was up. He'd moved from twenty questions to a full-fledged interrogation this afternoon. Worse still was that she'd wanted to share what had happened with him.

But Bree didn't need to get any more tied up in this man. Not when she wanted to spill her guts to him. Not with Jude stalking her and an alleged ghost showing up in her locked bedroom. She felt as if she was being sucked into a whirlpool of events and was going down fast.

She shouldn't be falling for Lucas. Things were happening too quickly, too intensely. She didn't trust what was before her eyes, let alone what was in her heart.

"I'm seeing double."

A male voice drew Bree from her thoughts, and she turned to find Giles heading toward her with Tally in tow.

"What are you doing here?" Bree asked her sister.

"Wanted to see if I could catch you for your break."

"Excuse me, ladies," Giles said with a dramatic bow. "I'm back to my post. I'm liable to have a heart attack if I stand here any longer surrounded by such beauty."

Tally laughed. "Don't work too hard, Giles. Now, Bree, what about that break?"

She'd left tonight's guest happily spending his money inside the Cane River Poker Room after she'd seen his girlfriend off on an Art District tour of night gallery showings. "Now's a good time. Hostess lounge okay?"

"How about outside?"

Bree frowned at that. "What's up? Mark okay?"

"Mark's fine."

Leading Tally off the floor, Bree flagged the hostess as she headed toward the VIP lounge. "I'm taking my break."

The hostess made a notation in her book and waved to Tally. Bree didn't give them time to chat. She wanted outside to find out what had brought her sister by. Her patience threshold had reached its limit before the sun had set today, and while Tally was known to swing by Toujacques, visits were never without a reason. If that reason was simple, Tally would have just called Bree on her cell.

"Hey, boys," Bree greeted the bouncers as they swept the patio doors wide, grinning toothily as they darted their gazes from her to Tally and back again.

"I'm seeing double," one said.

"That's an old joke around here, guys," she said. "Can't you come up with something original?"

Bree had no doubt that by the time she headed back

inside, she and Tally would be treated to every lame joke these clowns could come up with.

The patio was quiet with only a group of middle-aged couples who looked as if they might be visiting on a tour. Tally motioned to a table in a far corner beneath a flaming lantern.

"What's up?" Bree sat down heavily, feeling the physical wave of relaxation as soon as she was off her feet. "You're starting to freak me out."

"I talked to Madame Alain today."

Sinking back in her chair, Bree closed her eyes. She was *so* not up for this. "What's up with her?"

"She asked me if anything was wrong with you."

"Oh, please."

"Is there?"

"What?"

When Tally didn't answer, Bree cracked an eyelid to find her sister frowning.

"Is there anything wrong, Bree? You're acting awfully strange. Not to mention you've been avoiding me lately. You always hide when something's wrong."

"I don't hide and I haven't been avoiding you. I'm busy."

Tally frowned harder, not buying it.

"When have you had time to notice what I'm doing?" Bree asked. "With getting the club up and running and Christien, you've got your plate full right now. You don't have time to worry about me, too."

"Just because I've got a lot going on doesn't mean I'm giving up my family. You of all people should know that."

"I didn't say you were giving up the family."

"Then tell me what's going on. Madame Alain said you were running through the court barefoot and you looked upset."

"Since when do you listen to Madame Alain? Come on, Tally. Cut me a break here. I've only got thirty minutes to pin my costume or I won't be going to the ball."

"You waited until the last minute to decide to go."

"I only just met Lucas."

Tally sighed. "What are you working on? Maybe I can help."

Bree opened her day planner, withdrew a sketch and waited while Tally checked it out. Her sister was quiet so long that Bree began to wonder if she saw something wrong with the design. That wouldn't have come as a shock. She'd been tired enough when she'd sketched it.

"This is the most amazing gown you've ever designed," Tally finally said.

"Thanks." Wow, her very first bright spot tonight. Well, except for sex with Lucas. That had been pretty amazing.

But she and Tally had learned to sew together and, until just recently, had shared a communal wardrobe with gorgeous outfits that had made appearances between Tou-jacques and the Blue Note.

"Got time to give me a hand?"

Tally returned the sketch, folded her arms over her chest and shot Bree a stubborn look. "I'll be happy to help—if you start talking. I'm not going anywhere until you tell me what's going on."

"Nothing except I need a dress for the ball."

"Let's start there. What's happening with you and Lucas? And don't tell me nothing."

Bree thought about arguing, but she was already on sensory overload, and quite simply, she knew her sister. Tally wouldn't back off until Bree gave her something to chew on.

"We're having sex. Yummy, sweaty sex. Lots of it."

"Good for you. I like him."

"Well, don't like him too much, because he's leaving after the ball."

"But he hasn't gone yet."

"Which is why I need to get my dress pinned. I don't want to waste perfectly good time sewing when I could be having sex."

Their gazes clashed across the torch-lit distance. Tally's determined, Bree's surely weary.

"Why were you running through the court barefoot today?"

"Needed something from my car. I told Madame Alain that."

More silence.

Oh, Bree could see where this was going. *Nowhere.* "Damn stubborn is what you are."

"Family trait. Oh, and by the way, Madame Alain also showed me the flowers you gave her. Want to tell me who sent that three-hundred-dollar arrangement? Neither she nor I is buying that the floral shop told you to keep them, and I'm guessing it wasn't Lucas or you wouldn't have given them away."

Bree stared hard and refused to bite. And here she'd thought this day couldn't get any worse.

"I want to know what's going on," Tally insisted. "I'm not leaving until you tell me."

"Don't you have to work?"

"I own the Blue Note, remember? I don't even have to call in if I don't want."

"Nothing's going on except I'm finally getting a piece of the action so I don't have to watch you have all the fun."

"Bree, you do remember I'm a joint owner on your checking account, don't you?"

"What does that have to do with anything?"

"You know how much I've always wanted to play the Hawaii Five-Oh," she said referring to Toujacques' highest jackpot slot machine. "The minimum bid on that baby is five hundred bucks. You know I won't waste my money, but it just so happens that I have your account number memorized. I wonder how many times I'll get to play with your balance?"

Bree blinked. She stared. Finally she said, "You wouldn't."

"Try me."

"I'll end up losing my town house and being forced to move back in with you. Your love life will go straight to hell."

"Why should it? I don't care if you're in the next room drooling."

"Christien might."

Tally laughed. "Honey, trust me. When Christien's in my arms, he isn't thinking about anything but me."

The laughter did it. Or maybe just plain old envy that Tally's love life was going along so smoothly when her time with Lucas was almost up.

"Jude's back." Bree blasted those words like a clean shot from a double-barrel rifle and got to enjoy the satisfaction of watching Tally sink back in her chair looking stunned.

"You are kidding me," she finally said.

"Teach you to ask."

"Omigosh. When? *Why?* Oh, Bree, why didn't you tell me?"

"And rain on your parade when you're floating around on cloud nine?"

Tally scowled. "You know I'm here for you no matter what. Even if I am all wrapped up in my own little world."

"Don't defend yourself. You have every right to be happy and wrapped up in your life. You've worked hard to accomplish what you have. You don't need to apologize to me or anyone."

"Yes, I do. If Jude's back in town and you didn't tell me, then I haven't been there." She shook her head as if to clear it. "What does he want?"

"Me."

Her eyes widened.

"That's all he's said so far, anyway."

"You believe him, Bree? Are you sure he isn't angry because of what happened with the police?"

"I'm not sure of anything except that he's screwing up my whole life just as I'm about to get two steps ahead." Bree gave a laugh that sounded tired and desperate. "Other than that, my best guess is he wants to use me to get close to your treasure. I'm sure he's come up with some way to exploit your good fortune and thinks I'm still an easy mark."

Tally's expression dissolved. "I am so sorry. I never realized how any of this would affect you or Mark. I thought the reward money would be a good thing. If one of us got on solid financial footing, all of us would benefit."

"It's not your fault Jude came back. I was the one stupid enough to get involved with him in the first place. This is just my past mistake coming back to haunt me. Period. The end."

"Have you called the police? You can get a restraining order. That's if Jude isn't still wanted—"

"He is."

"You've talked to the police already?"

"No, no. Not yet. Not until after they announce the promotion and Lucas leaves. We don't have much time left together. I'll tough it out until then."

"You know, Bree, not reporting Jude might be like aiding and abetting."

With the way her luck had been running lately, she'd wind up in jail. "Then I'll play stupid and pretend I didn't know there was still a warrant. I refuse to waste the little time I have with Lucas dealing with Jude."

Tally looked shocked for a second, then her expression collapsed. "Oh, my poor sister."

The heartache on Tally's face was enough to pitch Bree over the edge. It was always that way between them. A twin thing. An emotional connection. They always knew, no matter what.

Tears prickled at the back of her lids. "I don't want Lucas to know about Jude."

Tally reached across the table and grabbed Bree's hand, gave a reassuring squeeze. "When did it happen?"

"What?"

"When did you fall in love with him?"

A stupid tear squeezed its way out despite her best attempts to hold it back.

Love? How could Tally be so sure when Bree wasn't?

"I just don't want him to know, Tally. He's my Mardi Gras date. There's no point."

"Of course there isn't."

That soft-around-the-edges tone made Bree bristle. "Really, Tally, I only met the man a week ago."

"If he's *the one,* then it doesn't matter how long you've known each other. He'll still be the one."

"*The one.* Oh, please. I honestly can't handle any more tonight. I can't."

"Honey, that costume is the least of your problems. Don't think another thing about it. I'll pin it between sets and we'll work on it together until we get it done."

"Really?"

"Of course. What are big sisters for?"

Tally was "big" by five minutes. Bree laughed and swiped at her eyes.

"I'm worried about Jude," Tally said quietly. "He sent you the flowers. When did you talk to him?"

Bree debated how much she should say, but just sharing her worries made her feel better. It had always been Bree and Tally against the world. At least that much hadn't changed.

"He showed up at the den this morning when I swung by to pick up some trim for my costume."

"How'd he know you were—" She broke off and narrowed her gaze. "He isn't following you, is he?"

Bree took a deep breath that didn't make it any easier to spill her guts. "By GPS."

Tally gasped, a look of such genuine worry on her face that Bree felt so ashamed for ever bringing this man into their lives. "Are you sure?"

Bree couldn't bring herself to explain about the mystery message. Not even to Tally, who didn't suffer from the same reluctance to have perfectly normal people think she was crazy with talk about ghosts.

So she whipped open her day planner.

Tally's eyes widened as she scanned the message scrawled across the pages. Then she began to laugh so loudly that she drew the attention of the nearby couples.

"Bree, do you realize what's happening here? The captain needs you to break the curse."

Bree couldn't reply. She had absolutely no clue what to say, and Tally knew it.

"I know you think I've lost it," Tally said. "But I love you, so I'm not taking it personally. I know it sounds

crazy. If I hadn't seen the captain for myself, I'm sure it would be hard to buy even though I'm not nearly as pragmatic as you are. But I swear on every hair on Mark's head I'm not crazy. Everything I told you about the curse is exactly what the captain told me.

"He fell in love with the beautiful Madeleine, then disgraced her by getting her pregnant. When she gave birth to twins, her grandmother cursed the babies and every descendent thereafter to know the joys of ambition and never the heartache of love. Only, from what the captain said, she thought she was blessing us. I'm a little sketchy on the details there, but I do know he needed me to fall in love to satisfy some condition of the curse." She clasped her hands over her breast dramatically. "He's been trapped in the ever after, Bree. He's trying to break the curse so he can find peace. Doesn't that break your heart?"

It broke something—the laws of probability, for starters. "Okay, let's say for curiosity's sake I'm willing to entertain that you haven't completely lost your mind. Why do you think he's writing me?"

Tally grinned a fast grin and smacked her hand down on the open day planner. "Why don't you write back and ask?"

LUCAS DROVE THROUGH the arrival gate at the airport. He'd driven Josie's hatchback, which, unlike Max's Porsche, held enough space for several people and a few suitcases.

After circling through the gate twice, he thought about parking, but as he was about to steer onto the ramp leading to the short-term lot, his cell phone jangled an incoming call. Glancing at the display, he found a text message from Max.

On our way.

Lucas made his way around one more time and slid into the idling traffic in front of the airline doors. He wasn't there long enough to draw the attention of the security guard when he spotted them.

The hydraulic doors whooshed open and the newly-weds strolled through, Max managing a garment bag and a huge rolling suitcase while still keeping a possessive arm around Josie. His baby sister snuggled against her new husband, her face alight with laughter, looking as though she was living her dream.

Lucas knew she was. And maybe that was what made the moment so memorable. That, and how glad he was to see two people he cared about so happy. Lucas and Max might have let their friendship go ten years ago, but after making amends, those years were forgotten. They'd grown up together, more brothers than friends, and that bond surged to the forefront now.

In the short time since his sister and Max had become engaged, Lucas had realized that he'd never filled the empty place Max had left in his life. There were lots of empty places he was discovering. And too much discontent. He'd been trying to outrun boredom rather than filling his life with things that mattered, things that would challenge and content him.

Life was about people to care for, about being cared for. He hadn't remembered that until returning home, until seeing Josie and Max start their future, until thinking about how they'd all grown up in the court together and how life had spread them apart.

But no more. He'd found his best friend again and now he wanted to know what life would be like with Bree in it.

Slipping the car into park, he got out. "Well, if it isn't Mr. and Mrs. LeClerc."

"I like the sound of that." Josie blew him a kiss.

As they approached, Max extended his hand.

"Hey, bro-in-law," Lucas said. "Glad to see the blushing bride didn't kill you."

"Not for lack of trying."

Josie flung her arms around Lucas's neck and hugged him tight. "I plan to enjoy my husband for a good long time."

He kissed her, feeling more nostalgic than he remembered ever feeling. "Glad you two had a good time."

"We can say the same to you since you're still in town." Max gave him a knowing smile. "Ever going home?"

"Wouldn't dream of missing Mardi Gras."

"Since when?" Josie said. "We want the scoop, Lucas. All of it. You can fill us in on the way home."

As the airport was in Metairie, he'd have a captive audience on the drive back into the city. Lucas popped open the hatch and helped Max load the luggage inside. Sure enough, Josie began the drill before he even pulled into traffic.

"So what's going on with the float?" she asked. "I don't have to tell you I've been freaking out."

Lucas laughed. "You called daily for reports. What were you freaking out about?"

"She didn't believe anything you told her," Max explained. "She figured you were telling her what she wanted to hear so she wouldn't hop an early flight."

"I hear about your trip first," he said, "or I don't tell you a thing about the float and I'll lie about everything I've been doing."

"You would, too," Josie retorted, but he didn't have to ask again before being regaled with honeymoon stories.

For two people who were obviously crazy about each other, Josie and Max had gotten out to see the sights

more than Lucas would have expected. He and Bree hadn't made it to the plantation once while they'd been at Félicie Allée.

Maybe because they knew they only had a few nights together, while Josie and Max would get a lifetime.

Before, when Lucas had thought about his whole life, the years had stretched before him like an eternity. But sitting in this car, facing a return trip to Pescadero, those years didn't sound like forever. They sounded like a finite number to be handled judiciously.

How many months might pass before he returned? His family was due for Christmas at his place this year, so he probably wouldn't make it back before Mardi Gras next year.

Suddenly he could imagine all the things that might happen in a year. Josie could get pregnant and actually give birth to his new little niece or nephew. Not that the new LeClercs had shared any plans to have kids in the near future, but if they wanted to they could.

Suddenly California seemed a lot farther away than he'd ever thought it before.

"There's really not much left to tell," Max finally said.

"I'm sure there's more, but it's not anything I'd want to hear." Lucas shifted his gaze off the road and eyed them meaningfully.

"You're a laugh a minute," Josie said. "Don't think you'll get off that easily. We filled up three memory sticks with pictures. Just wait until I get to my computer."

"Wishing you made that flight about now?" Max asked.

"You know, I don't think five hundred pictures of 'Oh, and here we are standing underneath a banana tree' is such a raw deal for letting me camp out in your place while you were off honeymooning."

Max leveled a razor-blue stare his way. "Your turn."

"Have you been spending any time with Bree?" Josie asked.

There was no deliberation about how much to tell them. There was no question. He wanted their opinions and their help. "We've been spending all our time together."

Josie hiked her knee up on the seat. Max leaned into the front, and they both waited for him to start talking.

He gave them a rundown about how he'd met Bree, his invitation to the ball and their subsequent trip out of town.

"What was she doing climbing my wall to get into the court?" Josie wanted to know. "She lives right on the entrance."

"That's the million-dollar question. She told me someone spooked her while she was walking home from work."

"You don't believe her?" Max asked.

He shook his head. "I believe her. She told me that she had it under control."

Lucas explained what he'd walked in on at the den just that morning and how he'd followed up his suspicions. He explained about Jude Robicheaux.

"She won't talk to me, and trust me, I've been giving her every opportunity. She just keeps telling me to trust her."

"You think this guy is the one who sent her into your yard?" Max asked.

Lucas nodded. "I'd bet money on it. But I don't know what to do to get her to talk to me. I could confront her with what I found out online."

"Why are you so surprised she won't talk, Lucas?" Josie asked, her voice soft-edged and concerned above the steady hum of the engine. "You've barely known her a

week. Don't you think you're asking her to move a little fast here?"

"We're not…casual." He didn't know how else to put *that* without getting into all the details. "I can't really explain it, but we're operating on an abbreviated time frame. I think we're soul mates."

"Soul mates?" Josie exchanged a glance with Max. "Does Bree share this assessment?"

He shook his head, irritated with her whole cautious demeanor. "We haven't discussed it."

Josie sighed. "Listen to me, Lucas. I see a couple of problems here. You have no clue what sort of relationship Bree had with this man and you can't bully her into telling you. I'm qualified to make that assessment."

As a licensed therapist who worked for social services, Josie did indeed offer a professional opinion.

"Then what do you suggest?"

"Be supportive. Be open to listen if she wants to talk, but back off with the rest of this. Going behind her back and digging into her past isn't going to help. Bree knows this guy. If she wants your help, she'll ask. You've got to respect that she knows what's best and trust her."

"What if she's in over her head?"

Josie reached out and touched his arm reassuringly. "If Bree is in over her head, then you can't force her to admit it. You can only support her, Lucas. You can't make her stand up to him. She's the only one who can decide to stand up for herself."

"You're telling me to stand by when she might get hurt?"

"I'm telling you not to bully her. Sounds to me like she's had enough of that already." Josie forced a smile. "For what it's worth, I'm acquainted with Bree. She has

never once struck me as an abuse victim. You don't know what's happening between her and this guy."

Lucas didn't reply as he maneuvered through late-night traffic and merged southbound, considering what Josie had said. The situation kept turning over and over in his head. He couldn't see clearly, and whenever this happened with work, he usually packed up his laptop and gave his head a rest. But Bree wasn't some technical problem he had to think his way out of.

"I understand what you're saying, Josie," he finally said. "And I respect your opinion. But I'm not going to let Bree be harassed by this guy because I haven't known her long enough for her to trust me."

He caught Max's gaze in the rearview mirror. "I need your help. I can't tail her 24/7 or she'll know something's up. Will you give me a hand keeping an eye on her?"

Those deep blue eyes met his and a lifetime of understanding passed between them in a glance. "You know it."

Lucas inclined his head.

"You two aren't hearing a word I'm saying," Josie said angrily. "You can't play Bree's around-the-clock bodyguards."

"Yes, we can."

When Josie folded her arms over her chest and shot disapproving glances between them, Lucas found himself feeling a little better. At least the dynamics of this relationship didn't change no matter how old they got.

14

WHAT DO YOU WANT from me?

Gabriel read the words Breanne had written in her journal, considered her sudden reversal when all along she hadn't believed her twin's claims of his existence.

Yet there was no question why she'd taken this leap of faith. The reason sat on a boudoir chair before the window looking serenely smug with her hands overflowing with a beautiful gown and sewing pins.

"Of course I won't leave you," Tallis said. "But I don't think it'll be long until you get your answer. The captain's here. I can feel him."

Breanne gave a nervous laugh. "Not only can you see him but you can feel him, too. What, did you inherit this little talent from Uncle Guidry when he left us the town house?"

"Ha, ha. No talent needed. Can't you feel the cold?"

Bree frowned. Tallis stretched her leg out and made a sweeping motion, passing her foot right through his knees. "He's right here. I only know that because I've actually felt the temperature drop when he showed up."

"Just be forewarned…if a ghost materializes in my bedroom, I'll probably bolt."

Tallis laughed. "I don't think that's going to happen."

"Why not?"

"Aside from the fact that I haven't seen him since he successfully played matchmaker for me and Christien—" she motioned to the journal opened on the night table, her diamond engagement ring glinting in the light "—if he could appear to you, then why would he be writing?"

Breanne cast a narrowed gaze at the journal in question, apparently considering. "Well…good. Why you and Christien and not me?"

"Haven't a clue. But I don't think Uncle Guidry ever saw him either."

"Then why'd he say the place was haunted?"

"Because the place is haunted. Maybe he felt the cold, too. I never asked. But didn't you say the captain started winging stuff around after he left the message?"

Gabriel couldn't resist. Gathering all his focus, he knocked a small box from the dresser. It toppled to the floor, landing on the edge of the rug with a soft thump.

Tallis smiled. "Like that."

Breanne sank onto the edge of the bed, fairly swooning.

Gabriel sent an envelope sailing off the dresser for good measure, and she jumped.

Tallis laughed.

"Child man," a familiar voice snapped, and had Gabriel been of corporeal form he might have blushed for being caught in such foolishness. Except he wouldn't give the crone the satisfaction.

"So how will you reply, pirate?" *belle grand-mère* asked. "You have our very great-granddaughters' attention. Now what do you plan to do."

"Break the curse. Dare I hope you might be tired of this eternal restlessness? Or do you truly want to spend another two hundred years suffering my company to have your revenge?"

He saw some emotion flicker across that withered face, prayed she might be mellowing. He hadn't considered any fate but his own, yet the whole two-souls-bound-together-in-the-curse thing couldn't have been pleasant for her either. Of course, *belle grand-mère* had chosen her path.

Oy, the misguided notions of righteousness.

He might have laughed, but as he stared into the face of the woman who had been his only companion for centuries, nothing about the situation felt amusing.

"So I ask again, what are you going to do?" she queried.

"Break the curse."

"So you've said. They're waiting."

"I know." Gabriel affected just the right tone of bravado—which he was not feeling at all, unfortunately.

He had been giving a great deal of thought to how he might convince Breanne to trust Lucas and give herself to love. She wouldn't find another man her equal. The auras didn't lie.

He'd learned that lesson the hard way.

And as Gabriel stared at his beautiful descendent, her aura fading back to the lifeless pewter color it would remain if she didn't give her heart over to love, he realized his only chance to convince her meant teaching the lesson he'd spent two centuries learning.

Which meant owning up to every bad decision he had made in life and facing that so many had shared in the consequences.

Casting his gaze between his beautiful descendents and the withered old crone who had sacrificed herself to make him pay for his sins, Gabriel knew a shame that crawled through him as alive as if he had never crossed into the realm of death.

He reached for the pen....

"Tally!" Breanne gasped and pulled her legs up on the bed.

"Chill, li'l sis. Looks like he's going to answer your question."

The old crone hissed. "Must you always play the melodramatic ass?"

"If you have a better suggestion, Madame..." Gabriel let his words trail off as he pressed the pen to the page to begin his missive, determined to write honestly and from the heart. He refused to spare himself the pain of reliving his wasted love affair, the shame of his own foolishness, the regret of his betrayal of the woman who had loved him.

It was the least he could do to atone, to attempt to set things right—not for himself, because he had earned his reward, but for those who partook in the dismal fate through no fault of their own. The thought speared him on the edge of a guilt so heavy not even death tempered the weight.

Madeleine. Their children. Generations of descendents following the path of ambition to be spared the heartache of love. Tallis. Breanne. Even this horrible old crone, for all her bitter choices, had only been reacting to *his* actions.

IMPOSSIBLE WORDS APPEARED on the pages as if an invisible hand wielded the pen. Tally chuckled softly, but Bree could only stare, the breath trapped in her throat, disbelieving yet unable to tear her gaze from the words that formed sentences, stringing together into a story.

My dear Breanne,
Would that I could appear to you and prove my existence beyond a doubt. Alas, I am the victim of my

own pride and foolishness yet again, a melodramatic ass of the worst sort, some would say. Unfortunately through the past few months I have come to understand how true is that claim.

The curse is real, brought down upon your head and the generations before you because of my selfishness.

In life I was blessed with the love of the exquisite Madeleine, who saw only the good in those she cared for. She was beautiful and kind, a gentle soul who deserved to be cherished.

You and your twin look so like her it wounds me until I cannot bear to look upon you. Alas, you are both too like me in spirit. Tallis has proven stronger than this curse, but you, my dear Breanne, have enough of my dear Madeleine's spirit that I fear for you. I hope you will understand what I write. I pray you also possess the strength to rise above this curse.

Madeleine gave her heart to me, loving me for all she saw that I could be, not the man I was. I was not worthy. Neither of her love, nor of the faith that she placed in me.

For only after my death did I begin to understand what I had not in life—that no man who truly loved a woman would ever let his pride come before her.

Yet love her I did. With my whole heart and soul, as much as I was capable of in life.

Otherwise those accusations of piracy would never have nettled me as they did. But they bit so deep because each one proved what I believed in my heart—that I would never truly be worthy of that gentle woman's love.

Had I believed in my own worth, I would have

asked her to sail from New Orleans to start a new life with me. I would have understood that she cared more for me than for the trappings of society, more than the opinions of other people.

She saw me for who I was inside, who I could be.

If only I had believed in myself.

I did not. I let my pride rule my wits and sailed from New Orleans to spite society, leaving behind a heartbroken Madeleine with my children in her womb.

Society turned their backs on her, but it was not their betrayal that eventually broke her spirit. It was my betrayal.

Her voodoo-wielding *grand-mère* made as much clear when she sacrificed her own eternity to ensure I suffered for my sins. She cursed us all, believing she blessed our descendents with ambition instead of love to save you the same heartbreak Madeleine had endured.

I have spent my death haunting this court that I built, believing there would be no way to break the curse, but with the birth of you and your sister— another set of twins—I have been given a chance.

All you must do is place love over your ambition.

Even if you have not realized the truth yet, you love. I see it in the way your restless aura sparks to life around Lucas. Auras never lie. They tell the heart of matters. Have you not felt kinship with this man remarkable for your short acquaintance? Have you not felt the power in his arms? Do you not recognize that he is your match in every way that matters, your spiritual and physical and intellectual equal?

Love follows rules that have nothing to do with time or place. When one soul recognizes another, the result is magic. That magic can be yours.

All it takes is believing yourself worthy.

And while that sounds like such a small and simple thing…you more than your twin, more than any of your cursed ancestors, will understand that it is not.

We share this in common, a trait unique to us, a trait born of our different circumstances, to be sure, but to the same effect. The only wisdom I can share is born of two centuries of experience, two centuries of atoning and finally understanding.

Until you believe in yourself, my dear Breanne, it matters naught who else does.

Yours in hope,

Captain Gabriel Dampier

Bree had eventually remembered to breathe, but when the pen finally came to a stop, came to rest beside her day planner, her gaze swam with tears.

Before she could even lift a hand to swipe at her eyes, to begin to pull her shell-shocked thoughts into some semblance of order, she felt the temperature dip sharply.

It felt as if a window had blown open and a winter wind swept in, a chill that sent goose bumps up her arms and built and shifted until it pierced her skin….

As if a ghost had kissed her cheek.

LUCAS'S CELL PHONE jangled a tune, and he grabbed it from the desk without taking his gaze from his laptop, flipped it to his ear and said, "Talk to me."

"You owe me big," Max shot back. "Josie's been giving

me the silent treatment all day. Not to mention I'm going broke losing at baccarat."

"Then stop losing and start winning."

"There's a plan."

Lucas laughed. "Is she all right? Haven't seen any sign of the degenerate, have you?"

"Bouquet of roses showed up tonight. Coral. Huge. Since she marched them straight to Silver-Tongue Sammie, I figured you didn't send them."

"You figured right."

"Then there's your answer."

Lucas and Max were tag-teaming Bree. Lucas had kept her all to himself after she'd come off duty, which had proven to be no problem. Max showing up at Toujacques that night had been trickier.

Bree wasn't buying that Max had started playing baccarat on his honeymoon and wanted to hone his skills. After a long night of watching him haunt the gaming tables, she'd finally called to ask if there was a problem with the newlyweds. Lucas told her they'd had a fight. Better that than letting her think Max was a gambling addict.

"How about you?" Max asked. "Come up with anything?"

"I did, in fact. Hit the jackpot around midnight."

It had taken him the better part of the night, but he'd managed to track Robicheaux's money trail to discover the man not only existed under three aliases but was involved with a sleazy Internet scammer named Harvey Brondell.

Lucas explained to Max how he'd tracked this guy through seventeen separate ventures. Robicheaux and Brondell had sold everything from dicey insurance policies to cut-rate cemetery plots. They'd exploited

historic artifacts from the Middle East and capitalized on the Pope's death by setting up an online store that sold bootleg copies of the pontiff's writings.

Each endeavor had yielded a small fortune.

It wasn't much of a stretch to speculate that Robicheaux might want to capitalize on Tally's treasure through his connection to Bree. Judging by the numbers he and Brondell were laundering through a variety of offshore accounts, a run with Captain Dampier could earn them another windfall.

Max gave a low whistle. "So what are you going to do? Pass off the information to the police?"

"I want to, but I keep thinking about what Josie said. If I take that step without Bree's knowledge and she finds out—"

"She'll be even more pissed at you than Josie is at me."

"But you're married already. There's nothing keeping Bree from telling me to take a hike."

"Tough luck. But I think I'll tell Josie I'm helping you see the error of your ways. Might get me out of the doghouse."

"Go for it."

Lucas hated causing trouble between the couple, but he hated the thought of Bree being harassed even more.

"Omigosh, I'm not believing this dress." Tally stepped back to survey Bree's appearance with a shake of her head.

"I'm not believing we pulled it together." Bree twirled around to see herself in the mirror.

One glimpse of the complete package made her glad she hadn't begged a gown from Susanna and Olaf. She could hold her head high next to all the elaborate costumes the krewe had commissioned for its court.

Modeled after the French fashion of the time, Bree's gown was a creation of lemon velvet and pastel silk that shone to perfection with the elaborate trim she and Tally had hastily tacked into place. With her hair upswept to showcase the glittering tiara, she looked a fitting courtier.

She whipped the skirt around, pleased it swished solidly. "Can't even tell half the gown is only basted together."

"We sewed all the important parts. Besides, no one will be looking inside." Tally rolled her eyes. "Except Lucas maybe, and I don't think he's interested in your seams."

Bree glanced back in the mirror again. Lucas would definitely have an image of her to haunt his dreams, along with memories of a steamy week she hoped he'd never forget.

She wouldn't. Not ever.

"Honestly, that is hands down the most gorgeous dress you've ever designed," Tally said.

"Couldn't have done it without you. Thanks for dropping everything to help."

"That's what big sisters are for."

And Bree was glad hers had come out to play again. She'd been missed. Their lives were changing so much… but when Bree thought about it, she knew Tally's schedule wasn't solely to blame. She had been hiding because of Christien and because of Tally's preoccupation with the captain's treasure and a ghost.

Because of Jude.

No more. She and Tally would both have to be open-minded as their relationship changed and grew. She wouldn't give up her sister for anyone. Not her bad-news ex or even a doll like Christien.

Not even a ghost.

"Let me return the compliment." Bree smiled. "You look stunning. Christien's going to drool when he sees you."

Tally gave the obligatory twirl so Bree could admire her handiwork—much more carefully sewn together. "I'm so glad you talked Josie out of that heinous 'variations of pink' theme she kept trying to run through the court," Bree said.

"Me, too," Tally replied. "I think she just had Valentine's Day on the brain with the wedding." She raked her gaze over Bree's gown again. "How'd you get all the artistic talent?"

"Right. Spoken by the Blue Note's main attraction."

Before Tally could reply, the phone rang. Bree glanced at the display. "Damn, it's work. I've got to pick up."

Tally waved her off. "I'll go tell the guys. We're worth the wait."

She disappeared out of the bedroom as Bree snatched the receiver off the cradle. "Hello."

"It's George, Bree."

George McSwain had been the operating manager of Toujacques since shortly after Bree had moved from her debut as a cocktail waitress to VIP hostess. Although not all the staff would agree, she thought he was a good fit for the position. Tough but fair. The big boys obviously agreed.

"What's up, George? Any problem with Renee covering my shift tonight?"

"Not at all, but listen, I got some news. I know you and Lana have been waiting for the meeting to find out who's appointed head hostess, but Charlie called tonight and they've already decided. I wanted you to hear it from me."

Her heart sank. There was no missing his tone that screamed she wasn't going to like his news. "Let's hear it."

"We're giving Lana the position."

Under normal circumstances, Bree would never have grilled him. If the big boys thought sidestepping Lana's tantrums was more important than who would do a better job, then she didn't want the position anyway. She would have accepted the verdict gracefully and professionally.

But Bree knew George, and he didn't sound happy.

"All right, I'll bite. What happened? I'm the most qualified for the position. You know that."

"I know, but I couldn't sell you to upper management."

"Why?"

He exhaled heavily, reluctantly, and Bree braced herself, her instincts on fire. "You had trouble with the law, Bree."

There was a beat of silence while more hail-size words hit her, then the blood rushed into her head so fast she felt dizzy. "My record is as clean as your office, George."

"Of course it is or we'd have known about it before we hired you. But someone got wind of some past trouble and mentioned it to the owners, who know everyone in this town and started asking questions.... Well, they got answers."

She wanted to ask who *someone* was but didn't need to. There was only one person who had anything to gain by digging into Bree's past. Only one person who was self-interested enough to tell the bosses what she'd found.

"There's no problem with your job, Bree," George hastened to assure her. "Trust me on that. You're the best damn hostess we've got. But they felt, given you were under investigation for a gaming scam, that a move into

management *at this time* might not be best for all concerned. You know how we're sidestepping the media with the gaming opponents right now. If they get wind of any past trouble, they'd blow things out of proportion and make all of us look bad. We don't want to deal with it and didn't think you would either. You know how it goes."

Yes, she did.

She remembered an exchange with Lana just a few nights ago and wondered what handsome man she'd been referring to.

That question wasn't a leap to answer.

Jude Robicheaux was a mistake that would haunt her forever.

"I appreciate you letting me know, George. I'd much rather hear it from you than walk in on it tomorrow."

"Sorry, Bree. Just bad timing. Remember that."

She assured him she would, then severed the connection, her hand replacing the receiver in slow motion, her whole body cold with the familiar feeling of shame that always seemed to accompany her past rearing up to smack her in the face.

She couldn't blame the big bosses.

And she couldn't even blame Lana. *If* Lana had tattled to management, she'd been fed the information by Jude. It was an old trick of his—scare off everyone in Bree's life so she'd be forced to turn to him.

Once upon a time she'd let him do that. Only Tally and Mark had been left. Jude had wanted her to leave them, too. She hadn't, but who was to say if he hadn't had more time that he wouldn't have eventually found some way to convince her? And just the thought of what her life might be like if she hadn't managed the break was enough to make her cringe.

No, Bree had no one to blame for losing the head hostess job but herself.

But as she digested that simple difficult-to-swallow fact, she remembered something the captain had written.

Until you believe in yourself, my dear Breanne, it matters naught who else does.

Lifting her gaze in the mirror, she scanned her image, found to her surprise that she didn't see a vulnerable young woman staring back but a woman who'd made mistakes and had grown from them. Was even more surprised to find that growing didn't seem like such a bad thing, even if it had cost her a promotion.

She should have been upset, but somehow losing the position to Lana didn't feel as important as it might have. The captain's words kept replaying in her head.

Until you believe in yourself...

For the first time since she'd read his message, she thought she really understood what he'd meant.

So she'd lost the promotion. Toujacques was just one part of her life. Or should be. Was a job more important than the special moments she'd shared with Tally getting her costume ready? Or enjoying all her hard work with the krewe by parading on the float and dancing at the coronation ball? And if she wanted to see Lucas again, why couldn't she ask him out?

There wasn't any reason she couldn't take on a few extra projects for Toni to earn enough for a flight to California. She could pop by his office and surprise him. Or wherever he happened to be working that day.

Or night.

Maybe she'd even catch him fresh from the shower in a towel and rescue him from a lonely night.

Staring into the mirror, Bree inclined her head at the

reflection that stared back. She might have to live with the effects of past decisions, but as soon as she saw Lucas off tomorrow, she was going to the police. At least this part of the past she could put to rest once and for all.

15

KREWE DU CHAUD'S PARADE kicked off the final weekend before Fat Tuesday and always drew a crowd. Lucas knew from past experience that Captain Gabriel Dampier was big business at Mardi Gras, so when he led Bree from the uptown restaurant where they'd enjoyed a pre-parade breakfast with the other krewe members, he wasn't surprised to find the streets jammed.

Costumed revelers swarmed in every direction at the parade's starting point on the corner of Tchoupitoulas Street and Napoleon Avenue. The crowd surged as Krewe du Chaud's court began emerging from the restaurant, and a deafening cheer went up, drowning out the marching band. Lucas held on tight to his beautiful date as they made their way through the crowds to their assigned float.

Gator Bait.

The gator was still an impressive old guy, with his sixty feet of bright green scales, clawed feet and a snapping mouth that always pleased the crowds.

Bree had wrangled a position on the old float from Josie to surprise him, and he was surprised, both by her thoughtfulness and by his excitement as they headed toward the float.

He'd ridden in the parades since birth. Literally. Most children's lives were marked with milestone school photos and achievements. Lucas's had been commemorated by

parade photos and newspaper clippings of Mardi Gras. A lifetime of evidence currently resided in Josie's attic, starting with photos of him as an infant propped in a carrier behind his parents on one of the original floats.

But in all those years of tossing throws to the revelers along the same parade route, he'd never climbed onto a float with such a beautiful woman by his side.

Bree was such a gut-wrenching vision in her costume that he was almost sorry he hadn't let her get dressed at Félicie Allée. *Almost.* Even though seeing her in this fantasy of yellow fabric and sparkly trim took his breath away, he could still envision all the naked curves below the beautiful dress.

Unable to resist touching her, Lucas slipped his hands around her waist and lifted her onto the steps. With a laugh reflected in the depths of her dark eyes, she hoisted her skirts and climbed up.

"I haven't ridden in this old guy since I was fifteen." He followed behind her. "That was the year Max squeezed inside Gator Bait's mouth through the maintenance shaft to wave at the crowds. Of course, I blocked the hatch with the coolers, so he had to ride the whole parade route with those big teeth snapping on his head."

"Roguish." Bree shot him a horrified glance.

"Good times."

The float captain, a man named Randy Schneider, who was actually a court resident from Number Thirteen, welcomed them on board and directed them to their positions and supply of throws. They were stationed in Gator Bait's middle, a prime spot, and Lucas led Bree to their stock and started passing along strands of colorful beads in a variety of styles.

"These are the special throws. Take some of these, too."

"Wait, wait, Lucas." She laughed. "I can't hold any more."

He glanced up to find her cradling an armful of beads that were slithering and slipping through her fingers. "First time as a masker?"

She arched that dark eyebrow and didn't bother to answer.

Reaching out, he gathered some of the strands, untangled them and slid them over her hand and up her arm. "Like this."

He strung beads, then continued up her other arm with the special throws. "We'll keep the box of doubloons with us. But you don't want to be bending up and down all day. Trust me."

"Glad you're old hat at this." She winked.

Before his thoughts caught up with his actions, he had her in his arms and was kissing the laughter from her lips.

A cheer went up along with some pretty lewd comments that had them both laughing by the time they sprang apart again. Just the sight of her heightened his excitement. She looked breathless and eager as the float started to move.

The crowds roared. The band played. And even though he'd come back home for Mardi Gras more often than not these past years, Lucas couldn't remember looking forward to a celebration this much.

"Do I just throw them?" she asked.

"Make the crowd work. Especially for the good ones. Like this." Leaning over Gator Bait's side, he dangled a handful of beads at the revelers, and a cry went up.

"Throw me something, mister!"

"Throw me something, lady!"

Lucas spotted some frat kids whooping wildly and

threw some beads. He tossed up one of his good throws—fat golden beads with Tally's treasure-chest pendant—to a boy on top of a ladder.

Bree turned her charm onto the crowd, taunting the revelers with her throws, laughing and waving, and he found himself yelling with her, enjoying the freshness of this celebration through her enthusiasm.

"Tally used to drag Mark and me to this parade to see the captain every year." She reached into the box at their feet for some doubloons. "It's a lot more fun on this side."

The parade rolled down historic St. Charles Avenue, then to Gallier Hall for a toast before heading into the French Quarter, stopping twice along the route to allow krewe members to get off the floats and interact with the crowds. They answered questions about the float and swapped throws for dances.

Lucas and Bree took a few obligatory turns in the street, then returned to the float breathless less than ten minutes later.

"This is hard work." She fanned herself with a hand and tossed a handful of doubloons into the crowd. "Always looked like a piece of cake from down there."

Lucas handed her a bottled water from a cooler. "We're only a third of the way there. Not ready to stop yet, are you?"

Bree tossed her head back, sending moist tendrils of hair wisping around her face and neck, and smiled at him with a dare. "Not on your life."

Cracking the lid, she brought the bottle up to his in a rousing toast. "To the captain."

"To us," he replied, taking a welcome swig.

Her dark eyes sparkled invitingly.

The parade eventually wound around to Court du

Chaud, where the floats made a second stop to honor the man behind the krewe. The crowds had grown dense. Revelers had ladders set up all along the street behind his house, and those without ladders climbed onto the walls.

Lucas knew from experience about the mess they'd find in the yard tonight—water bottles, beer cans and debris littering the bushes—but the mess always proved worth the excitement.

Revelers waved and shouted greetings of respect to the captain rumored to be haunting the court, and the krewe members launched into the captain's anthem. The floats blared the theme song from *Downtown Pirates.*

Lucas sang while trying to pick out Bree's alto in the din, a lovely voice that again belied her claims of being the untalented one in her family. And as they climbed down from Gator Bait yet again, he noticed the tree she'd scaled into his yard on the fateful night, a night that had started a sequence of events that was changing his life.

A woman dressed in a costume caught him, and he allowed himself to be led into a dance, managing to keep Bree close as she danced with an old man. They'd only taken a few turns when he gifted his partner with a treasure-chest necklace and accepted another woman's offer, working his way back to Bree, catching sight of her changing partners, too.

Then some revelers crowded between them, and Lucas maneuvered his new partner around to get back to Bree. He hadn't managed the task before something exploded against his head so hard that he staggered.

"What the hell—"

His partner broke from his arms and mouthed a silent *Oh.*

Whatever had hit him had exploded in white dust,

covering him in the stuff, and he glanced down to find the broken torso of the cupid statue he'd made for his mother in the third grade sitting on the pavement, now limbless and half-crushed as it took another hit under some reveler's boot.

Lucas blinked in amazement, glancing in the direction the thing had come from…and saw Bree.

Her expression stopped him cold.

It took only an instant to register how she stood rigid in her partner's arms, everything about her on red alert. Lucas recognized the long-haired man holding her too close.

Robicheaux.

Breaking through the crowd, he moved in and said, "Hands off the lady."

Robicheaux lifted a clear gaze to Lucas's, a gaze that flashed amused defiance. "She's mine right now."

The amusement nailed Lucas someplace deep, someplace he'd had no idea he even possessed. But the feeling of icy fury didn't let him think, just react.

Grabbing Robicheaux's ponytail, Lucas yanked the man's head back. Bree broke away with a gasp.

"Lucas, don't."

He heard relief in her voice, anger and fear. Whether for him or the man who'd held her, Lucas didn't know, he only knew he controlled the moment and that wouldn't change.

To avoid the possibility of retaliation, he caught Robicheaux's hand, twisted it back and leaned close.

"I know everything about you," he snarled in Robicheaux's ear. "From Harvey Brondell's name and your seventeen Internet collaborations to your last five addresses under three aliases."

Lucas lifted Jude's arm higher until he grunted in pain. "I see you around Bree again and I'll send that information straight to an associate deputy of the FBI. If you were smart enough to do your homework about me, you'll know I wrote NCID. There'll be an APB out on you in every hick town from Boothbay Harbor to Silicon Valley."

Jude didn't get a chance to reply. Lucas gave him one solid heave and sent him stumbling into the crowd. Then he caught Bree's arm and led her away in case the idiot had a gun and decided to use it.

"How did you—"

"Later. Come on."

Keeping her in front of him, Lucas led them around the back of Gator Bait, cutting in front of the flambeau bearers who marched behind the float. He wanted her off the street and out of sight before the parade started moving again.

She moved along quickly by his side, her expression so tense he was sorry he hadn't damaged Robicheaux.

He only knew the result of what had been between Bree and the man, police reports that told him nothing about why she'd been with Robicheaux, whether he'd ever hurt her.

But Lucas had seen the look on her face, heard the sound in her voice…and he knew anger that was unlike anything he'd ever known before, a fury that this bold, beautiful woman had ever had to deal with such a lowlife.

No woman ever should.

Breathing to dispel the sensation, he knew he needed his calm about him. Bree had closed off completely, her distance firmly in place. The only hint of the encounter was a pallor that made her golden skin seem ashen and her eyes haunted.

The crowds were so thick that it took them nearly a full

ten minutes to circle around until they could access the court alley, and each second that ticked by, Lucas expected Robicheaux to emerge, tried to figure out what to say to Bree. If she gave him a chance to say anything.

But she didn't resist when he led her to his door without further incident. She didn't question why he'd brought her here rather than her place. Maybe she'd already guessed he didn't want her easily accessible until he had a lock on how her ex-bum might react to their confrontation.

She didn't say anything at all.

There was a warrant out for Robicheaux, and Lucas wondered if Bree knew. Every self-righteous blood cell he possessed screamed to pick up the phone and call the police, but Josie's warning continued to loop in his head.

I'm telling you not to bully her. Sounds to me like she's had enough of that already.

"Come on." He led her into the living room. "Let's talk."

She wouldn't meet his gaze and went to stand at the window. The silence felt heavy. The intimacy that had always been such a natural part of being with her vanished entirely, leaving Lucas to wonder if he'd assumed too much already.

LUCAS KNEW.

Bree didn't know how he'd found out about Jude, didn't know if she even wanted to know.

She wasn't sure how she felt about anything right now. But this wasn't how she'd envisioned their denouement or how she'd feel wearing her beautiful new gown.

She should be on a float right now, in a parade with Tally and Christien and their friends.

Not dealing with the past.

"Bree?" Lucas sounded cautious.

She didn't know what to say. She only knew that she couldn't turn around, didn't want to see him looking so dashing in his pirate garb. So she stared into the court, the colors vibrant in the bright winter sun while she stood inside.

Then suddenly he was behind her, slipping his arms around her and pulling her against him. His body surrounded her as it always did, arousing, possessive, *right*. He didn't say anything, just rested his chin on the top of her head and held her close.

They stood there staring into the courtyard, neither speaking. Bree tried to find anger. He'd obviously been prying into places she hadn't wanted to share with him or anyone. She didn't like men who only cared about their wants. But even though she'd stereotyped Lucas as that sort of man at first, he'd proven himself so much more.

But she couldn't find anger with his arms around her, not when the tender way he held her assured her how much he cared.

"I overstepped my boundaries," he said quietly. "I knew it when I made the decision to start digging around about you."

"But why?"

"John and I saw a car in the parking lot at the den. I knew someone had been inside."

"I told you I had everything under control."

His arms tightened around her, a caring embrace. "There were marks on your face."

Bree squeezed her eyes tightly shut, remembering when Jude had grabbed her, not enough to hurt but enough to get her attention, to intimidate her.

She'd been so worried about hiding her past and

proving she could handle things on her own that she'd ignored what should have mattered most.

"I should have waited until you told me what was going on." His voice was a throbbing ache. "But, Bree, I'm in love with you. I know it sounds crazy because we've only just met, but I know you're the one. I never believed it happened this way."

When one soul recognizes another, the result is magic.

He shrugged. "I don't know what to say except I'm sorry. I was trying hard to play by the rules, to let things progress naturally, when all I wanted to do was share how I've been feeling. I already made the arrangements to extend my stay indefinitely. I figured if we had enough time together…"

Love follows rules that have nothing to do with time or place.

"But when I knew you weren't going to tell me what was happening, I couldn't stand by and do nothing, not without knowing what was wrong. Not if you were in danger."

So he'd charged in to play the hero, taken the decision out of her hands because he hadn't liked the way she'd handled it.

Had she really left him another choice?

Not a man like Lucas. He wouldn't give up what he wanted.

He wanted *her.*

Would she have wanted him to?

The gentle strength of his embrace answered that question. The way she felt in his arms overrode the past. Had she explained the situation, he could have helped her deal with Jude, but she hadn't wanted him to think less of her.

Then it struck her that Lucas hadn't judged her at all—she'd never given him that chance.

Bree had been judging herself.

She'd wanted him to believe she was an independent woman who handled her life on her own terms.

And he did.

She was the one who hadn't believed.

"How much do you know?" she asked.

"Only that the police investigated you for some scam Robicheaux was involved in. I know you were cleared. I checked out what he's been up to and found out about a bunch of Internet scams he's been running with a partner that might make Tally's treasure and your connection to it look attractive."

"No surprises there. He saw an angle. That's all he wants."

"I don't think that's all he wants."

She heard amusement in his voice and, surprised, she slanted her gaze his way to find him smiling.

"He's male, Bree. An idiot, true, but still male. I'm sure the treasure isn't *all* he wants."

She recognized his attempt to lend humor to the moment, to lighten what was such a painful place for her.

He understood and he loved her. She believed that. He'd shared his feelings openly, even unsure how she would react to his interference. She hadn't been nearly so honest—to him or to herself.

Now Bree was left to decide what she wanted.

All it takes is believing yourself worthy.

"Jude was a way out of a difficult situation—or so I thought," she said, taking a leap of faith and giving Lucas that chance. "I was young and life seemed impossible sometimes. My mother left when my brother was fourteen, but she'd never been around much even before that. Tally

and I had been on our own with him forever. Not that we minded. We had each other and that was all that mattered, but we could never seem to get ahead. When Jude came along…"

Honesty came so much easier than Bree had ever imagined, and as she explained the situation, she felt as she had the other night with Tally—relieved.

Lucas listened, didn't blow any of his own reactions or emotions over her. He seemed to sense she had enough of her own to deal with right now.

She explained how Jude had narrowed her world down to him and how she was in so deep by the time she recognized the problem she hadn't known how to get out. But luck, in the form of Jude's bad deal, had saved her.

"He needed to leave town fast, which would have meant me leaving Tally and Mark. Jude wanted that, of course—he and Tally hated each other—but I wouldn't leave my family. So he skipped town and left me to deal with his mess."

"Did he ever hurt you?"

Never so much as having to answer this question did.

But Bree reminded herself not to give past mistakes too much power. Would she really want to change the past if it meant not becoming who she was today?

"Not physically, if that's what you're asking," she said. "He was subtle, controlling."

"Is that why you didn't call the police? You wanted to tough it out?"

She shook her head and decided she owed Lucas the truth whether it sent him running or not. "I didn't want him to think he could intimidate me. Then there was you. If he knew I was involved with you, he'd know he couldn't compete and move on."

A double-edged admission if ever there was one, but in typical Lucas fashion, he took her admission in stride. He didn't seem to need to hear this wasn't the only reason she'd gotten involved with him, and to prove it he pressed a kiss to the top of her head and held her, just held her.

"I had no clue why Jude came to town, Lucas. I saw him for two minutes in the den, and he didn't tell me. I'd suspected he turned up because he heard about Tally and the treasure and I had decided to go to the police after you left."

"Why after?"

"The job promotion. You. I just needed a week. I'd know who had the job and you'd leave. I didn't want you to know about him, about…" She heaved a sigh. "I refused to give that man one second of time I could be spending with you."

Those strong arms maneuvered her around until she had no choice but to face him.

"You didn't think knowing about your ex-bum would influence how I felt about you, did you?" He hooked his finger beneath her chin and tipped her face toward him.

The emotions in his beautiful green eyes made her insides melt, made all her doubts fade beneath the truth she saw there.

She was the only person afraid of the past.

"At first I thought it might," Bree admitted. "But after I got to know you, I realized it was more about me feeling bad about me."

Lucas didn't say anything. He didn't have to because his actions said everything. Lowering his face to hers, he caught her mouth and kissed her with a heat that made the past fade back where it belonged and assured her the only thing that mattered was the here and now and being together.

So with a sigh Bree sank into his embrace, tasted the promise in his kiss and let herself take the advice of her ghostly ancestor.

To believe.

"You know," Breanne said as she snuggled against Lucas, their auras flashing the vibrant colors of a rainbow. "Since you've extended your stay indefinitely and we're already missing the parade, we've got some free time until the ball tonight. I'm thinking it wouldn't hurt to make a trip to the precinct to report that Jude's back. Care to join me?"

Lucas, who looked like no self-respecting pirate Gabriel had ever seen in his tight black trousers and flowing white shirt, kissed the top of Breanne's head and sent those rainbow hues sparking in a fabulous display. "Let's go."

Gabriel brushed absently at a crease on the sleeve of his top coat. Not that the crease would smooth away, of course. It had been his constant companion for nearly two hundred years. Had he known he would die wearing this top coat, he'd at least have seen the thing properly cleaned.

But when he saw the peaceful expression on Breanne's face, he thought he just might forgive Lucas the absurd costume. After all, the fellow hadn't actually been there when pirates and privateers had sailed the seas.

"Look at those auras flash." Gabriel laughed.

"Impressed with yourself, aren't you?"

The sound of *belle grand-mère*'s voice sliced through him as sharp as a rusted sword.

Gabriel turned toward the sound. "Honestly, *belle grand-mère*. Are you not tired of this infernal nothingness yet?"

She scowled but didn't reply. Gabriel found that encouraging.

"Come on, old woman. Not even you can deny they're in love. So much for ambition. Breanne barely flinched when she lost her job promotion, and look at them together. They glow." He watched the young couple head out the front door with a feeling so different than the familiar pride that had bolstered him in life. He was proud, to be sure, but of the outcome his machinations had wrought. A pride that felt much more like pleasure for the two people beaming at each other right now.

"Ha! What do you think of my parlor tricks now?" He could not stifle his enthusiasm, although he knew he would get no compliments from *belle grand-mère*. "Did you see me lob that statue from the wall? And my aim?"

"You almost killed the boy, pirate."

"What?" Gabriel demanded indignantly, ignoring her insult and gliding to the door where the boy in question stood.

He inspected Lucas's head, saw no hint of a bruise, even if the red mark from his impeccable aim and impressive force hadn't yet faded. He passed his hand through the fading mark. "Do you mean this? 'Tis nothing. I didn't even addle his wits."

Gabriel hoped, because Lucas stopped dead in his tracks, frowned and ran a hand along his forehead right where Gabriel's hand had been.

"Are you all right?" Breanne asked.

Lucas rubbed his temple harder. "Just a chill, I think."

"A chill?" Breanne asked. "Really?"

Lucas nodded, and with a laugh Breanne looped her arm through his, glanced over her shoulder and mouthed the word, *Thanks*.

Gabriel exhaled another satisfied sigh as he watched the two lovebirds saunter off to tackle the trouble together. 'Twas a concept he was only just acquainting himself with.

"Thank you, *belle grand-mère*." He turned back to the old woman who stood behind him, an old woman who somehow didn't look nearly as bitter as she did tired, he thought. "Thank you for helping me protect Breanne and bring these two together. And for giving me a chance to see past myself to this." He swept a hand toward Breanne and Lucas as they closed the gate behind them, hands clasped.

"So the curse has become a blessing, pirate?"

"I suppose," he said slowly, considering. "In some ways it has."

He didn't know what surprised him more—his own change of heart about these wasted years or *belle grand-mère*'s reaction.

Wrapping her arms around herself tightly, she let out a wail so loud he winced. "You suppose, pirate? I suppose this means I'll now spend my eternity reminding my softhearted granddaughter not to let you run roughshod over her."

Gabriel didn't know how long he stood there staring. He couldn't seem to wrap his thoughts around the old crone's words. Was she saying that after the curse was over he might stand a chance of winning back Madeleine?

The anguish on her face was his answer.

"*Belle grand-mère*." He extended his hand, a gesture of peace he hoped she would accept in the spirit he meant. "On my honor, if I have earned a chance for a real eternity, I will devote every minute to earning your granddaughter's forgiveness."

"Earning? Do you think yourself capable?"

Gabriel didn't answer quickly. Indeed, he considered what he'd gleaned of his choices gone bad, of lessons he'd learned while watching his two strong descendents put aside their ambitions to take their chances on love.

"I do." And he had never meant anything more in his life—or his death. "What I do not yet know, I shall learn."

She considered him gravely, but something in those bead-black eyes flickered. "This I shall like to see."

Then *belle grand-mère* accepted his hand, and if Gabriel had expected fireworks and fanfare when the curse finally broke, he'd been mistaken. There was a glint of light beckoning from beyond the court, a diamond sparkle like the sun on the waves.

A welcoming warmth filled him, pulled him toward the light, and he felt…eager to see what a real eternity would bring, and for a chance to convince his beautiful Madeleine that he had indeed learned the value of love.

Epilogue

Lucas sat on the front steps of his childhood home, sipping his morning coffee and reminiscing about a lifetime of awakening to the sight of Court du Chaud in all its glory. In the winter the lush greenery might fade, and the pavement in summer sizzled beneath a heat so complete the humidity sucked the breath from his lungs, but he was home.

There was no place in the world like it.

Number Sixteen had passed from his parents to Josie and now would become his—if he and Josie ever ironed out the details of the sale so they could close the deal.

He had no doubt they eventually would because his little sister was eager to have her family back in her world. Lucas in Number Sixteen. Max in Number Seventeen. The only difference—Josie had finally crossed the alley the way she'd always wanted.

All was right in Josie's world.

All was right in his, too, Lucas thought as Bree strolled down the walkway toward his gate, sipping a cup of Café Eros's jet-fuel java, looking as if she could take on the world.

Just the sight of this woman filled him with a sense of excitement, made him grateful he'd come home. He loved Bree whether she was dressed to the nines and sitting in

his bushes or wearing her historical finery. He loved her den-ready in worn jeans and tight sweaters. He loved her best naked.

This morning she looked stylishly professional in a scarlet slacks ensemble that hugged her slim curves. She'd pulled up her hair in an elegant sweep that let him admire the lines of her face and made him think about kissing her.

Maneuvering the gate open one-handed, she slipped through, a fluid move that made him think of sex.

Everything about Bree seemed to make him think of sex.

"Good morning, beautiful. All set for your first day?" he asked as she strolled up the walkway.

Reaching the bottom step, she twirled on her pumps for his perusal. "Do I look the part? Toni said she wants me to work on the floor at first. See how the place runs and meet customers."

"You look good enough to eat." He set his cup on the step beside him and stood. "Having any second thoughts about the career change?"

"Not a one. It's high time to shake things up." She smiled up at him. "I'm excited, Lucas. I'm going to be a designer. No more endless nights. No more running around in a frenzy catering to overindulged men."

Reaching the bottom step, he extended his hand to caress her cheek, unable to believe that this one beautiful woman had completely changed his life.

Change was the last thing he'd expected when stepping off the plane for his stint as Max's best man. He'd been amused that Josie had finally caught her lifelong target, but he hadn't understood. He hadn't believed in the magic of love then.

Another change for the better.

Bree leaned into his touch and let her eyes flutter shut, and he thumbed her lower lip, couldn't stop from leaning down to welcome her with a kiss.

"I'm hoping there's still one overindulged man you want to cater to." He breathed the words against her mouth.

"I happen to specialize in what that man wants." She caught his lip with her teeth. "Mmm. Missed you last night."

"Me, too." He kissed her again.

"Madame Alain's watching."

"We'll give her something to talk about. She's already buzzing because you're moving in with me, and you're not even here yet. Sure you don't want to sneak out the back so she can't catch you and make you late for work?"

"And scale that wall in this outfit? Thank you, no."

"Not even if I give you a boost?"

"You just want to peek up my skirt."

Unable to resist, Lucas caught her around the waist and pulled her against him, loving the feel of her in his arms, the way her expression softened right before they kissed.

"You're not wearing a skirt."

She arched her eyebrow. "Details."

He liked this expression, too, looked forward to learning how she looked during every second of every day as they merged their lives together. A process they'd already begun.

Jude Robicheaux had been officially relegated to the past now that the police had picked him up. From what the detectives said, no one would be hearing from him for a long time.

Bree had resigned her position at Toujacques to accept an exciting offer from Toni Maxwell.

Lucas would buy Number Sixteen from Josie, who'd moved in with her new husband. Bree and Tally would keep Number One for their brother Mark when he came home from college.

They'd already begun moving Josie's things over to Max's and Bree's things here. California could wait. He had a lot of loose ends to tie up there, not the least of which was an office to relocate and an assistant to convince there were more available men than women in the Big Easy.

The most important change in Lucas's mind was Bree agreeing to marry him. They hadn't set a date, still had details to smooth through. But for right now he was perfectly content to put a ring on her finger and have her take over his house.

And look forward to a big wedding celebration.

Everything was falling into place, and he had no doubts the process would continue. "If I get this sale settled with Josie."

"What's the trouble?"

"I can live with her asking price, but I can't live with the attic. She wants to leave everything for me to deal with."

"All your trophies and her dance ribbons?

"Everything."

"What if I agree to help you sort through it all? Never know what you'll find around here. Look what Tally found under the piazza."

She fluttered her lashes in a sexy look, so Lucas locked her tightly against him, felt the quick thump of

her heartbeat. He'd already found everything he wanted in Court du Chaud.

Life with the woman he loved.

* * * * *

*Don't miss Jeanie London's
next Harlequin Blaze novel!
Watch for her installment of*
THE WHITE STAR *miniseries
coming in April 2006.*

HARLEQUIN®

Blaze™

COMING NEXT MONTH

#237 ONCE UPON A SEDUCTION Jamie Sobrato
It's All About Attitude

He's *so* not Prince Charming. Otherwise Nico Valetti wouldn't be causing all these problems for Skye Ellison. Not the least of which is the fact that she can't keep her hands off him. And since she is traveling in a car with him for days on end, seducing him will just be a matter of time.

#238 BASIC TRAINING Julie Miller

Marine Corps captain Travis McCormick can't believe it when Tess Bartlett—his best friend and new physiotherapist—asks for basic training in sex. Now that he's back in his hometown to recover from injuries, all he wants is a little R & R. Only, Tess has been working on a battle plan for years, and it's time to put it to work. She'll heal him…if he'll make *her* feel all better!

#239 WHEN SHE WAS BAD… Cara Summers
24 Hours: Island Fling, Bk. 3

P.I. Pepper Rossi had no intention of indulging in an island fling. She's at the romantic island resort simply to track down a priceless stolen painting. Only, with sexy ex-CIA agent Cole Buchanan dogging her every step, all she can think about is getting him off her trail…and into her bed!

#240 UP ALL NIGHT Joanne Rock
The Wrong Bed

Devon Baines can't resist the not-so-innocent e-mail invitation. And once he spies Jenny Moore wearing just a little bit of lace, he doesn't care that he wasn't the intended recipient. Sparks fly when these two insomniacs keep company after midnight!

#241 NO REGRETS Cindi Myers

A near-death experience has given her a new appreciation of life. As a result, Lexie Foster compiles a list of things not to be put off any longer. The first thing on her list? An affair with her brand-new boss, Nick Delaney. And convincing him will be half the fun.

#242 CAUGHT Kristin Hardy
The White Star, Bk. 3

With no "out" and no means to reach the outside world, Julia Covington and Alex Spencer are well and truly caught! Trapped in a New York City antiquities museum by a rogue thief isn't the way either one anticipated spending the weekend, but now that it's happened… What will become of the stolen White Star, the charmed amulet Julia is meant to be researching? And what *won't* they do to amuse one another as the hours tick by?

www.eHarlequin.com

HBCNM0206